"What care I how chic it be, if it not be the best for me?"

B. ALTMAN & CO. AD

CHIC
SIMPLE®

WOMEN'S WARDROBE

ALFRED A. KNOPF NEW YORK 1995

THIS IS A BORZOI BOOK
PUBLISHED BY ALFRED A. KNOPF, INC.

Copyright © 1995 by Chic Simple,
a partnership of A Stonework, Ltd., and Kim Johnson Gross, Inc.

KIM JOHNSON GROSS JEFF STONE

WRITTEN BY RACHEL URQUHART
PHOTOGRAPHS BY JAMES WOJCIK
STYLE DIRECTION BY AMANDA MANOGUE BURCH
STYLING BY HOPE GREENBERG AND
LISA WERTHEIMER WELLS

ART DIRECTION BY WAYNE WOLF
CHAPTER ILLUSTRATIONS BY ALEXANDRA WEEMS
ICON AND FASHION ILLUSTRATIONS BY AMY NEEDLE
HANGER AND FIRST AID ICONS BY ERIC HANSON

Library of Congress Cataloging-in-Publication Data
Urquhart, Rachel.
Women's Wardrobe/[Kim Johnson Gross, Jeff Stone; written by Rachel
Urquhart;
photographs by James Wojcik].—1st ed.
p. cm.—(Chic Simple)
ISBN 0-679-44484-X
1. Clothing and dress. 2. Fashion. 3. Beauty, Personal. I. Gross, Kim Johnson.
II. Stone, Jeff, 1953–. III. Title. IV. Series.
TT507.U77 1995
646'.34—dc20
95-24809
CIP

Printed and bound in Great Britain by
Butler & Tanner Ltd, Frome and London
First Edition

GRATEFUL ACKNOWLEDGMENT IS MADE
TO THE FOLLOWING FOR PERMISSION TO
REPRINT PREVIOUSLY PUBLISHED MATERIAL:

INTERNATIONAL FABRICARE INSTITUTE:
International Care Symbols chart, copyright © 1988
by International Fabricare Institute. All rights
reserved. Reprinted by permission of International
Fabricare Institute.

LIVERIGHT PUBLISHING CORPORATION:
Excerpt from "pity this busy monster, manunkind"
from *Complete Poems: 1904–1962* by E. E. Cummings,
edited by George J. Firmage, copyright © 1944,
1972, 1991 by the Trustees for the E. E. Cummings
Trust. Reprinted by permission of Liveright
Publishing Corporation.

THE NEW YORK TIMES COMPANY: Excerpt
from "Coat Checking at the Philharmonic" by William
Geist (February 7, 1987), copyright © 1987 by The
New York Times Company. Reprinted by permission
of The New York Times Company.

G. SCHIRMER, INC.: Excerpt from "I Feel Pretty"
from *West Side Story*, music by Leonard Bernstein
and lyrics by Stephen Sondheim, copyright © 1956,
1957 (copyright renewed) by Leonard Bernstein and
Stephen Sondheim. Jalni Publications, Inc., U.S. and
Canadian publishers. G. Schirmer, Inc., worldwide
print rights and publisher for the rest of the world.
International copyright secured. All rights reserved.
Reprinted by permission of G. Schirmer, Inc.

WARNER BROS. PUBLICATIONS INC.: Excerpt
from "Singin' in the Rain," words by Arthur Freed,
music by Nacio Herb Brown, copyright © 1929
(renewed) by Metro-Goldwyn-Mayer, Inc. All rights
controlled by EMI Robbins Catalog Inc. (Publishing)
and Warner Bros. Publications Inc. (Print); excerpt
from "Anything Goes," words and music by Cole
Porter, copyright © 1934 (renewed) by Warner
Bros. Inc. All rights reserved. Reprinted by permis-
sion of Warner Bros. Publications U.S. Inc., Miami,
FL 33014.

For Amanda Manogue Burch,
Susan Harrington, Evelyn Johnson,
and Mary Louise Norton—
four great gals who know how
to put the chic into CHIC SIMPLE
and have fun doing so.

K. J. G.

In memory of Nancy Stringfellow—wore black dresses, stiletto heels,
and bright red lipstick, and let her cigarette ash always dangle long enough
to make people nervous—downtown style in Boise, Idaho.

J. S.

To George and Theo,
for their enormous love, support, humor, and, of course,
profound collective fashion sense.

R. U.

"The more you know, the less you need."

AUSTRALIAN ABORIGINAL SAYING

Chic Simple is a primer for living well but sensibly. It's for those who believe that quality of life comes not in accumulating things, but in paring down to the essentials. Chic Simple enables readers to bring value and style into their lives with economy and simplicity.

CONTENTS

HOW TO USE THIS BOOK: Chic Simple is about information—why else use the aboriginal saying "The more you know, the less you need" as our corporate motto? And nowhere is this more appropriate than in the perplexing world of clothes and fashion. Understanding the important quality points of different clothes is the basis of the Chic Simple philosophy of developing personal style. The fashion-savvy woman understands the significance and the appropriateness of what she's wearing and how it fits the occasion, the season, or her body type. To make it simpler to keep all these considerations in mind, we created the following system of icons, which flag contextual information in quick, graphic shorthand.

ICONS

This outfit is flattering to a certain BODY type but perhaps not to others. As in all broad generalizations, there will be exceptions to the rule—and you also may not care—so read with one eye cocked at the mirror.

When purchasing clothes, it is important to invest in VALUE. A garment might cost $500, but if it is of high quality and timeless lines, so that you can wear it four times a month all year long for five years, it's actually costing you only a little over $2 per wearing. (It would be nice if American Express would allow one to pay according to this same formula.)

Remember when you got sent home for wearing culottes or a short dress to school (or work)? With the dress-down Friday becoming a weeklong phenomenon, DRESS CODES are now more about appropriateness—the summer/winter, what, when, where questions.

Survival gear, must-haves, or just the BASIC wardrobe building blocks, these are the essential items that will allow you a lifetime of pleasure and value when carefully selected. They're the kinds of things you borrow from your mother and somehow never return.

Hairshirts are an interesting way of adding TEXTURE, but this reference is about the additional element of style that different or unusual material can add to an outfit's visual and tactile impact. A trench coat becomes a different, more flirtatious animal in silk; the shape and function are the same, but with a texture change, the identity switches.

In general, most of us would look better if we avoided PATTERNS—there is nothing more terrifying than watching what appears to be a chintz sofa walking toward you; however, a judicious use of classic prints is another way of adding vitality to the basics.

Though it's tempting to think about, one does not live in black or navy alone. COLOR provides sizzle and is the magic in expanding any wardrobe. This denotes a special color combination or flexibility.

VERSATILITY concerns how easily a garment can mix and match with a variety of wardrobe fundamentals. It doesn't mean you can use it to dry the dog and polish the silverware, but you may be able to wear it to the office and on a blind date that night with just a change of earrings.

FIRST AID. This icon indicates more in-depth information at the back of the book. Also, before you buy a piece of clothing, consider the maintenance factor—whether it's a garment that one can throw into the washer and dryer or something that needs to be hand-blocked by Tibetan monks in a small commune in Nova Scotia that only takes in garments during key cycles of the moon.

A total wardrobe that in THREE SIMPLE STEPS puts the chic into Chic Simple.

STYLE

"'When a girl feels that she's perfectly groomed and dressed she can forget that part of her. That's charm. The more parts of yourself you can afford to forget the more charm you have.'"

F. SCOTT FITZGERALD, "Bernice Bobs Her Hair"

WHAT AM I GOING TO WEAR?

For some of us, a closet is a very small space packed with strange out-fits we can't quite find. The clothes we finally do locate don't seem to really work once we've got them on. This book is for us. By helping us to define our own personal style, it will teach us how to shop in our clos-ets and create a wardrobe that meets our many needs. Who are we? How do we live? What clothes really fit our bodies, our lives, our style? It will help us answer these questions, as well as showing us the secrets to mixing the varied wardrobe items that we have. It will help us to clear out the bad and recognize the classics that never seem to age. It will teach us how to interpret a price tag and decide what clothes are worth investing in, and show us ways to dress for comfort, work, play, and evening. Most of all, it will teach us how to build a wardrobe that will last—with care, culling, and the occasional addition—for years.

WHAT DO I LIKE TO WEAR?

PEOPLE ARE VERY VERSATILE. WE CAN BE INFINITELY

SUGGESTIBLE, INCURABLY PROVOCATIVE, OR COMFORTABLY PREDICTABLE.

THE FIRST HINT OF SPRING MAY BE ALL THE ENCOURAGEMENT WE NEED TO REACH

for a pretty dress. But faced with a tough day at the office, we know enough to pull out the power suit that strikes

just the right authoritative note. Our lives are not simple. They require us to be different people at different times.

WHO ARE YOU? ARE YOU SHY? **FLAMBOYANT?** A SEDUCTRESS? WHAT DO YOU NEED TO MEET THE DEMANDS—KIDS,

COCKTAIL PARTIES, BOARD MEETINGS, ZUCCHINI-GROWING **COMPETITIONS**—YOUR LIFE MAKES UPON YOU? HOW

ARE YOU GOING TO HANDLE YOUR AGE—BY ADAPTING STYLES WITH PRIDE AND **SOPHISTICATION** TO WHO YOU

ARE NOW, OR CLINGING TO A PAST VISION OF YOURSELF BY DRESSING TWENTY YEARS TOO YOUNG? FINALLY,

WHAT STYLE WORKS FOR YOU? DO YOU PREFER THE TAILORED LINES OF A MORE CLASSIC LOOK? THE FLOWING

LOOSENESS OF **ROMANTIC** CLOTHES? ARE YOU DRESSING TO GET **ATTENTION**, OR TODEFLECT IT? DO YOU LIKE THE

RISK OF FITTED, SEXY CLOTHES, OR ARE YOU MORE COMFORTABLE WITH AN **UNDERSTATED**, NO-NONSENSE

APPROACH? ARE YOU **FUNKY**, ATHLETIC, **MINIMALIST**, EXTRAVAGANT? THE QUESTION IS...WHO ARE YOU—**TODAY?**

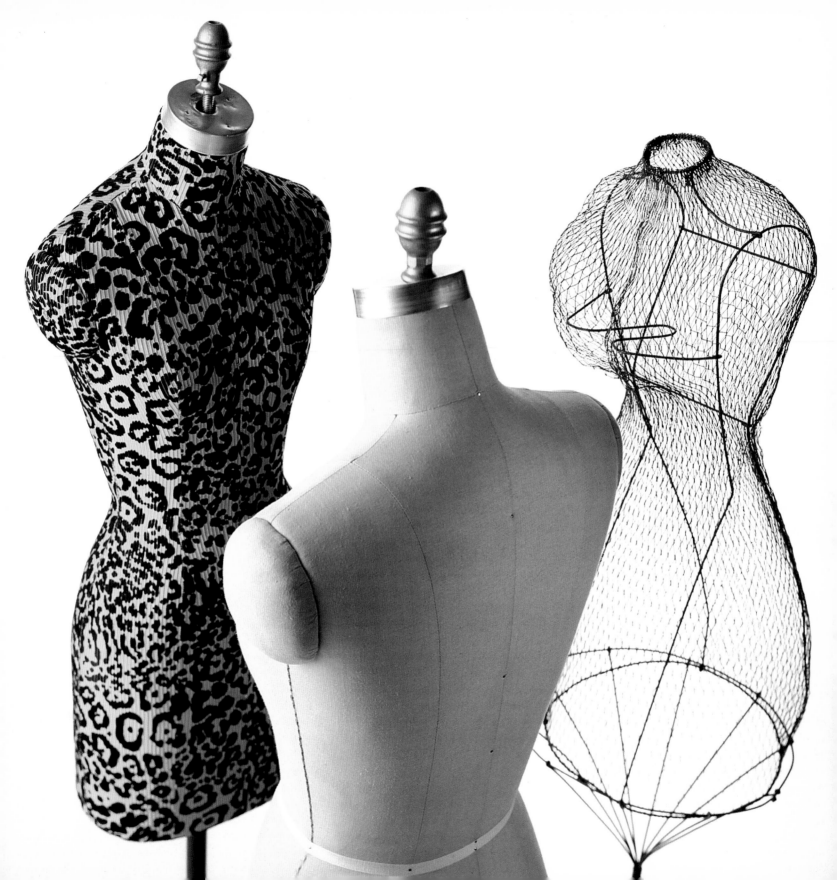

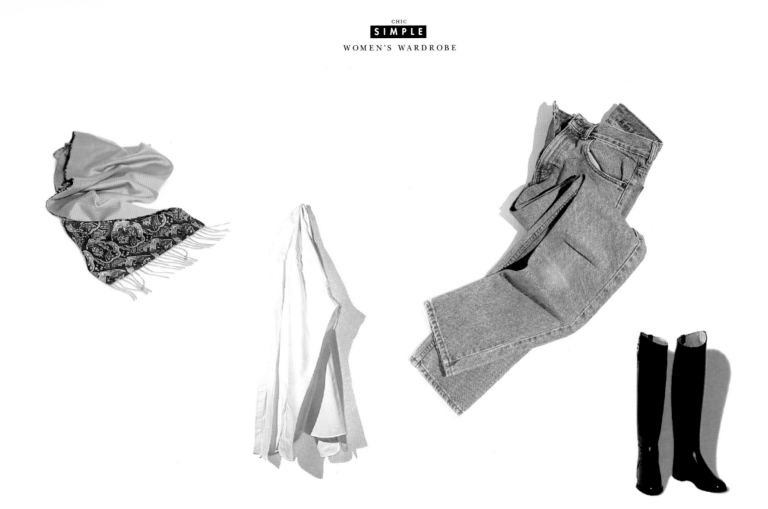

WHAT DO I FEEL GOOD IN?

YOU WILL ASK MORE OF YOUR CLOTHES THAN YOU WOULD

A SPOUSE. YOU WILL DEMAND THAT THEY MAKE YOU FEEL

PRETTY, AND WITTY. AND WHY? *BECAUSE YOU CAN.* YOU MAY WEAR

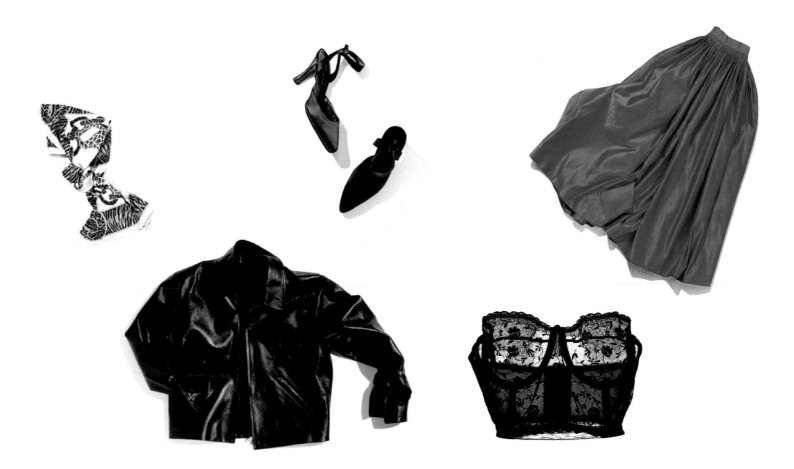

a perfectly cut suit like a coat of armor—to conquer, to defend, to protect. At times, your clothes will announce you; at other times, disguise you. Your daily uniform? The things you reach for, time after time. One really great thing about clothes? They will never complain that you're simply too damn hard to live with. But you need to know what makes you feel secure—even if that changes depending on whether you're at home, or at work, or at your best friend's wedding. Cut, color, and pattern are what you must consider. Sometimes, security is knowing that you look drop-dead fabulous—even if it involves subjecting your feet to an uncomfortable pair of shoes for a couple of hours. In fashion, as in NHL hockey, pain is relative.

"I feel pretty, Oh, so pretty, I feel pretty, and witty and bright."

MARIA in *West Side Story*

WHAT FITS ME?

THE COLOR MIGHT BE PERFECT. THE

PATTERN AND TEXTURE MAY BE PURE

GENIUS. BUT IF THE LINES OF AN OUTFIT ARE

off and it doesn't fit properly, then you might as well toss in the

towel and begin again. Line and fit are about how clothes conform

to your body. Proportion is the key for visual effect. As for fit, your

clothes should feel like a second skin. Sometimes, this depends on

the brilliance of the designer. Has he draped, cut, tucked, and sewn

seams in ways that not only inspire wonder, but also hide your weak

spots? And you. Have you chosen to dress in something that really

suits you? It can be baggy or tight, short or long, or even asym-

metrical—just as long as it's supposed to be that way on you.

FIT CHECKPOINTS 1. Check that hips do not bulge above pockets. 2. Check for unflattering creases extending from crotch. 3. Does the blouse pull at the buttons? 4. Do the stripes hang properly? 5. Check for puckering along seams. 6. Check that knits are elastic and retain their shape at ribbing (neck, wrists, and waistband). 7. Pleats should lie flat, not pull apart. 8. Zippers should lie flat and be easy to use. 9. Is there any fabric bagging around the knees or at the rear end? 10. Check shoulders and sleeve length; shoulder seams should not pull, and sleeves should extend to wrist joints.

Facing the Facts. Confronting the mirror can be tough, but the alternative—a blind certainty that bold horizontal stripes bring out the best in your figure—is worse by far. See yourself clearly, but be gentle. Are you petite? Rubensesque? Do you hate your elbows? Even if green is the color of the moment, does it make you look like someone who resides in a damp, mossy crevice? Are you the proud owner of the world's best collarbone? Bellybutton? Calf muscles? If so, terrific. Go out and find something that will show them off. The more you know about your body—sizes, good sides and bad sides, Spandex tolerance—the better you'll be at dressing it. Ultimately, you are dressing for yourself, not a salesperson, your mother, or to make your significant other jealous. By all means, fall in love with magazine spreads, but be self-assured enough to realize when something's just not for you.

HEADS UP. Wearing clothes well is about posture. What did you mother—or was that General Patton?—always tell you? Stand up straight, shoulders back, chest out, hips square. Book balancing may no longer be necessary, but are you holding your head high? Standing balanced on solid footing? If so, you'll improve a lot more than the way you look. Posture affects breathing, circulation, digestion, alertness, energy, confidence, and voice projection—and it's free. There's only so much a beautifully cut jacket can do. The rest is all up to you.

[🦋 FITTINGS *first aid—page 201*]

WHAT IS MY STYLE?

STYLE IS NOT ABOUT CLOTHES ALONE. IF IT WERE, A WHITE SHIRT, A PAIR OF SUNGLASSES, AND A GLEN-PLAID JACKET WOULD ALWAYS LOOK THE SAME NO MATTER WHO WAS WEARING THEM. STYLE IS ABOUT MAKING

something your own. Coco Chanel knew this. Maids' uniforms, costume jewelry, men's yachting clothes—all were reinterpreted by her to suit her taste and sense of fashion. Style looks effortless. It removes any possibility that the wearer should ever dress any other way. Did anyone ever wonder what Katharine Hepburn would look like in flashy clothing? Style is confident. It can be brash and loud, or soft and demure. Madonna, for example, is known for constantly reinventing herself; she tries on every possible look. Others, like Lauren Hutton and Jodie Foster, have perfected a more low-key approach. What will your mark be?

"I knew I needed a look and I got one."

MARIA CALLAS in the play *Master Class* by Terrence McNally

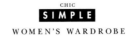
AUDREY HEPBURN: LITTLE BLACK DRESS **BARBARA BUSH:** PEARLS **DIANA VREELAND:** RED LIPSTICK **DOROTHY:** RUBY SLIPPERS **FLORENCE GRIFFITHS-JOYNER:** LONG, ELABORATELY PAINTED NAILS **FRAN LEBOWITZ:** MEN'S CLOTHING **GRACE KELLY:** SWEATER SETS, KELLY BAG, HERMÈS SCARF AS ARM SLING **HARRY TRUMAN:** BOW TIE

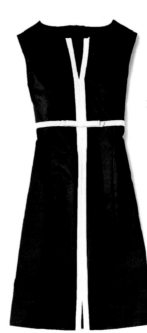

AUDREY HEPBURN

In the 1950's, she made the little black dress sophisticated and playful—the essence of her charm.

GRACE KELLY

A symbol of femininity and taste, this elegant handbag gave form and function to the image of the perfect princess. In fact, Hermès, its maker, named it the Kelly bag in her honor.

PERSONAL STYLE

WE HAVE ALL SEEN HER AND GAWKED WITH ADMIRATION—
AND NOT A LITTLE ENVY. SHE NEEDN'T BE BEAUTIFUL, NOR DRESSED

in anything we couldn't imagine for ourselves. But her clothes are a brilliant orchestration of color and texture,

JACKIE O: BIG SUNGLASSES, PILLBOX HATS **JAMES DEAN:** LEATHER JACKET **KATHARINE HEPBURN:** MENSWEAR-INSPIRED CLOTHES **MADONNA:** UNDERGARMENTS AS OUTERGARMENTS **MARLENE DIETRICH:** TUXEDO **MICHAEL JACKSON:** SINGLE SEQUINED GLOVE **NANCY REAGAN:** RED **TWIGGY:** FAKE LASHES, MICRO-MINISKIRT

JACKIE O

Her dark glasses symbolized her sense of fashion, her private nature, and the star status we inflicted on her.

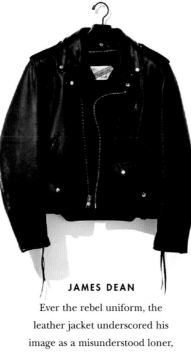

JAMES DEAN

Ever the rebel uniform, the leather jacket underscored his image as a misunderstood loner, a romantic antihero.

BARBARA BUSH

The essence of patrician style, her four strands of pearls stood for good breeding and a traditional, understated sense of fashion.

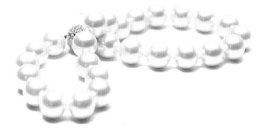

fabric and fit, sensibility and style. And she wears them like a badge—they don't wear her. Maybe it's a color she's claimed as her signature. Perhaps it's her panache at mixing the unexpected. She may even buy certain basics over and over, in varying textures, fabrics, and cuts—just different enough to keep things new. Chances are, her look is consistent: every time you see her, her style is unmistakably her own. Her personal style is her personal uniform.

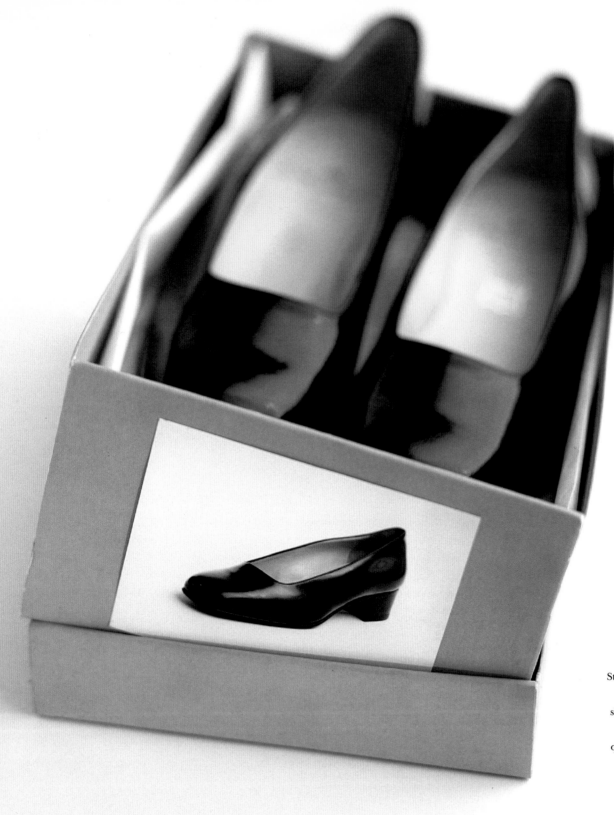

STORING

Storing shoes in boxes allows
you to pile them up on a
shelf instead of losing them
on the closet floor. For a
quick shoe review, label the
boxes with a Polaroid of
what's inside.

WHAT'S IN MY CLOSET ?

CULLING IS AN ESSENTIAL ACTIVITY IN NATURE AND IN FASHION. THE BAD NEWS? IT'S PAINFUL: EVEN IF YOU WOULDN'T BE CAUGHT DEAD IN IT, CAN YOU BEAR TO PART WITH YOUR EX-BOYFRIEND'S RATTY college sweatshirt? It's also time-consuming: you'll have to try on the contents of your closet and your bureau—maybe two or three times. Yes, it's depressing if you've outgrown your lucky jeans. The good news? Sometimes, a hard look at your wardrobe reveals whole new ensembles—and you won't have spent a penny. You may find the reason you're not wearing a particular dress is simply that you've neglected to buy stockings that go with it. Purge your closet before embarking on a big shopping trip; you'll have a better idea of what you really need.

CONSIDER SHELF LIFE: If you never wear it, apply the twelve-month rule, and recycle. If you must, allow yourself a few exceptions. **DISCERN:** Be ruthless, or bring in a ruthless friend—preferably one whose style you admire. **DOCUMENT:** Borrow a camera and document outfits you come up with. **FILL GAPS.** List what you need, and buy accordingly. **ORGANIZE:** Redesign your closet so you can see everything, and group things—whether by size, color, or use—in a way that makes sense to you. **RESTORE ORDER:** Make your closet a haven of order and function. There can be method to the madness—you just have to impose it. Try on outfits in front of a full-length mirror. Weed out what no longer fits. Determine what you reach for daily and give it prime real estate. **RECYCLE:** Keep a box on the floor for thrift-shop donations. **PARTY:** When the purge is finished, invite friends over for a give-away. It may help to know that someone you like is wearing a beloved item.

> "Dreck is dreck and no amount of fancy polish
> is going to make it anything else."

LINDA ELLERBEE

[✇ CLOSETS *first aid—page 185*]

HOW MUCH SHOULD I SPEND?

YOU'VE JUST SEEN THE DRESS THAT WILL change your life. The problem? Its price tag will put you in hock, and that's not quite the transformation you had in mind. Organize your budget. Sort out what you want from what you need, then think about what you can afford. How do you know if something's too divine, or just too dear? Put it under the microscope. Money well spent will buy you high-quality fabric, sensible (if not brilliant) design, and remarkable workmanship. A few questions: How versatile is it? Chances are, you'll

"Blue denim becomes more comfortable as it's worn and washed, but only six wearings after a pair of blue jeans achieves comfort perfection, holes begin to appear."

CALVIN TRILLIN

have that exquisitely tooled black leather bag for years. It's the hot-pink quilted purse that may be headed for the tag sale next season. How well does it fit into the rest of your wardrobe? A really perfect suit is always more than just the sum of its parts. How delicate is it? One good rainstorm and even the most expensive suede pumps will look shabby. Invest in a good basic wardrobe, then spruce it up with a few things each season that will update or enhance what you already own. Clothes worth spending money on shouldn't be disposable.

WHAT'S A GOOD INVESTMENT? Classic design and the best quality you can afford: a beautifully tailored suit and blazer in a high-quality, seasonless fabric; pants that really fit in a neutral color; the perfect simple black dress. Accessories that last: an everyday leather bag; a classic, structured handbag; a fine leather belt; durable opaque stockings. Things you'll wear to death: fine cotton shirts; well-made sweaters. **WHAT'S NOT WORTH SPENDING A LOT OF MONEY ON?** Generic basics: cotton T-shirts; designer jeans; espadrilles; casual summer dresses; canvas or straw totes; durable underwear; canvas sneakers. The vulnerable: suede shoes; sheer stockings. Anything trendy: fun items that you'll wear for just one season.

INVESTMENT GUIDELINES

Buy fewer things, but better quality. Is it a necessity? Versatile? Made well? Timeless in cut, color, and pattern? Do you feel great in it? How often will you wear it?

IT'S INEVITABLE. YOU HAVE TO CARE FOR YOUR

CLOTHES. HOW MUCH TIME AND MONEY DO YOU WANT

TO SPEND DOING IT? HIGH-MAINTENANCE CLOTHES ARE

LIKE HIGH-MAINTENANCE FRIENDS—THEY NEED A LOT OF ATTENTION.

HOW DO I TAKE CARE OF IT?

Ask yourself some questions: How delicate is it? How easily does it stain? And

how careful are you willing to be while you're wearing it? Think about how

often you'll be putting it on, and for what kind of event. Will it be subjected

to baby drool, hot-weather perspiration, or salad dressing? Does it have to be

dry-cleaned? Hand-washed? Ironed? If it's an outfit you reserve for special

occasions, then maybe you can handle the burden. If you're planning on wear-

ing it daily, you might want to opt for something that's a little easier to love.

TRAVEL

Cover a hanging shirt with
two or more plastic dry-
cleaning bags to prevent
excessive wrinkling en route.

**LOW-MAINTENANCE
FABRICS**

Wool knits and crepes;
crinkle cotton and cotton
knits; machine-washable
silks; synthetic blends;
microfibers; denim;
corduroy; fleece;
jersey.

**HIGH-MAINTENANCE
FABRICS**

Finely woven cottons; linen;
metallic, hand-painted, or
embroidered fabrics; peau
de soie; suede; raw silk;
beaded fabrics.

[WASH & DRY *first aid—page 178*]

GREASE
RELEASING

ELEMENTS

"[Women] can look at a woman in a turquoise dress and figure where she bought it, what her house looks like, what books she reads, how often she has sex." CYNTHIA HEIMEL, *What Makes Women Tick?*

WHAT AM I SAYING?

Clothes talk, even when we don't. They speak volumes about us. It's hard to assemble a wardobe and communicate personal style without understanding its elements. The color, fabric, pattern, and texture of what we wear can hint at the most subtle aspects of our lives. White, satin, fishnet—all are loaded with different meanings. Why do we choose what we choose? What decisions do we make when choosing to put two disparate pieces of clothing together? Make sure that you and your clothes speak the same language.

HOW TO USE COLOR

JUST AS COLOR CAN BE THE DISTILLATION OF COMPLICATED MORAL MESSAGES—VIRGINAL WHITE, MOURNFUL BLACK, SEXUAL RED—COLOR CAN ALSO CAMOUFLAGE: THINK OF THE SEA OF NAVY AND GREY ON THE floor of a stock exchange. Color in clothes can be regional—the beige and pastel tones of the South versus the blacks and subdued tones of the urban North. It can denote seasons: We tend to wear darker colors in the winter and brighter ones in summer. It can create optical illusions: Light colors make us look larger; dark colors make us look smaller. Color can be powerful and confusing, especially when it comes to clothes. The bottom line? Unless you feel comfortable in a rainbow of different hues and can mix them like an alchemist, your best bet is to build a wardrobe based on a neutral palette—black, white, grey, navy, or beige. It will help you decode your wardrobe and create versatility within it, and make it possible to add color in accent pieces without feeling overwhelmed.

COLOR AND YOU: When *Color Me Beautiful* came out in 1973, the prescription-by-season approach to personal color, still followed by many, suggested: • Each person's skin and hair is optimally complemented by certain colors. • Colors come in palettes that are useful to keep in mind when building a wardrobe. • Test a color against your skin. Does it smooth and clarify your complexion? Minimize lines and shadows? Bring a healthy glow to your face? If so, it's your color. • Determining your season is a matter of selecting the color group that flatters you. Winter's colors are clear, icy, and vivid—navy, black, white, and red—and suit those with strong coloring, like contrasting hair and skin tone. Summer's palette is less intense—soft blue, rose-brown, and plum—so as not to overwhelm soft, more uniform coloring. Autumn tones are strong and earthy—dark brown, gold, and moss green—and complement darker coloring. Spring colors are clear—peach pink, bright blue, and golden yellow—to bring out delicate coloring.

BEIGE

IT IS THE ABILITY OF

BEIGE TO BLEND IN THAT

HAS MADE THE COLOR POPULAR

with spies and safari buffs. Beige never

makes a fuss. It camouflages, stays neutral,

lets other colors take the limelight. It has

been said that beige is the black of the

South, though such regional distinctions

in fashion are beginning to blur. Subdued,

quiet, sophisticated, yet friendly, beige is

for long-haul classics, not big splashes.

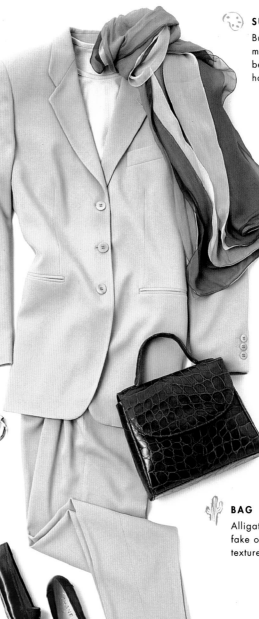

SUIT
Buy a suit with matching pants or skirt because beiges are hard to match.

SUIT
Because it's light in color, beige is not slimming; but when put together with similar tones, it creates an elongated line.

BAG
Alligator, whether it's fake or real, adds rich texture to basic beige.

CARE
High-maintenance beige shows dirt and wrinkles easily.

SWEATER

Use different textures to mix different shades of beige, especially for sporty looks.

JEWELRY

Pearls, gold, and shell jewelry work well with beige. Silver often does not.

SHOES

If you're buying the real thing, keep it simple, as alligator skins have a long life. Stamped leather is less expensive and does not wear as well—better for trendier styles.

WEATHER

Beige is suitable for mild climates, but in cold winters, it works better as an accent.

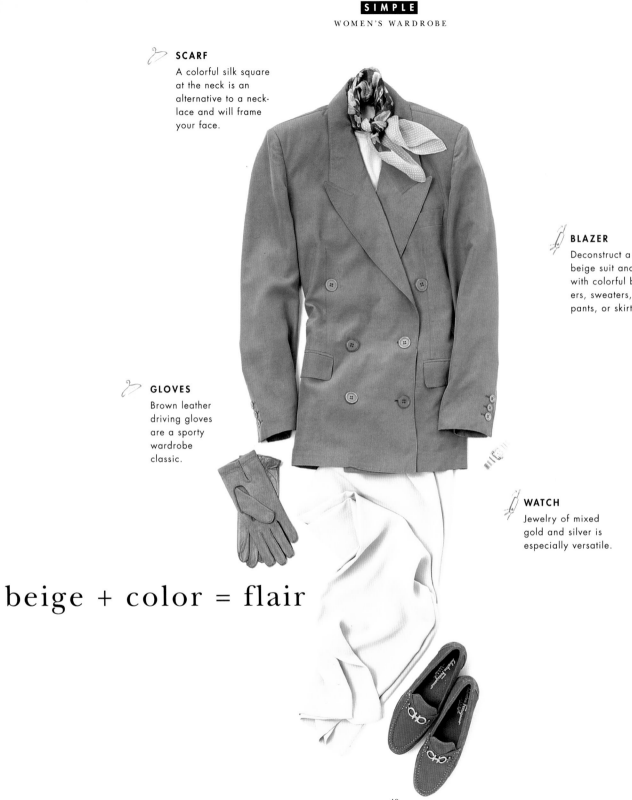

SCARF
A colorful silk square at the neck is an alternative to a necklace and will frame your face.

BLAZER
Deconstruct a beige suit and mix with colorful blazers, sweaters, pants, or skirts.

GLOVES
Brown leather driving gloves are a sporty wardrobe classic.

WATCH
Jewelry of mixed gold and silver is especially versatile.

beige + color = flair

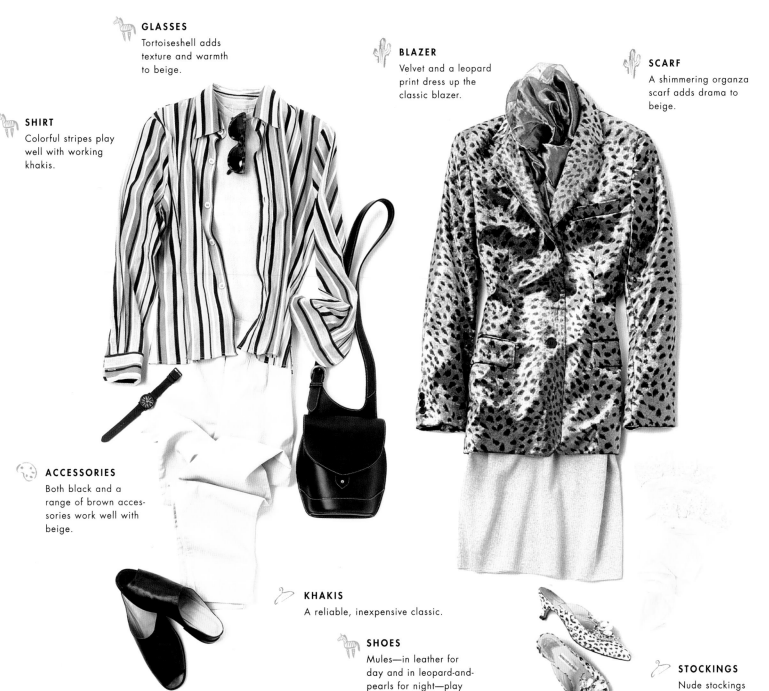

GLASSES
Tortoiseshell adds texture and warmth to beige.

SHIRT
Colorful stripes play well with working khakis.

BLAZER
Velvet and a leopard print dress up the classic blazer.

SCARF
A shimmering organza scarf adds drama to beige.

ACCESSORIES
Both black and a range of brown accessories work well with beige.

KHAKIS
A reliable, inexpensive classic.

SHOES
Mules—in leather for day and in leopard-and-pearls for night—play with the easygoing beige palette.

STOCKINGS
Nude stockings complete the beige wardrobe.

VELVET VEST
Different shades of dark blue can mix if the textures vary enough.

BLAZER
Navy is difficult to match, so for greater versatility, buy a suit with matching pants or skirt.

MUFFLER
Camel and grey are two other wardrobe neutrals that complement navy.

ACCESSORIES
Black dresses up navy. Brown makes navy more casual.

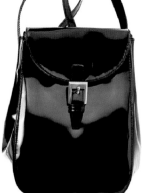

Navy is the color of a quarter to midnight, or just before darkness falls. It connotes seriousness and sophistication, without death. And it mixes well—though not as effortlessly as black—with other colors.

T-SHIRT
A navy blazer and a navy-and-white-striped shirt is a classic nautical look.

SNEAKERS
A navy blazer and white canvas sneakers is a classic sporty combination.

JEANS
Brightly colored jeans (or classic white or blue) get instant respectability when paired with a navy blazer.

SHOES
Dress up navy with black sandals in the summer.

Navy goes with everything (except navy)

WHY

1. IT HIDES STAINS. 2. IT DETRACTS FROM POOR TAILORING AND GENERAL WEAR. 3. IT GOES WITH ALL COLORS. 4. EVEN THE CHEAPEST OF FABRICS LOOK DECENT IN

BLACK. 5. IT DRESSES UP. 6. IT DRESSES DOWN. 7. IT CAN BE ELEGANT, CLASSIC, SEXY, FUNKY, OR MOURNFUL. 8. IT IMPARTS TIMELESSNESS TO CLOTHES. 9. IT HAS AN

BLACK

IMPRESSIVE PEDIGREE—NUNS, AUDREY HEPBURN, BEATNIKS, AND MORTICIA ADDAMS—AND IS THE UNIFORM OF FASHION EDITORS WORLDWIDE. 10. IT CAN GO

SUMMER OR WINTER. 11. IT HAS A UNIQUE ABILITY TO STAND OUT, BLEND IN, SEDUCE, REPEL. 12. WHAT OTHER COLOR DOES ALL THIS AND TAKES OFF TEN POUNDS?

?

"She picked the black dress off the chair and smoothed it gratefully. It had done its work well. Other girls had floundered through the dance in wretched tulles and flounces and taffetas, like the dresses her mother had tried for two weeks

HERMAN WOUK, *Marjorie Morningstar*

to buy for the great occasion. But she had fought for this tube of curving black crepe silk, high-necked enough to seem demure, and had won; and she had captivated the son of a millionaire. That was how much her mother knew about clothes."

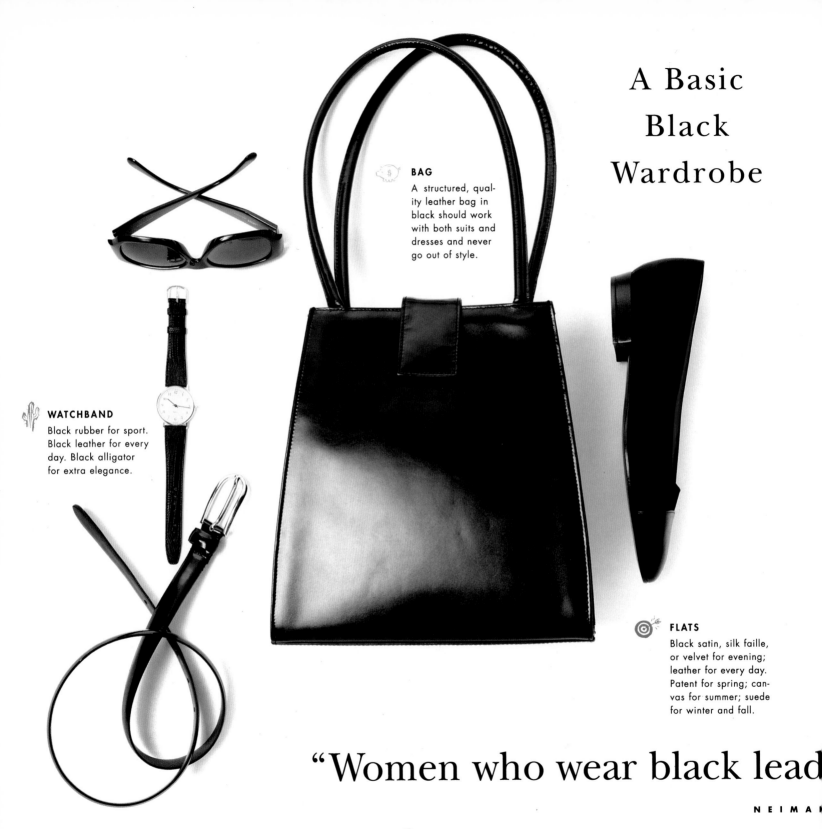

A Basic
Black
Wardrobe

BAG

A structured, quality leather bag in black should work with both suits and dresses and never go out of style.

WATCHBAND

Black rubber for sport. Black leather for every day. Black alligator for extra elegance.

FLATS

Black satin, silk faille, or velvet for evening; leather for every day. Patent for spring; canvas for summer; suede for winter and fall.

"Women who wear black lead

DRESS

A simple black dress can be dressed up or dressed down depending on the accessories.

TURTLENECK

It should be lightweight and close-fitting, if you plan on wearing it under a suit jacket.

T-SHIRT

A classic T-shirt can be the star of the show in satin or a dependable supporting actor in cotton.

STRAPPY HEELS

Instant evening, especially in satin.

STOCKINGS

Opaque black stockings are slimming. They diminish anxiety about short hemlines and create a long silhouette.

colorful lives."

 SWEATER SET
A colorful sweater set radiates against black.

 SILK SCARF
Pattern and color are always well framed by black.

SUIT JACKET
A black suit deconstructs easily into pieces that can each be worn with colorful companions.

 SKIRT
The unmatchable skirt? Try it under a black blazer.

PUMPS
A slender heel up to 1½ inches high is as appropriate at work as it is for a more dressy occasion.

BANGLES
Gold and silver jewelry both complement black but differ in mood. Gold and black is a more elegant, "uptown" combination. Silver and black has a little more attitude, is more "downtown."

SHOES
A squat heel is sensible for a lot of walking and standing, yet looks young with a short skirt.

BLACK + COLOR = DRAMA

Black can be intimidating. So dark, so full of attitude, so . . . black. But used as a backdrop, black brings out the best in colors and patterns. It has the effect of simultaneously toning them down and punching them up. And with a basic black wardrobe, you'll always have something to pair with that chartreuse shirt or that leopard-print skirt you've been holding on to.

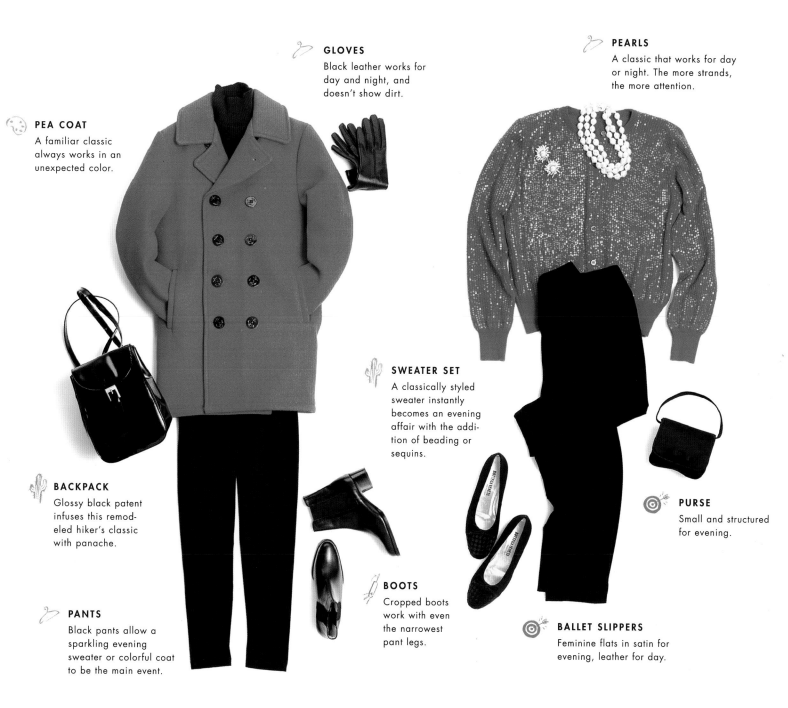

GLOVES
Black leather works for day and night, and doesn't show dirt.

PEARLS
A classic that works for day or night. The more strands, the more attention.

PEA COAT
A familiar classic always works in an unexpected color.

SWEATER SET
A classically styled sweater instantly becomes an evening affair with the addition of beading or sequins.

BACKPACK
Glossy black patent infuses this remodeled hiker's classic with panache.

PURSE
Small and structured for evening.

PANTS
Black pants allow a sparkling evening sweater or colorful coat to be the main event.

BOOTS
Cropped boots work with even the narrowest pant legs.

BALLET SLIPPERS
Feminine flats in satin for evening, leather for day.

"New York being New York, the crowd was a sea of black. Women in this city are afraid to wear color. And no dictum from Paris or Seventh Avenue will ever change them."

AILEEN MEHLE, a.k.a. "Suzy," *W* magazine columnist

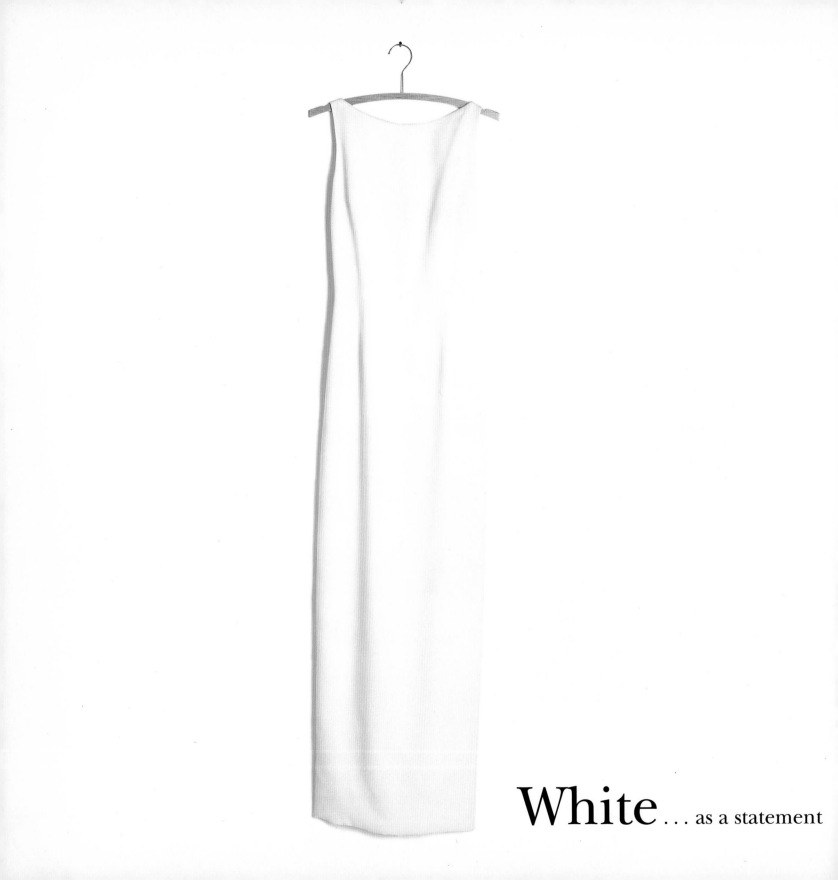

White . . . as a statement

THE POWER OF WHITE

The absence of color is white. The very lightness of white's purity has made it the color of heavenly joy and chastity. Angels wear white, as do babies, modern Western brides, and virtuous romance-novel heroines headed for tragic fates. It is clean—where would hospital hygiene be without it?—and requires cleaning. Its impracticality has made it a mark of social status through the ages. White commands attention in the form of an evening gown—monochrome power at its most dazzling. Dressed down, white is the most basic of tones. The color of canvas sails and bleached muslin, it is versatile, crisp, and cool, a backdrop that can handle anything.

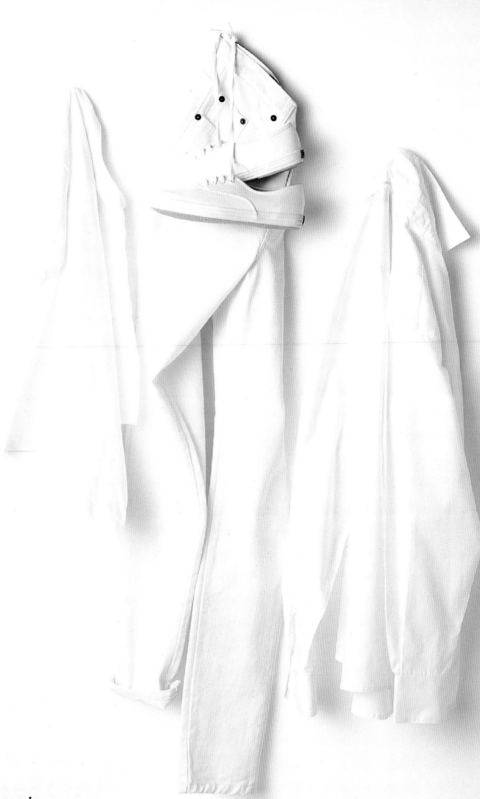

. . . as a wardrobe necessity.

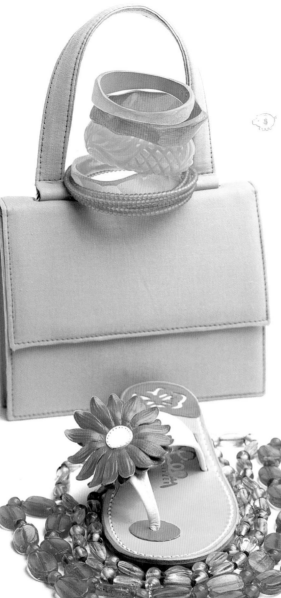

JEWELRY

Whimsical summer jewelry can be found in colorful plastics, papier-mâché, and stones. They're for fun, not big-investment items.

SHOES

A large, colorful flower on a sandal will bring attention to your feet. Avoid if toes are not well pedicured or if you hate your feet.

HANDBAG

Elegant lines and a joyful color can dress up even the simplest of summer dresses.

Think of sherbet, mangoes, and the candy-colored houses of the tropics. The vibrant tones of summer sparkle in sunlight. They make us smile, whether we wear hot pink as an accessory to show off a tan in February, or a pool-blue suit to cool us off in the heat of July. We can wear summer colors as an accent or the main event, but they are—like the season that inspires them—bright, relaxed, and, above all, fun.

summercolors

intense sunlight + saturated color = summer

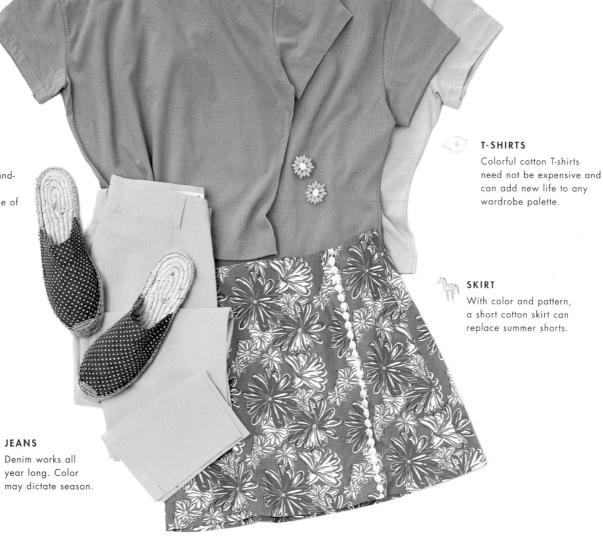

ESPADRILLES
Inexpensive canvas-and-rope beach classics come in a wide range of colors and patterns.

T-SHIRTS
Colorful cotton T-shirts need not be expensive and can add new life to any wardrobe palette.

SKIRT
With color and pattern, a short cotton skirt can replace summer shorts.

JEANS
Denim works all year long. Color may dictate season.

LILLY PULITZER. It started in 1959, at a family fruit stand in Florida. Lilly Pulitzer was a society wife with too much time on her hands. She took to making simple sleeveless shifts from colorful flowered material and selling them alongside the grapefruits and oranges. A rage was born. Pulitzer's wild floral prints defined the Palm Beach look of the 1960's and have been collected for years by women all over, including the young Jackie Kennedy. After a hiatus during the 1980's, Pulitzer's dresses returned to the racks in the mid-nineties, in time to cash in on the latest celebration of fifties and sixties nostalgia.

Winter Colors. The

color of fog and soldiers' uniforms,

grey can be militant or mysteri-

ous. It can be subtle—shadow-

grey—a sign that we don't want to

be noticed. It can be conformist,

like the 1950's businessman in his

grey flannel suit. It can be non-

committal, as in the misty quali-

ties of heather grey, or strong,

like gunmetal grey. As it darkens

to charcoal, grey begins to take

on some of the sophistication

of black. It is wintry except in

softest pearl or glittering silver.

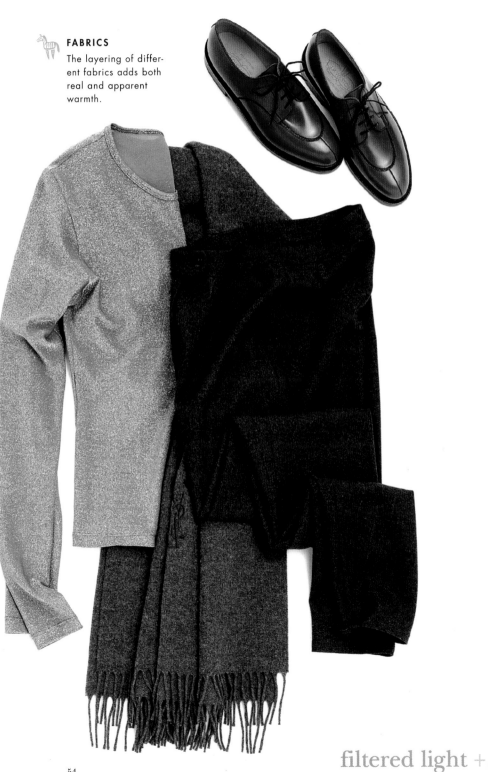

FABRICS
The layering of differ-
ent fabrics adds both
real and apparent
warmth.

filtered light +

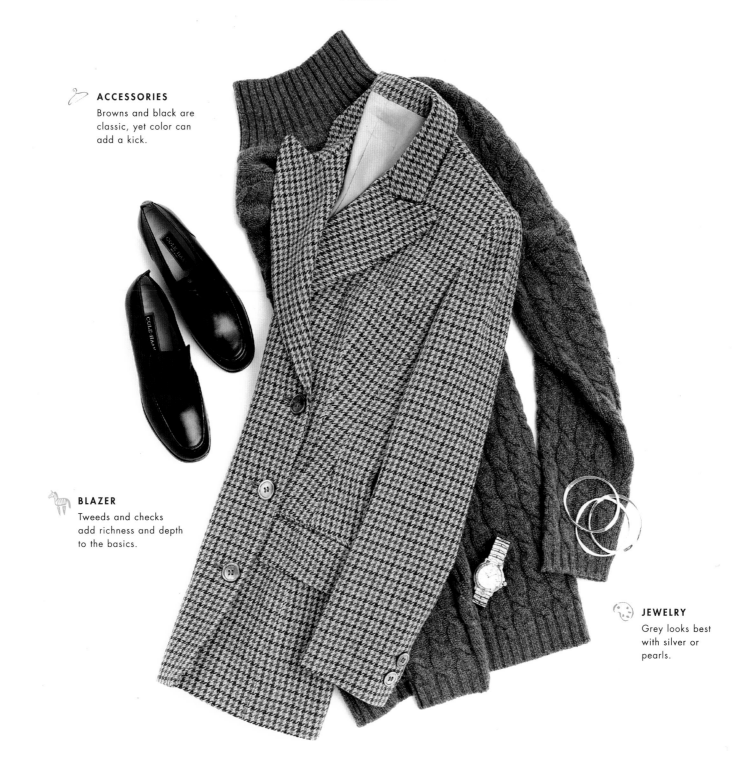

ACCESSORIES
Browns and black are classic, yet color can add a kick.

BLAZER
Tweeds and checks add richness and depth to the basics.

JEWELRY
Grey looks best with silver or pearls.

subdued color = winter

FABRIC

IN THE BEGINNING, THERE WERE ANIMAL SKINS TOSSED

OVER CRO-MAGNON SHOULDERS, OR MAYBE AN INSOUCIANT FIG LEAF

TIED JUST SO. NOW WE HAVE FIBERS WHOSE NAMES SOUND MORE LIKE THE CONTENTS

of a test tube than something you'd want against your skin. Fabric is important. It determines the warmth, comfort, cut, and, along with workmanship, the price of a garment. More than color or style, fabric can tell you what time of day a piece of clothing is to be worn, or in what season, or even what activity you will be engaged in while wearing it. We use fabric to send signals. A worsted wool suit, with its strong, crisp lines, says you're in control. A downy angora sweater telegraphs a more sensual message. Fabric is also one of the main factors in determining whether your clothes will travel as well as you do. When wearing a wrinkle-resistant wool or synthetic in a jersey or crepe, you'll disembark from the plane looking pressed and ready. In delicate silk or linen, you may end up looking like a pile of laundry. And with a seasonless fabric—a tropical wool or matte jersey—you can travel around the world.

BREATHABILITY. Refers to the ability of the fabric to allow the body to release heat. Loosely woven, highly "breathable" fabrics like linen feel good in the summer. The more waterproof the fabric, the less breathable; the more breathable, the less waterproof.

COLOR-BLEEDING. If the manufacturer has been negligent, the dyes on fabrics may not be colorfast enough to withstand the procedures listed in the care instructions. Articles labeled as dry-cleanable will sometimes contain dyes that bleed excessively when dry-cleaned. Deep colors may transfer onto lighter areas. Garments labeled as washable may also bleed and lose color, especially those in darker colors. If an article is multi-colored, test it for colorfastness before washing.

DRAPE. Refers to how the fabric is tailored and structured to hang on the body .

HAND. The tactile quality of the textile: how it feels to the touch. Smoothness and coarseness depends on fiber and weave.

MEMORY. The ability of certain materials to return to their original shape after being stretched or crushed.

PILE. A fabric with a surface made of cut (such as velour and velvet) or uncut (such as terry cloth) yarns, so that it has a plush, "furry" texture.

[FABRICS *first aid—page 189*]

SEXY

sheer fabrics, lace,
satin, silk jersey, clingy
knits, angora

QUICK-DRY

synthetics

DAY

wool, synthetic blends,
denim, cotton, silk, linen,
knits, corduroy, flannel,
gabardine, matte jersey,
seersucker, leather,
suede, tweed

BREATHABLE

natural-fiber fabrics—wool,
cotton, linen, silk; synthetic
and natural-fiber blends if
synthetic is a small percentage
of the mix; fleece, capilene

NIGHT

satin, silk, sequins,
beading, chiffon, taffeta,
brocade, moiré, organza,
lace, rayon blends in
luxury fabrics, lamé,
velvet

NONBREATHABLE

nylon, Mylar

TRAVEL

synthetics; microfibers;
wool; cotton, wool, linen,
and synthetic knits
and crepes; denim;
washable silks

SEASONLESS

rayon; viscose; Lycra; wool
gauze; cotton, lightweight
wool, silk, and rayon crepe;
cotton; denim; microfibers;
synthetics blended with
natural fibers

DRAPE

rayon, wool crepe, wool
gauze, high-performance
wool, silk, satin, chiffon, knits,
silk and rayon velvet

CLASSIC

wool, cotton,
linen, silk, cashmere,
velvet

CASUAL

cotton knits, denim,
fleece, stretch fabrics,
synthetics, tweed, cotton
flannel, corduroy

WINTER

rayon-wool blends,
wool, silk, heavy knits, flannel,
cashmere, velvet, corduroy,
fleece, down, fur, leather,
mohair, tweeds, chenille,
suede

BUSINESSLIKE

worsted wool, tropical
wool, wool crepe, fine
cotton, silk, synthetic
blends

SUMMER

rayon, cotton, and linen
blends, tropical wool, cotton,
linen, light knits, seersucker,
cotton piqué, canvas,
ramie, terry cloth

SUPERMASCULINE

broadcloth, chino, corduroy,
flannel, gabardine, wool
tweeds

SUPERFEMININE

angora, brocade, chenille,
chiffon, crinkled silk or cotton,
damask, eyelet, organza, silk,
satin, velvet, sequins, lamé,
voile, lace

PROGRESSIVE

synthetic blends,
metallics, vinyl

SPLIT PERSONALITIES

Fabric will often reveal the personality of a piece. Classic shapes assume completely different characters when they're made from different fabrics. When it's worked in sequins, an unassuming, easy-to-care-for white cotton T-shirt becomes dazzling, yet fragile, and most likely limited to evenings. Wear it with a formal outfit, or dress up a pair of jeans. Combining the unexpected is what personal style is all about.

Subtle in a scarf, or
wildly feminine when
done up big on
spring and summer
dresses.

They're wild by their very nature.
But we've seen so many stylish
people wearing them (particularly
leopard) over the decades—Diana
Vreeland, Carrie Donovan, Betty
Rubble—that they have
become classics.

Pattern. They can be bold or demure, sublime or ridiculous. They can even convey different interpretations of the law. Narrow pinstripes? Banker. Broader pinstripes? Gangster. Broad stripes? Convict. They can camouflage (the soldier's fatigues) or announce (the tourist's Hawaiian shirt). There are "no-pattern patterns," like the subtle striping on a shirt or the small arrows of a herringbone tweed, which add texture to a garment. Bold patterns, often found on bathing suits, can diminish or accentuate lines of the body.

"Some people were born to push the

DUFF,

PLAIDS

Because distinct plaids were associated with various Scottish clans, wearing them became a dangerous political statement and was once prohibited by British law. Now they decorate everything from umbrellas to dog collars. They are best used as accents—wool scarves, kilts, flannel shirts, and in the lining of a coat.

POLKA DOTS

Comical when large, demure when tiny, they are best used sparingly—on silk scarves or boxer shorts, for example—as they can attract a lot of attention.

STRIPES

Horizontal, they seem nautical. Vertical, they are more businesslike. While they can look fresh or refined, be careful not to cover yourself in them: stripes are tiring to the eye.

Larger patterns will tend to make you look larger; smaller ones do the opposite. Vertical stripes elongate; horizontal bars widen and shorten. Patterns will not show stains as easily as solids, but they are harder to match, and you may tire of them more quickly. They can be used to distract—a patterned scarf around the neck draws the eye to the face. But they can also call attention to flaws we might rather hide, so use patterns as you use color: as an accessory. Your mistakes will be less expensive. And your triumphs? Witty and elegant, of course.

envelope of fashion and some to lick it."
MTV VJ

TEXTURE

THINK OF IT AS THE SUBTLEST FORM OF PATTERNING. IT IS WHAT GIVES CLOTHING ITS RICHNESS AND VISUAL DEPTH. THOUGH YOU MAY BE DRESSED IN BLACK FROM HEAD TO TOE, THE RIBBING ON YOUR TURTLENECK,

which sets it apart from the tight weave of your wool gabardine suit, which is in turn complemented by the plushness of your alpaca overcoat and the dull shine of your leather backpack—that is texture at work.

Experiment with opposites: the sheen of satin with the earthier roughness of wool;

VARIETY

Contrasting textures make a simple muffler a thing of intense style and practicality. With one side a shiny silk and the other a plush velvet corduroy, this is a scarf worthy of two lives.

luxurious velvet with basic denim; sheer voile with cotton broadcloth. Playing with contrasting textures can help fudge colors that don't quite match. And combining items of different textures is a way to vary the seasonality and mood of your wardrobe without having to buy a lot of extras.

MIYAKE. Born in 1938, Japanese designer Issey Miyake has been called a sculptor whose medium is fabric. His radical experimentation with pleated, wrinkled, and folded cloth (opposite)—as well as with basket-woven straw, *ikat* weaves, and paper fabric—has yielded designs that seem ancient, contemporary, and futuristic. Using historically Japanese shapes and exotic combinations of materials, Miyake subjects his fabrics to punishing treatments in order to bring out well-worn textures and richness. **FORTUNY.** Mariano Fortuny was born into a prolifically artistic family in Granada in 1871. Exceeding even his accomplished relatives, Fortuny went on to become a staggeringly creative designer and inventor, perhaps most famous for the pleated silk fabric that now bears his name. Each of his silk dresses required three to four times their width in material and were stored by gathering up the pleats and tying the dress into a tight ball, making it ideal for travel. The pleats were formed by crimping wet silk between heated porcelain rods, a process which held one of his twenty patents. Fortuny died in 1949, but his fashion influence lived on in the collections of such designers as Balenciaga and more recently Mary McFadden, Karl Lagerfeld, and Issey Miyake.

MIXING

Day meets night in a mix
of silk organza, alpaca,
and wool crepe.

MIXING

Winter velour, spring patent, and summer white suits all seasons.

DRESS SUIT

Classic, clean lines and solid colors give you the most flexibility. Wear this outfit to the office, and take off the jacket for dancing in the dress after dark.

IT'S ALL IN THE MIX

MIXING IS NOT ABOUT HAVING A LOT OF CLOTHES. IT'S ABOUT BEING RESOURCEFUL. IT CAN ALLOW YOU TO CREATE THE MAXIMUM WARDROBE WITH MINIMUM INVESTMENT. HOW? START WITH A SOLID wardrobe of quality basics that are built predominantly around a single color. Then try mixing in the unexpected. Deconstruct a suit. Try wearing the jacket with other skirts and pants. Same with the bottom components—the skirt or pants can work with a variety of sweaters and vests. If you have a few things of value that are just perfect, you will reach for them over and over again, and feel good about wearing them in different ways. Mix unexpected colors, textures, patterns. Mix attitude. A blazer worn with a T-shirt has a whole different personality than one worn with a blouse. And different jewelry or shoes can change a dress dramatically each time you put it on. The beauty of true versatility? Anything you wear a lot—no matter how pricey—will get cheaper every time you put it on.

"When I have few clothes I manage better than when I have a lot, because I use my imagination."

INÈS DE LA FRESSANGE, *fashion designer and former Chanel model*

JEWELRY
A classic pearl necklace works day or night, with blue jeans or black tie.

JEWELRY
Big, decorative fake pearl or rhinestone earrings work best for evening.

HANDBAG
An evening basic: the small, structured handbag in satin, with little, if any, decorative detail.

JACKET
Placing a colorful suit jacket over your basic black dress give both pieces new life.

STRAPPY HEELS
Strappy satin shoes are about as evening as evening gets.

Versatility = Value.

Look for colors that fit into the basic palette of your wardrobe. Look for classic design and style that is consistent with your own. Look for fabrics that are seasonless—tropical wools and medium-weight cottons, for example. Seasonal fabrics, like linen or velvet, may be well worth the investment, but they won't necessarily be appropriate year-round. Try to calculate wear-and-tear: will the piece hold up to heavy dry cleaning? Massive laundering? Bad weather? The stretch and pull of constant use?

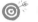

SUN HAT
Straw signals spring and summer. Change the ribbon for variety.

SCARF
1960's-vintage Pucci scarves still look great today.

T-SHIRT
A white T-shirt relaxes a blazer, but keeps things respectable.

JEWELRY
Classic gold links, in any size.

DRESS
A seasonless fabric like lightweight wool crepe makes for clothes that can be worn year-round.

SHOES
A heel dresses up a basic sandal.

PANTS
Hot-pink pants scream summer or resort, and are especially elegant in silk shantung.

T-SHIRT

A cotton T-shirt worn while traveling absorbs sweat, is comfortable, and can fill a multitude of roles: casual day-wear, beach coverup, nightshirt.

WRAP

Travel with a wrap, sweater, or vest in case of temperature changes.

JACKET

Wearing the suit jacket when traveling means there's less to pack and gives you a look of respectability.

TOTE BAG

A large tote can hold all the necessary carryons.

JEANS

Jeans are comfortable and seasonless, resist wrinkling and dirt, and can be dressed up with a blazer.

SHOES

Wear your heaviest shoes while traveling, but make sure they go with most of the outfits you're bringing.

+ = Instant Travel. Your suitcase is your closet when you travel. Things to think about when choosing clothes to pack: How much room does it take up? Does it match with other pieces you're bringing? Will it go day and evening? Can you wash it by hand? Can you wear it more than once? Does it wrinkle easily? Suit fabric should be seasonless—perhaps a lightweight wool—so it can travel

[FITTINGS *first aid—page 201*]

TOP
Pack a top that can stand on its own without the suit jacket.

SUIT
A dark suit with matching pants and skirt can be deconstructed to create a variety of looks with few accessories.

TRAVEL
Ideal travel fabrics bounce back after being crushed. They include those worked into crepes or knits, wools, denim, synthetics and synthetic blends, and microfibers.

DRESS-UP
Evening pants and evening shoes can take a classic dark jacket out for a night on the town.

to both warm and cool climes. Dark colors are easier to dress up and dress down, and to wear separately with other wardrobe accessories. Dark colors also don't show dirt as easily as light ones. After packing the items you need most, add a few garments and accessories that will help to create varying looks with the clothes you have chosen. Then write it all down to help you remember what you have put together and packed.

PACKING

THE PERFECT WARDROBE EMERGES FROM THE PERFECT PLAN. WHAT CLOTHES DO YOU NEED FOR MEETINGS, DINNERS, OR SIPPING SINGAPORE SLINGS ABOARD A JUNK IN THE HARBOR? AND your luggage—think of it as a portable closet. Will it keep your clothes looking fresh and ready for anything?

Suitcases. Hard-sided luggage prevents wrinkling and tends to protect clothes better. Soft-sided luggage weighs less and is easier to schlep around. Because it's less bulky, it's also easier to store at home when not in use. No matter which kind you decide to buy, consider how much it weighs empty—you want to be able to carry it for half a mile when it's packed. If your luggage doesn't have wheels, consider investing in a luggage caddy; your shins will be grateful. When buying a duffel, get one with a padded shoulder strap (but always remove it before checking the bag at the airport), a foam-padded bottom, and the sturdiest fabric—16-ounce nylon is slashproof.

FLYING

Try packing everything in a bag that qualifies as a carry-on. Checking baggage is a drag, and your bag can get lost. The FAA allows each airline to determine dimensions of carryon luggage and the number of pieces one can carry on board. Federal guidelines recommend a limit of two pieces, including a briefcase. Bags stowed under a seat can measure up to 9" x 14" x 22". For bags stored overhead, the limit is 10" x 14" x 36". Garment bags should measure no more than 4" x 23" x 45".

Garment Bags. With clothes on hangers, unpacking's a snap. Because they're ideal for suits and other formal clothing, they're a godsend for the business traveler. Beware of packing more than you can carry. Also, avoid checking garment bags. Their bulk, weight, and size usually earn the wrath of baggage handlers, and that can be hard on your clothes. Tips: When buying, look for bags that allow you to use your own hangers. Pack your clothes straight from the dry cleaner. Doubling up on plastic bags will deter wrinkling, and using disposable hangers means you don't have to worry about losing them.

PACKING CHART

In determining the minimum amount of clothes needed for the maximum number of activities on a given trip, a packing chart can serve as an effective visual aid.

1. First, map out the days you will be traveling in a column. Then make three adjacent columns, to designate what to wear in the A.M. and P.M. each day, and extras (see below).

2. In the extras column, note the clothing and equipment you will need for special activities like tennis or swimming, and list other basic items like nightwear, under-wear, and an umbrella.

3. In the A.M. column, designate the first day and the last day as travel days. Choose clothes that are comfortable and versatile enough to be worn during your trip. Record in appropriate slots.

4. Next, determine the type of clothes you will need for your trip. Try to limit yourself to a neutral color scheme that can be accented with colorful accessories.

5. Then choose one wardrobe basic—per-haps a suit—that can achieve different looks with accessories. Determine the days and nights it can be worn. Record in appropriate slots.

6. If needed, choose a second wardrobe basic. Fill in remaining slots.

7. Next choose accessories: shirts, sweaters, jewelry, scarves, or vests that will complement each wardrobe basic and help create a variety of looks.

8. At this point, it would be easy to deter-mine if an extra garment is needed to complete your travel wardrobe.

9. Now look at the chart and decide on shoes—they're bulky and heavy, so choose wisely.

10. Pack this chart in your handbag. It will remind you of your wardrobe scheme, and help you distinguish the unnecessary from the essential. It also will stand you in good stead if you ever need to get reim-bursed for lost luggage.

BUSINESS TRIP CHECKLIST

__ Address book
__ Airline tickets
__ Appointment book
__ Briefcase
__ Business cards
__ Calculator
__ Computer with acccessories
__ Confirmations—hotel, etc.
__ Correspondence
__ Credit cards
__ Expense forms
__ Files
__ Letters of credit
__ Meeting/presentation
 materials
__ Notebooks
__ Paper clips
__ Passport
__ Portfolio
__ Publications
__ Reports
__ Rubber bands
__ Samples
__ Stamps
__ Stapler, staples
__ Tape recorder, tapes, batteries
__ Time records
__ Wallet
__ Writing materials: pencils,
 pens, highlighters, markers,
 business stationery, legal pads

INTERNATIONAL CHECKLIST

__ Addresses for
 correspondence
__ Auto registration (if driving)
__ Cash, including some in the
 currency of the country to
 which you are traveling
__ Credit cards
__ Emergency contacts
__ Extra prescription glasses
 and contact lenses
__ Insurance papers
__ International driver's license
__ Lightweight tote bag for
 purchases
__ Medications, prescriptions,
 and general medical
 information
__ Passport, visas, health
 certificates
__ Phrase book or dictionary
__ Photocopies of birth
 certificate and passport
 (kept separate from wallet, to
 expedite replacing passport if
 it is lost or stolen)
__ Sunglasses
__ Tickets and travel documents
__ Travel itinerary
__ Traveler's checks and
 personal checks

DAY	A.M.	P.M.	EXTRAS
MONDAY - *travel day*			
TUESDAY			
WEDNESDAY			
THURSDAY			
FRIDAY			
SATURDAY			
SUNDAY - *travel day*			

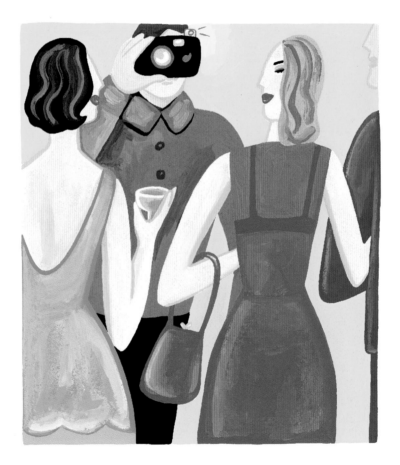

CLOTHES

"Connie returned to her room, threw her pyjamas on the tossed bed, put on a thin night-dress and over that a woolen day-dress, put on rubber tennis-shoes, and then a light coat, and she was ready. If she met anybody, she was just going out for a few minutes. And in the morning, when she came in again, she would just have been for a little walk in the dew..."

D. H. LAWRENCE, *Lady Chatterley's Lover*

WHAT MAKES UP MY WARDROBE?

You open your closet. It's filled with clothes, yet you think you have nothing to wear. What do you love? What do you need? What should you throw away? Where do you start? The essential wardrobe is about the basic clothes you wear day after day, season after season, year in, year out. They give life to the odd pieces of fashion and accessories you may collect each season. They are the foundation to your wardrobe.

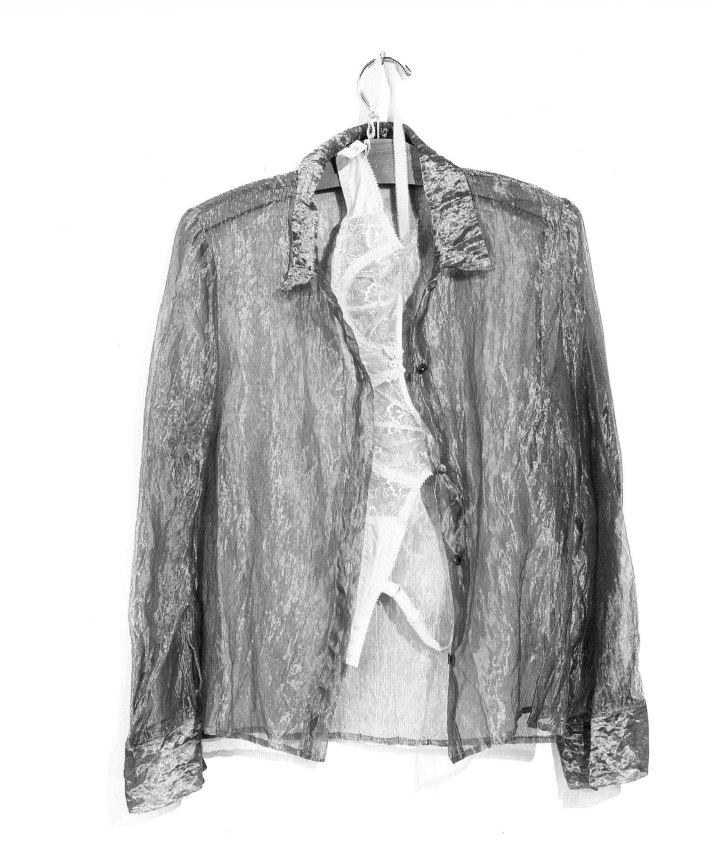

UNDERNEATH

OF ALL THINGS USUALLY HIDDEN FROM THE NAKED EYE,

WHAT SLIPS BETWEEN YOU AND YOUR OUTERWEAR RANKS AMONG

THE MOST ALLURING. BUT UNDERWEAR IS NOT TO BE UNDERESTIMATED:

It has everything to do with the clothes that cover it. It shapes our bodies so that we can fit into tiny-waisted

ball gowns and second-skin tube dresses. It may swathe us in satin, lace, or cotton, making us feel warm, or

confident, or pretty, or seductive. At times, our underwear is our outerwear: We let the whole world see

us in our drawers. Other times, we're more private: We might let one special person peek beneath the layers.

Start to build your underwear wardrobe with basic colors: white, black, nude. Fit and fabric make all the

difference. Spend time finding the right size and cut. Make sure leg holes and waist don't cut into your body.

Think about usage: Underwear that looks the prettiest on its own often looks lumpy under clothes.

BRA TALK: BUSTIER. Tight-fitting strapless bra, highly stylized. Think Madonna. COOKIES. Removable pads in a padded bra. Think cheaper than surgery. DEMI-BRA. Half-bra that exposes the upper part of the breasts. Think Frederick's of Hollywood. FRONT-CLOSURE BRA. Bra that closes in front. Think grateful high-school boyfriend. HOOK-AND-EYE. Type of closure, usually at back. Think frustrated high-school boyfriend. MERRY WIDOW. Elaborate strapless corset or bustier with garters attached. Think Lana Turner. MINIMIZER. Bra that reduces breast size by one cup size. Think partial mummification—or would that be mammification? PASTIES. Decorative nipple coverings. Think go-go dancer. PUSH-UP BRA. Bra with low-cut front, removable pads, and underwire support. Think 1950's. SOFT CUP. Bra with no underwire. Think overeager preteen. WINGS. Material that runs along sides and back of torso, giving extra support for heavy breasts. Think comfort.

Notes:

1. Will maintain aerodynamic shape under wind tunnel stresses up to 12 G of force.
2. Not to be unfastened during operation of heavy machinery.
3. Available in Government issue: Desert Sand Camouflage
 Black & White Urban Camoflage
 and Arctic White.

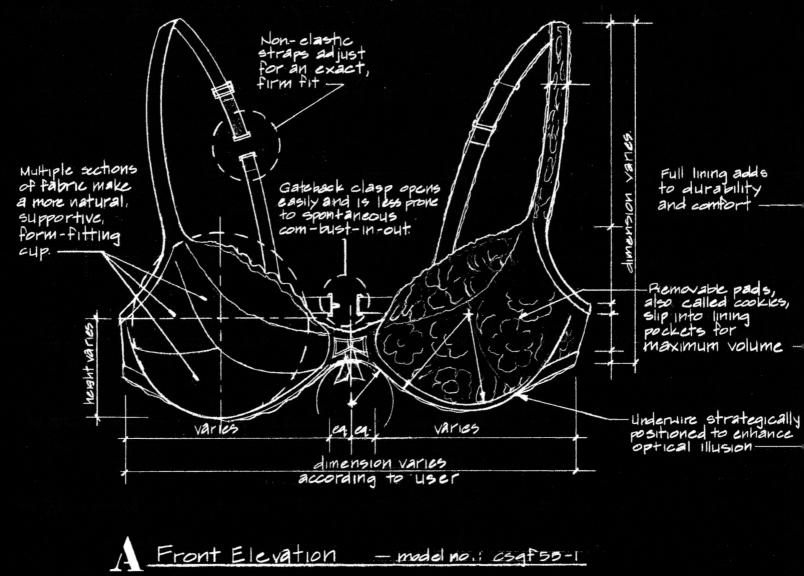

Non-elastic straps adjust for an exact, firm fit

Multiple sections of fabric make a more natural, supportive, form-fitting cup.

Gateback clasp opens easily and is less prone to spontaneous com-bust-in-out.

Full lining adds to durability and comfort

Removable pads, also called cookies, slip into lining pockets for maximum volume

Underwire strategically positioned to enhance optical illusion

dimension varies.

height varies

varies eq. eq. varies

dimension varies according to user

A Front Elevation — model no.: csgf55-1

varies varies

radius varies

Elasticized fabric
promotes stability

B Side View

Just be glad you don't live in late-nineteenth-century England: you might be sporting the Lemon-Cup Bust Improver, an early bra that contained a "light coiled spring in each cup packed with bleached horsehair." Bras have come a long way: Women who burned them in their youth are now looking for support in unprecedented numbers, thanks to body-conscious fashion. You should demand four things from a bra: fit, comfort, support, and good looks. Easier said than done? Here are some basic pointers. Know your size, or consult with someone who can tell you what it is. Spend the time to find the right bra, try it for a day, then, if it works, buy lots of them, in different colors (white, black, and nude). If you're looking for something to wear every day, choose a bra that's well constructed rather than one that's too dainty. Ask yourself what you expect from your bra. Do you want to look like Jayne Mansfield (who was an impressive 42DD), or are you trying to play things down a bit? The good news is that anything is possible.

WONDERBRA: In 1992, British *Vogue* ran a rave review of a padded underwire push-up bra called the Wonderbra. Sales went through the roof, even though it had been introduced in Britain thirty years before. In 1994, when the Wonderbra made its first appearance at Macy's in New York City, it sold over three thousand in just ten days. More recently, Wonderbra incorporated into their swimsuit designs the underwire support and padding made famous by their

LINGERIE

THE THRILL IS KNOW-ING THAT, UNDER AN OLD PAIR OF JEANS AND a comfortable sweater, you have on the kind of satin and frills usually reserved for antique dolls—or, more likely, the harlots of the House of the Rising Sun. Maybe you're the only one who knows; maybe you've let someone else in on the secret. It's expensive, but you can't put a price on desire. Each piece must feel luxurious against the skin, so fabric is key. It must be expertly designed to both fit and flatter. A recent and long-overdue innovation is lingerie for heavier women that uses stretch lace and other new fabrics to combine support with sexy, feminine styling. Ultimately, it must be ready to seduce—you are probably not buying French teddies to cook in. And as any designer can tell you, seduction is in the details.

LINGERIE FACTS: At the turn of the century, the well-dressed woman spent one-fifth of her clothing allowance on lace-trimmed petticoats of satin, brocade, or silk. • All six of the 1904 Floradora dancers—famed for lifting their lingerie-inspired silk skirts in a frou-frou number—reportedly married millionaires. • Boyish flapper fashions of the 1920's inspired Theodore Baer to invent the "teddy," which, unlike its functional cousin, the camisole, could be worn on its own. • Madonna brought underwear out in the open in the early 1980's, with the trend reaching its peak in 1990—the year Jean Paul Gaultier dressed her in a bustier with lethal-looking cones for her Blonde Ambition tour. In 1948, Frederick's of Hollywood introduced the Rising Star, the world's first push-up bra. Victoria's Secret opened the doors of the first of five boudoir-inspired boutiques in 1982, bringing lingerie out of the closet and into the mainstream. By 1995, there were 601 potpourri-scented stores across the country.

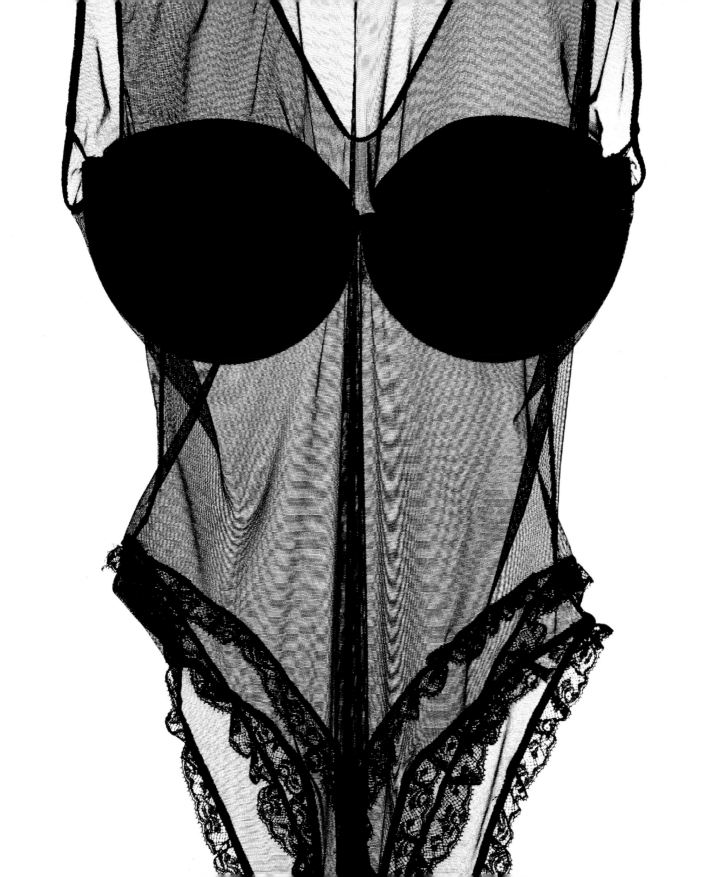

BULLETPROOF

THE EFFECTS ARE REMARKABLE. NO DIETING. NO EXERCISE. NO LIPOSUCTION. JUST AN AMAZING COMBINATION OF LYCRA AND GOOD TAILORING, AND WE CAN NIP, TUCK, AND SMOOTH WITH THE BEST

of the scalpel-wielding plastic surgeons. Things that used to jiggle or flop or bulge just don't anymore. We can look back at the women of Crete—who bound their middles in iron to achieve twelve-inch waists—with pity as we pull on our stretchy polyester sausage-casings. And if you've always wanted a bustline like Gina Lollobrigida, or hips like a ballet dancer, or a stomach that's as flat as a pool table, body-sculpting underwear

> "There will come a time when a warning label will be attached to the outside of garments like this that will read: Open at your own risk."
>
> WAYNE WOLF

will get you close, if not all the way there. Look for dress slips that slim your hips and your tummy; panties that uplift your buttocks; shorts that hide your hips, thighs, and underwear lines under tight-fitting pants and skirts. It's about making the best of what you have. And who knows? Once you've stuffed and sculpted and shaped to your heart's content on the inside, maybe you'll feel confident enough to try a new style on the out.

THE BODYSLIMMER: For Nancy Ganz, founder and owner of Bodyslimmers, Inc., it all started in 1988 with a small piece of nylon-and-Lycra she made into a hybrid girdle-slip that slimmed the hips and tummy. She called it the Hipslip, and followed it two years later with a Bodyslimmers line of push-you-pull-you bodywear that includes Bustbooster bras, Buttbooster panties, Thighslimmer shorts, and Bodysculpting slips. "This is not about changing yourself to make you look like something you're not," she says. "It's about slimming, shaping, and making the best of what you already have."

BODYSLIP™

Slims the torso, smoothes the hips, controls the jiggles, and lifts the bustline.

WAISTCINCHER PANTY™

For bulging tummies and thick waists, the waist-cincher firms, without a trace of pinching at the waist or leg.

THIGH-SHAPER

Shapes the hips, slims the thighs, and gives some support to the lower back.

HIGH-WAISTED BELLYBUSTER™

For jellyroll middles, the BellyBuster smooths the midriff, shapes the hips, and accentuates the waist.

Caveat emptor

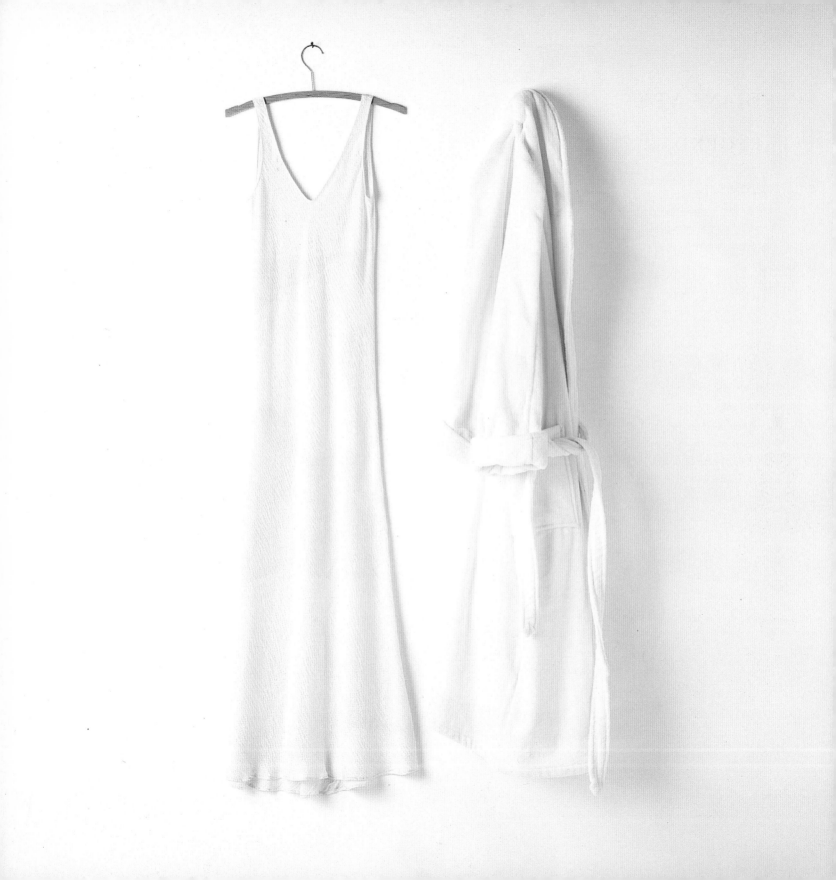

DIANA VREELAND, THE LEGENDARY EDITOR OF AMERICAN *VOGUE* MAGAZINE, USED TO HAVE THREE FITTINGS to get her custom nightgowns just so. But for the rest of us, it isn't that complicated. Night-

NIGHTWEAR

wear's meant to be cozy, warm, and, above all, comfortable. An oversize button-down shirt, a cotton T-shirt, a flannel nightgown—they may not be the stuff of wild sexual fantasy, but each has its own subtle sensuality and can swaddle and soothe. Isn't that what sweet slumber is all about? Sometimes, nightwear is the soft terry robe—its warm, absorbent fabric descended from towels and 1950's beachwear—that you throw on in the morning, having slept in your birthday suit. After all, six percent of American women sleep naked (versus nineteen percent of men). Whatever it means to you, you'll want your nightwear to be soft, loose, and as easy to wash as it is to wear. Nightwear is something you long to languish in at the end of a tiring day. And it's the last article of clothing you should be losing sleep over.

TOPS OR BOTTOMS TONIGHT?

What is it about men's fashion and nightwear? The next time you want to seduce in a negligee, remember that Claudette Colbert seemed to do pretty well with Clark Gable's p.j.'s. But whatever outfit gets you into the bedroom, chances are you'll catch forty winks in something a little more relaxed. Maybe it was once his—an old button-down shirt, a giant T-shirt, a pair of boxers, and the top to his pajamas. Of course, even in our sleep, patterns are about more than pure design. In *The Language of Clothes*, Alison Lurie writes that pajama stripes mimic the stripes on a jailbird's uniform—a jokey reminder of the prisonlike state of marriage.

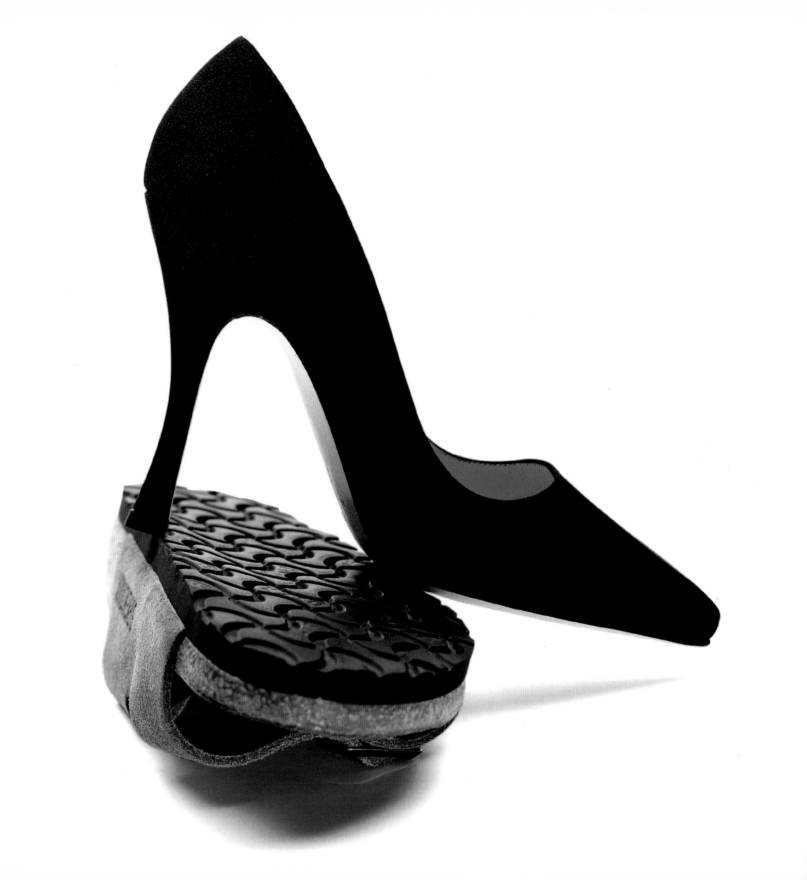

SHOES

THE PERFECTLY TURNED ANKLE. THE UNDULATING SWAY OF THE HIPS. THE ENDLESS LEG. SOME OF THIS HAS TO DO WITH YOUR BODY, BUT MUCH OF IT IS ABOUT YOUR SHOES. THROUGH THE AGES, THE FOOT

has been subjected to a greater degree of sexual attention and pain than perhaps any other body part. We have broken and bound it, fetishized it, and perched it atop stilettos—all in the name of sex appeal (and, some people would say, subordination). Shoes have an undeniable power. They can make us feel tall, powerful, sexy, solid, or fast. They can also make us lame. What do the experts counsel? Vary your shoes. Wear heels only part-time. Build up a solid wardrobe of shoes that fit you. Try orthotics if you need them. Exercise and stretch to keep the muscles in your legs from shortening. Walking shoes and flats may not make you feel your sexiest, but they're better than a cane and hospital booties.

BIRKENSTOCKS

It isn't surprising that Birkenstocks came from a company that designed arch supports for mass-produced shoes in the late nineteenth century. This flexible, contoured arch-support system was incorporated into a shoe in 1964. Known more for comfort than for beauty, Birkenstocks have gone from being regulation footwear for the granola set to the casual shoe of choice for millions.

STEPS FORWARD: In the mid-nineteenth century, Charles Goodyear invents vulcanization and gives us the first rubber soles. • Carmen Miranda elevates chunky platform shoes to new heights of popularity in the late thirties, prompting *Vogue* to report in 1939 that "Nothing is dowdier than a dainty foot." • World War II rationing forces women into the wedgie, which has a wooden platform sole, to conserve leather. • After rationing, women crave feminine shoes once again. In 1952, Ferragamo uses steel spikes to jack up heels as high as five inches, and the stiletto is born. • The punk-rock movement of the late 1970's brings a British work shoe, Doc Martens, into fashion. • A 1983 study by the Society of Podiatrists indicates that being athletically active may enlarge the foot. The report concludes that owing to increased participation in fitness activities, one in ten women now wears a size ten or larger shoe.

Oxford button-down shirts,
Levi's jeans, white cotton T-shirts,
baseball caps, bomber jackets,
little black dresses, striped French
sailor shirts, a string of pearls, navy
blazers, trench coats, gold hoop
earrings, Cartier tank watches,
Ray·Ban sunglasses, cashmere
cardigans, loafers

WHAT MAKES A CLASSIC A CLASSIC?

It's an old friend with a new twist. A chunkier heel, perhaps? An animal-print pattern? A Vibram sole? It doesn't matter—whatever makes you kick up your heels. You buy it for what it's always been: a familiar shape that seems to weather time and is always just a comfortable reach away in your closet. You buy it for what it lets you be: yourself. A classic classic? It is dependable, timeless, and tamperproof, yet open to reinterpretation.

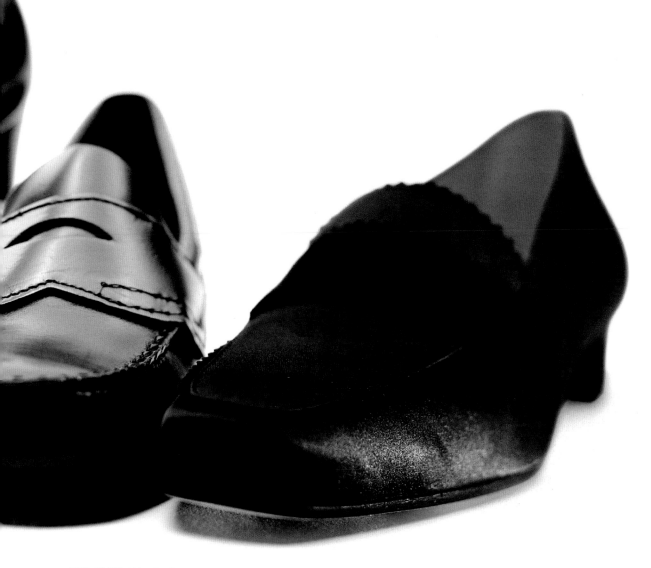

THE ESSENTIAL SHOE WARDROBE: **SLIPPER.** Look for simple feminine lines. Think ballet dancer. **SNEAKER.** Look for support, white canvas, relaxed functionality. Think weekend. **ATHLETIC SHOE.** Look for whatever your sport demands. Think speed, movement, poetry in motion. **LOAFER.** Look for classic lines, sturdy construction. Think bookworm. **BOOTS.** Look for weather protection, warmth, nonslip soles. Think L. L. Bean, Will Rogers, Nancy Sinatra. **SANDAL.** Look for foot-flattering detail and ventilation. Think flat for the beach, strappy for night. **FLATS.** Look for comfort, versatility, and style. Think sweet relief. **DAY PUMP.** Look for reliable black or brown, versatility, quality leather. Think job interview. **EVENING PUMP.** Look for high heels, sleek lines, black, glamour, sex appeal. Think Marilyn Monroe.

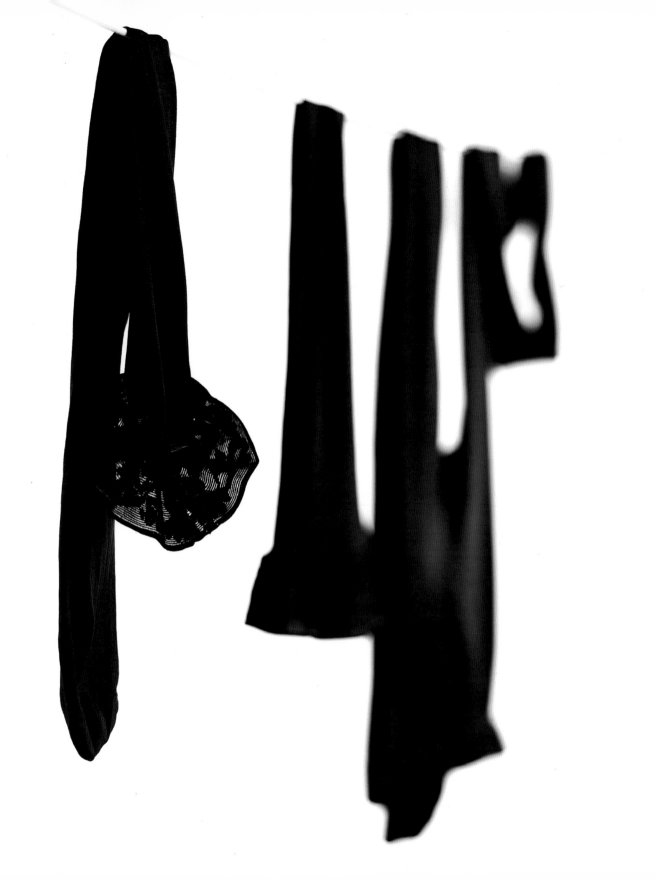

Socks. The artist David Hockney wears a different color sock on each foot, but most of us don't want to direct that much attention to our ankles, especially if the rest of us is looking snappy. To avoid this, stay away from unsubtle patterns—although one or two pairs of funky socks can come in handy when you need a little cheering up. Color selection should be based on your wardrobe palette. Keep it neutral, to echo the color of your pants. Just avoid socks that allow skin to show when you're seated in pants. Kneesocks provide the most coverage and stay up the best. But if a pair of anklets or over-the-knee socks are your fashion statement, then go right ahead. Weight and fabric are usually dictated by the activity and time of year.

HANG 'EM HIGH

Don't dry your socks or pantyhose in the dryer. Heat destroys the elastic that helps keep them up.

WARM FUZZIES

Sometimes layering a medium-weight wool sock over a silk or nylon knee-high will keep you warmer than a single bulky wool sock.

THICK & THIN

In the sixties, thick dancers' tights were made in thinner weaves to become pantyhose worn under minis.

Stockings. Before the 1920's, when flapper fashions ushered in hiked-up hemlines and the first flesh-colored stockings, stockings came in two colors: white and black. Stockings have now, for the most part, been replaced by easy-to-pull-on pantyhose and come in a multitude of colors, fabrics, weights, and textures. You only need a few colors on hand—black, nude, and possibly navy—to work with your entire wardrobe. Opaque hose is usually reserved for casual looks and short skirts. If there is a sheen, it becomes dressier. Sheer is dressier still, yet it remains the everyday choice in warm climates. Built-in control panels can help push in your tummy. Reinforced toes and heels are sturdy but unsightly with sandals and open-toed shoes. And if short skirts are your thing, watch out for control-top lines.

CAMOUFLAGE: Darker colors—especially black—are slimming. • Medium-sheer hose can be more slimming than very sheer or opaque hose, because they allow for some shadow along the leg. • Echoing the color of your outfit with your hosiery elongates the body. **RISKY BUSINESS:** Opaque hose and tights make wearing short skirts feel less risky, and they also continue the line of an outfit so that the hemline issue becomes less important. **APPROPRIATENESS:** Sheer hose tends to look better at night and in warmer seasons. **VALUE NO:** It does not necessarily make sense to spend a lot of money on delicate, sheer pantyhose. No matter how well they are made, they will run. **VALUE YES:** It does make sense to spend more on opaque hose and tights, which, when cared for properly, can last for years. Also, thick, opaque hose usually has more stretch. It tends to keep its shape longer than sheer. **CARE:** Hand-wash hose with a gentle soap in lukewarm or cold water. Wring dry in a towel before drip-drying.

Quality Control

YOKE

Split shoulder: a vertical seam down the yoke on the back of the shirt.

COLLAR

Evenly stitched around the edges.

BUTTONS

SIMPLE: Bone, mother-of-pearl, animal horn. DRESSY: Antique patterned metal, black jet, crystal, rhinestone, old coins.

PLACKET

A count of fourteen stitches per inch on a shirt's placket—the strip of fabric on which the buttons are sewn— indicates quality.

FABRIC

Quality lightweight, finely woven cottons include Egyptian and Sea Island cotton, which have a sheer, satiny finish. Cotton poplin and broadcloth have a smoother weave than oxford cotton. Linen and cotton batiste for warmer weather. Silk for the dressiest looks. Wool for chilly weekends.

BUTTONHOLES AND SEAMS

Well finished—no dangling threads or frayed fabric.

SLEEVES

Sufficient room. Where it joins the cuff, fabric should be gathered into pleats, not tapered.

TAILS

Long enough to come together between the legs; ideal for wearing with leggings.

S H I R T S

AT TIMES, THE PERSONALITIES OF A WHITE SHIRT SEEM VIRTUALLY INFINITE. A CLASSIC COTTON CAN LOOK CRISP AND TAILORED. CHANGE THE FABRIC TO SILK OR SHEER ORGANZA,

and the look is instantly dressier, sexier—menswear-inspired fashion at its most feminine. Exaggerate the tailoring—more seams, dropped shoulders, a playful collar—and even classic cotton can become jazzy and brash. Take away the collar altogether and add a tiny stripe, and the shirt takes on a simpler, quieter, more ascetic look. Loose shirts can be worn over an undershirt or camisole, in lieu of a jacket. Untucked, they can hide a bulky waistline, or give modesty and shelter from the sun to a skimpy bathing costume.

Tucked in or worn under a jacket, they take a back seat to the perfect suit. When is a shirt not a shirt? When it's too pretty or feminine to betray much of its historical roots as men's clothing—in other words, when it's a blouse.

OFF THE CUFF

Cuffs finish the shirt sleeve. Even if the shirt is a plain cotton or denim fabric, the cuffs can make it dressier by folding over on themselves and requiring cuff links. These are known as French cuffs. The plainer barrel cuffs, which close with a button, are cheaper to manufacture and therefore more common. But they, too, can be jazzed up, with a pearl, jeweled, or antique button.

BUTTONS

Think of them as shirt jewelry with
the ability to transform the personality
of your shirt. A plain white button-down
metamorphoses into a glorious dress
shirt if you change the buttons from
horn to antique rhinestones. Changing
buttons can bring new life to dresses,
jackets, and sweaters as well.

 CUFF BUTTONS

Are they plastic or made from natural substances? Are they covered with the same material as the shirt? Do they look hand finished or machine stamped? Are they all there? Do extras come with the garment?

S W E A T E R S

THE ORIGINAL "SWEATER" WAS A THICK WOOL BLANKET USED BY STABLEHANDS AT THE end of the nineteenth century to make racehorses perspire during training exercises. Draped over the likes of Lana Turner and Grace Kelly, it induced perspiration in a decidely different population. Sweaters are infinitely flexible. They can be thick and woolly, warming men and women alike on snowy winter weekends. Or, as Coco Chanel discovered, they can be feminine and subdued, like the cashmere twin-set you substitute for a suit jacket, changing your look from hard power to soft sophistication. Beaded sweaters and cashmeres with exquisite buttons say luxury, and have shown up at elegant evening parties and fashionable resorts for decades, paired with dress-up fabrics like chiffon, satin, and silk taffeta. And everyday sweaters made from cotton, linen, wool, and Polartec fleece serve a remarkable range of activities—from tea with Grandma to trekking in the Dolomites.

"She wore a short skirt and a tight sweater and her figure described a set of parabolas that could cause a cardiac arrest in a yak."

WOODY ALLEN

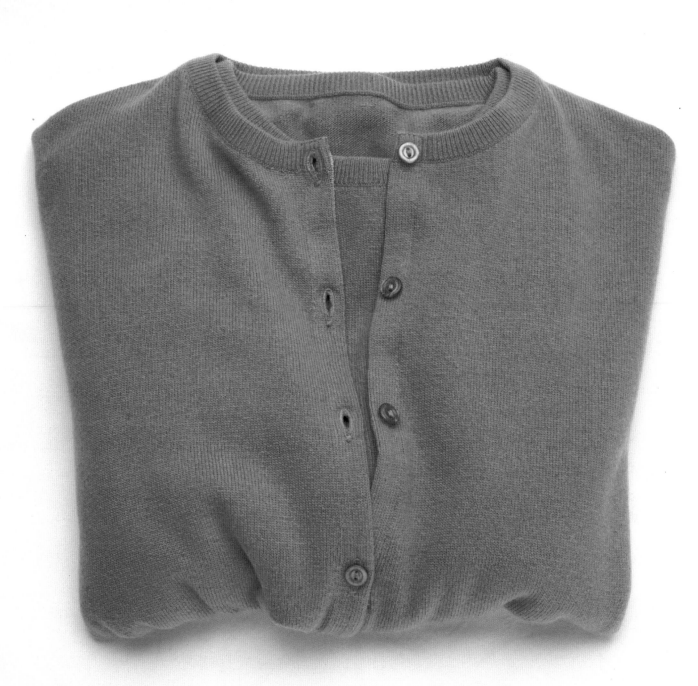

SWEATER SET

The lightweight ensemble that layers a cardigan over a pullover is a hallmark of good breeding and propriety. Drape the cardigan over your shoulders, or tie it around your neck or waist for easygoing style. Accessorize a twin-set with pearls or beads to dress up jeans, or wear it in place of a jacket to dress down a suit. Wearing it under a blazer adds both texture and layering, which can be helpful when traveling.

EVENING SWEATER

A beaded border. A decorative pearl
or rhinestone button. In other words,
a few exquisite details are all a cardi-
gan needs to go from simple classic to
elegant evening.

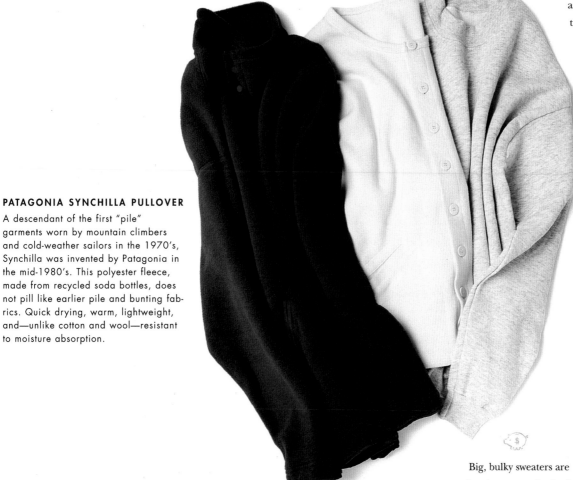

TAILORED SWEATSHIRT

Comfortable, with a hint of athleticism. More stylized than a basic sweatshirt, but keeping the loose comfort and soft cotton fleece. It's a favorite for dressing up leggings.

Wrapped around your shoulders, a pullover functions as a scarf, adding color and texture to an outfit. This also puts it within easy reach when the temperature drops.

PATAGONIA SYNCHILLA PULLOVER

A descendant of the first "pile" garments worn by mountain climbers and cold-weather sailors in the 1970's, Synchilla was invented by Patagonia in the mid-1980's. This polyester fleece, made from recycled soda bottles, does not pill like earlier pile and bunting fabrics. Quick drying, warm, lightweight, and—unlike cotton and wool—resistant to moisture absorption.

CHAMPION SWEATSHIRT

The Coca-Cola of sweatshirts. It was inspired by cotton pullovers worn by outdoor workers at the turn of the century. The fit is bulky and wide, and the line is almost triangular, with a tapered waist opening up to broad shoulders. The cotton-polyester blend, constructed in a "reverse-weave" process to minimize shrinkage, combines hipness and nostalgia with simple athletic function.

Big, bulky sweaters are often less expensive in the men's department.

SWEATERS AND THE BODY POLITIC: • Wrap it around your waist to add visual interest and camouflage your belly. But remember that it will draw attention to your backside. • Wrap it around your neck—the added color or texture will frame your face. • If you are pear-shaped, avoid long sweaters, which will make the hip area appear wider. • If you are short-waisted, wear sweaters that fall below your waist. • If you are top-heavy, wear darker sweaters, or fuller sweaters that don't hug you too closely. • Don't tuck in sweaters if you are short-, long-, or thick-waisted.

TURTLENECK

KATHARINE HEPBURN UNDERSTOOD TURTLENECKS.

THE SLEEK, CONTEMPORARY SILHOUETTE. THE REMARKABLE ABILITY

TO DEFINE A JAWLINE (AS IF SHE NEEDED HELP IN THAT DEPARTMENT).

The sophisticated simplicity of revealing so much by showing so little. She even knew enough to wrap them

around her neck. Was it for warmth, protection, or simply style? Who cares? It looked great. Cat burglars, skiers, and

a number of men with goatees have also appreciated them, but less for their aesthetic properties than for their abil-

ity to camouflage, warm, and impute intellectual hipness. Everything about a turtleneck depends on how it fits

and what it's made of. Big, bulky hand-knits are about homespun charm, borrowing from your boyfriend's closet,

and warm, cozy weekends, especially when paired with jeans or leggings. A tight, ribbed turtleneck with a slim

neck defines the body in a sexier way. Lying smoothly under a suit jacket, it creates a tailored, sporty look. In the

end, the turtleneck's form is simplicity itself, whether it's at the center of attention or part of a layered ensemble.

G L A S S E S

WHEN YOU WERE YOUNG, YOU MAY HAVE BEEN TEASED

mercilessly because of them. But now that you're older, you know a good thing when you squint at it. Glasses can create a signature style, or they can be frameless and barely visible, one small evolutionary step from the contact lens. You may depend on them, resent them, lose them, or use them to look smart—but that doesn't mean you can't have fun with different frames for different moods, or seasons, or activities. Maybe you feel more comfortable

CASEWORK

Think of it as luggage for your glasses. It should be hard on the outside, for protection, and have a soft interior, to prevent scratching. You can have a collection of cases and use them as you would any accessory. Color and pattern may work in your favor: black cases are hard to find in an overstuffed handbag.

EYEGLASS CHAIN

If you've ever worn glasses, then you've probably lost glasses. An eyeglass chain helps you keep track of them. Pick one that goes with the style of your frames. Croakies, the neoprene strips athletes use to hang on to their shades, are a good bet for sports and outdoor activities.

showing up at work in a serious tortoiseshell or horn frame. It's possible that they fit your corporate image better than those rhinestone-studded, pink cat's-eye frames you might wear to a downtown gallery opening. Face shape matters. An angular face tends to look better in rounder frames. A round face is flattered most by angular or squarish frames. Frames with low and dark-colored bridges shorten a long nose. Finally, match the size of your frames to the size of your features— unless you want to look like Elton John.

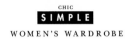

V E S T

THE VEST IS AN EFFICIENT PIECE OF CLOTHING THAT CAN ADD ENORMOUS POSSIBILI-

ties to your existing wardrobe. A denim vest under a velvet jacket creates a rich, unexpected mark of personal style. Vests can be functional: they can keep the upper body warm, camouflage a few extra pounds, or be miracles of organization—as fishermen and photojournalists know. Cold-weather buffs layer them under their parkas for extra warmth. Or they can be luxurious—sewn from silk, velvet, or bro-cade—and act as an accent piece under a subdued jacket. Or you can make a vest the main event: worn long and fitted, and with nothing underneath, it will look perfect over evening pants at a summer cocktail party.

Fleece Vest. Originally used for serious outdoor activities like kayaking and mountain climbing, it's probably the only garment you'll find scaling the north face of K2 and schmoozing during Saturday soccer.

When mixed with less sporty accessories— a pair of oxfords and a striped turtleneck, for example, or layered under a blazer, for added warmth and tex-ture—you have a more tailored look.

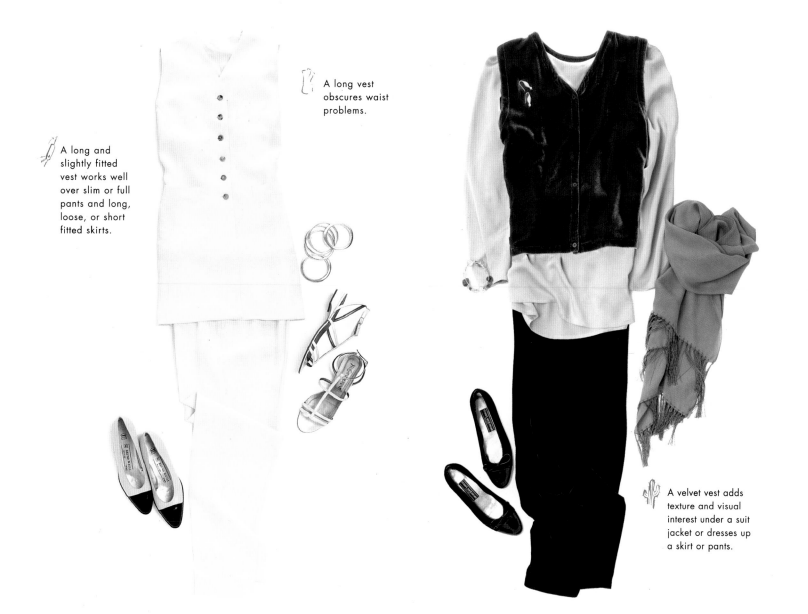

A long vest obscures waist problems.

A long and slightly fitted vest works well over slim or full pants and long, loose, or short fitted skirts.

A velvet vest adds texture and visual interest under a suit jacket or dresses up a skirt or pants.

The Shirt Vest. A fitted vest worn on its own becomes very feminine and dressy. Maybe it's the exposure of all that upper arm or the suggestion that a vest may be worn with nothing underneath.

The Accessory Vest. The vest can be the main event or a subtle accessory. When paired with an oversize shirt or jacket, it camouflages waist problems while creating a look of casual elegance.

ATHLETIC BRA

Born out of the running boom
of the mid-1970's, athletic bras
are about comfort and support.
They are usually made from a
soft cotton-Lycra blend that
absorbs sweat and cinches in
the bosom like a girdle.

LEGGINGS

Skin-tight yet elastic, leggings
have equally benefitted bicycle
messengers, dancers, gym rats,
and stylish women. Comfortable
and highly functional, they cre-
ate a long, leg-conscious line
that looks great under sweaters,
shirts, T-shirts, and blazers.

SOCKS

Cotton will make them
absorbent. Elastic will keep
them up. Padding at the
ball of the foot and the
heel will prevent blisters
and provide a cushion.

INSTANT ACTIVE

Okay, so you never got a varsity letter in high school. That doesn't mean you can't sport some of the garb.

Black leggings, an athletic bra, white cotton socks. Taken piece by piece, athletic wear can look great as part of

your everyday, casual wardrobe. As an ensemble, who knows? Maybe it'll inspire you to take up kick-boxing.

ATHLETIC REMIX

Leggings are amazingly versatile. Dress them up with a long, fitted suit jacket, and they'll take you to lunch. A pair of black leggings, a vintage Pucci blouse, and basic black sandals? A jazzy summer-weekend look. The athletic bra is another simple shape. Try it under a sheer blouse with a pair of wide-leg palazzo pants. Of course, age is a factor, especially where your midriff is concerned. This is basically a young look, and may make an older women seem as if she's trying too hard.

PUCCI

Emilio Pucci, a former member of the Italian Olympic ski team, first caught the public's eye in the mid-1940's, when he was photographed for *Harper's Bazaar* wearing ski pants of his own design. The magazine had asked him to create a few winter pieces for women, launching his career as a sportswear designer. Based in Florence, he became famous for making psychedelic-patterned dresses out of brightly colored silk scarves. With a following that continues to grow to this day, his wild patterns and colors are emblems of 1960's fashion, yet, like any item that has achieved true classic status, they remain popular today.

Sport Watches.

You can tell a lot about a person by the time she keeps. Do you even wear a watch, or do you depend on the patience of strangers? The Rolex says your watch is more than just a timepiece. It's expensive, elegant, and versatile, looking just as fine at the beach as it does at the office. The Timex Ironman says you're interested in sports, accuracy, split-second information. It's an inexpensive piece, worn casually or for athletics. Unless, of course, you're President Clinton, in which case you'll wear it everywhere, even at your inaugural ball.

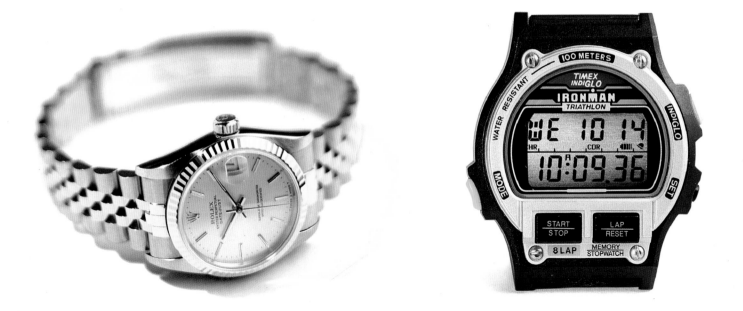

ROLEX: It's hard to believe that something so stylish could also be so strong. Patented in 1926, the Rolex Oyster was the world's first truly water-proof watch. Mercedes Gleitze swam the English Channel in 1927 while wearing one. And in 1978, Reinhold Messner was wearing a Rolex Oyster when he made the first ascent of Mount Everest without oxygen. Its signature mixture of silver and gold means the Rolex goes anywhere—to the beach or a board meeting—and also looks good with most jewelry. It is expensive and elegant—not a good watch to lose—and carries with it the inevitable cachet of a classic. **TIMEX IRON-MAN:** Named for the Hawaiian endurance event that encompasses biking, swimming, and running a marathon, the Ironman is the best-selling watch in the country. Its features include water-resistance to a depth of 100 meters, eight-lap recall, 16-hour stopwatch, 10-hour three-mode countdown timer, Indiglo night-light day-and-date display, and alarm. The ultimate functional watch.

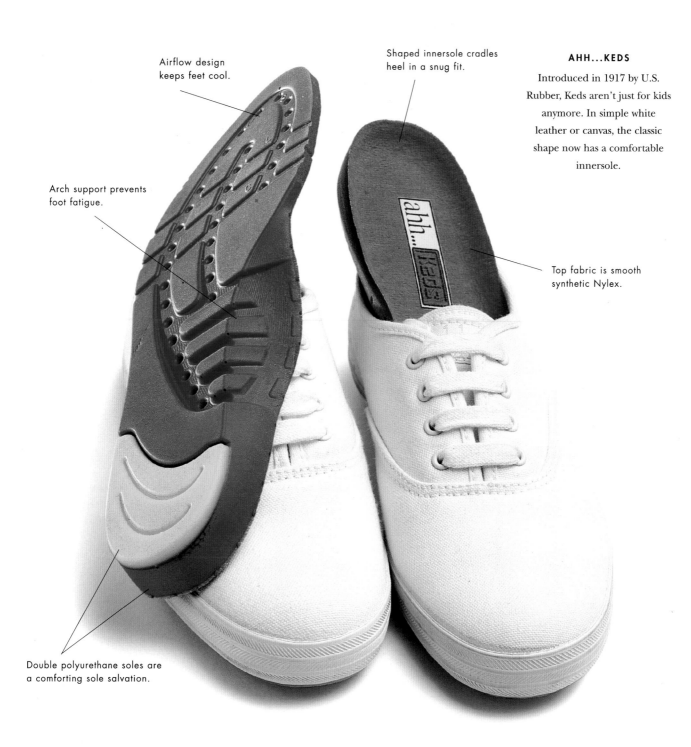

Airflow design
keeps feet cool.

Shaped innersole cradles
heel in a snug fit.

AHH...KEDS

Introduced in 1917 by U.S.
Rubber, Keds aren't just for kids
anymore. In simple white
leather or canvas, the classic
shape now has a comfortable
innersole.

Arch support prevents
foot fatigue.

ahh...keds

Top fabric is smooth
synthetic Nylex.

Double polyurethane soles are
a comforting sole salvation.

Historical Update

NECKLINE

Sweetheart necklines, shirring, and under-wire bras augment bustline.

LEG CUTS

Leg cuts that hit at the hip bone, or skirted suits that hit just below the top of the leg, will minimize hip problems.

STRIPES VS BANDS

A print distracts from any one body area. Overall horizontal stripes will exaggerate flaws, though bands at the waist between side-color blocks will flatter a wide middle.

BATHING SUITS

WE WOULDN'T MIND LOOKING LIKE ONE OF THE WOMEN IN THE *SPORTS ILLUSTRATED* SWIMSUIT ISSUE. ELLE MACPHERSON WOULD DO JUST FINE, THANKS. WE THINK IT MIGHT BE POSSIBLE. WE'VE BEEN WORKING OUT.

We've given up most of our favorite food groups. We head to the swimsuit section of our local department store with a glimmer of hope in our soul. Ten suits later, we've decided that anyone who looks decent in a bathing costume is really just a hologram. Another twenty, and we're ready to move to Minsk. Now that we need them, where are those knickers and tunics women wore to "take the waters" in the late 1800's? A few pointers: Know your body type and your trouble spots. Do you have big hips and a small chest? Is your tummy thicker than you want it to be? Are you self-conscious about your full bust? Every season, there are new fabric blends and cuts to hold, flatter, and conceal an amazing spectrum of body types. Try on a range of styles. Patterns can be used to camouflage or draw attention to specific areas. The good news is that with innovations in fabric and design, you're likelier than ever to find a suit you're happy with—one that finally lets you put your own swimsuit issue to rest.

ONE-PIECE. The one-piece has changed a great deal since the early 1800's, when "taking the waters" involved stepping into a bathing costume with a fitted bodice, high neck, long sleeves, stockings, and canvas shoes. By the late 1800's, women's swimwear had been whittled down to a heavy wool tunic and knickers. In 1907, the competitive swimmer Annette Kellerman swam the Thames dressed in a one-piece suit, which got her arrested on charges of indecent exposure. Just prior to World War I, Karl Jantzen produced the first skin-tight, rib-knit stretch suit. More recent innovations include control panels, underwire bras, and spandex fabrics that "memorize" body shape. **BIKINI.** In 1954, the Paris designer Louis Réard came up with the idea for a two-piece bathing suit. Later that year, the United States dropped an atom bomb in the Pacific Ocean. Réard called his explosive creation the "bikini," after ground zero, Bikini Atoll. Since then, the two-piece has been a barometer of beach skimpiness. The smallest version—no top, a thong for the bottom—has found more favor in some European and South American countries than in the U.S. For the less exhibitionistic, the modern-day bikini comes in styles that include push-up bra tops and "boy-leg" bottoms.

Beach Blanket Bingo

ONE VS. TWO The decision to hide or show
off your belly button is an entirely personal one. Within
the two basic bathing suit categories, here are a
few body guidelines.

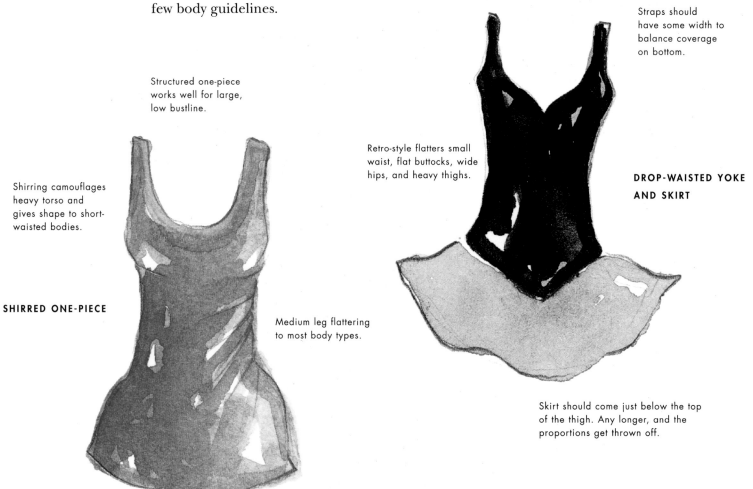

A high neckline will
lengthen the torso, espe-
cially with a skirted suit.

Straps should
have some width to
balance coverage
on bottom.

Structured one-piece
works well for large,
low bustline.

Retro-style flatters small
waist, flat buttocks, wide
hips, and heavy thighs.

**DROP-WAISTED YOKE
AND SKIRT**

Shirring camouflages
heavy torso and
gives shape to short-
waisted bodies.

SHIRRED ONE-PIECE

Medium leg flattering
to most body types.

Skirt should come just below the top
of the thigh. Any longer, and the
proportions get thrown off.

Inside tummy panels or
a shirred front (three or
more rows of gathered
fabric) conceal and
smooth the stomach.

BANDEAU

A bandeau is a narrow, strapless brassiere or bikini top. The word derives from the French term for band or bandage; originally, bandeaus were just unstructured strips of fabric tied around the bust.

Bandeau top makes narrow shoulders seem bigger.

Strapless top accentuates collarbone.

High-cut leg flatters long slim legs.

COLOR BLOCK

Horizontal waist details visually shorten a long torso. Bright-colored waistbands or side panels have a narrowing effect.

Color-blocking and a high or square neckline will disguise a full bust.

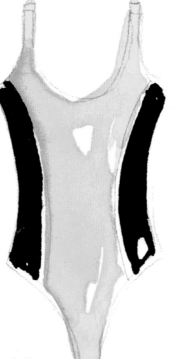

ATHLETIC TOP

Ideal for flattering broad shoulders. X-back for extra support and comfort.

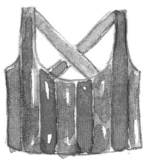

SHORTS

Bottoms can be tight and boyishly sexy, or loose and comfortable, doubling as shorts for sailing, windsurfing, and other water sports.

A brightly patterned top with a matching solid (dark) bottom will draw attention away from hips and legs.

THE BEACH AT THE MOVIES

JAWS *Beach Blanket Bingo* THE SURE THING *"10"*

FROM HERE TO ETERNITY *The Blue Lagoon*

SPLASH *Chariots of Fire* DEAD CALM *The Turtle*

Diary ON THE BEACH

SHIRT

A big cotton shirt. Perfect for
sleeping in, working in, or
throwing on over a bathing
suit. It's comfortable, familiar,
modest, and it protects you
from the sun.

COTTON SWEATER

A big sweatshirt or cotton
sweater. Great for when the
sun is on its way up or down.
It's warm, comfy, and
absorbent. Best of all, it's
already part of your
wardrobe.

Coverups. The farther away you get from
the water, the more your bathing suit feels like under-
wear. You need a coverup. It is, by definition, the sim-
plest of things. An oversize button-down shirt. A large
sweatshirt. A thin cotton dress. A pareo jauntily knot-
ted at the hip. But it will get you home, or to the
store, or to a pool party—wherever you need to be
when it comes time to pack up your sand toys and go.

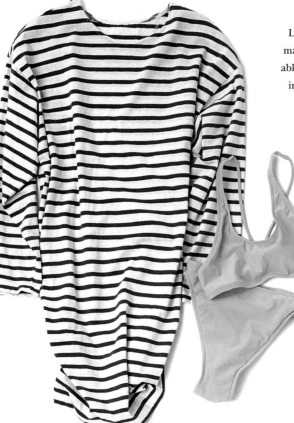

COTTON DRESS

Long-sleeved or short, it doesn't matter. It should be cool, comfortable, and easy to throw in the washing machine. Perfect for getting you from beach to barbecue.

SARONG

When Dorothy Lamour appeared in the 1940 film *Road to Singapore*, she inspired millions of Western women to wear this fabric wrap (also known as a pareo) from the Pacific Islands. Five to seven yards of material, tied at the waist or chest. That's all it is. Use it as a beach towel, as a picnic blanket, or (with the right shoe) as a cocktail dress.

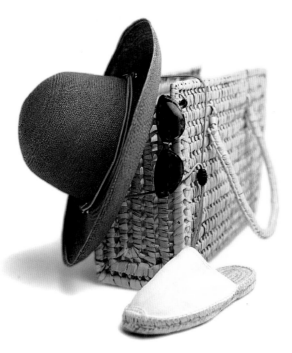

S A F E S U N

YOU DON'T NEED MUCH. A BATHING SUIT, TO KEEP YOU FROM

GETTING ARRESTED. SOME SUN, SAND, AND THE OCCASIONAL WAVE.

PURE HEAVEN, BUT THINK ABOUT PROTECTION. A SUN HAT WITH A BRIM WIDE

enough to shield your face. Shades that are coated to block harmful ultraviolet rays and so dark that

you can't see your eyes through them when you look in the mirror. Espadrilles that put a cool, corded-

rope sole between the hot sand and your feet. A straw bag—one that lets the sand sift through and is big

enough to carry a day's worth of sun lotion, trashy novels, water, towels, and whatever else you might need.

SUMMER SHOE WARDROBE

The basic summer shoe wardrobe, in all its glory. The leather fisherman's sandal: a sturdy and practical summer shoe. The canvas sneaker: the ultimate in comfort and function. The leather thong: easy dress-up. The colorful ballet slipper: sweet and feminine. The strappy heeled sandal: cool and sophisticated, even in yellow.

"Her tight little skirt slipped up over her thin, pretty legs as she took the high step. There was a run in one of her flimsy silk stockings. She was doubtless unconscious of it; it was well back toward the seam, extending, probably from her garter, halfway down the calf. Mr. Durant had a hard desire to catch his thumb-nail in the present end of the run, and to draw it on down until the slim line of dropped stitches reached to the top of her low shoe."

DOROTHY PARKER, "Mr. Durant"

SKIRTS

WE SEEM TO WORRY MORE ABOUT THE LENGTH OF OUR HEMS THAN WE DO ABOUT THE SHAPE OF OUR SKIRTS. AFFECTED BY STOCK-MARKET CRASHES, WARTIME RATIONING, AND DESIGNER WHIMSY, SKIRT LENGTHS ARE skittish by nature. In a perfect world, hemlines would be fitted like window shades, with built-in rollers to facilitate the inevitable ups and downs. One thing we can be thankful for is that pretty much anything goes. The length of your skirt says a lot about you. It can indicate boldness, self-consciousness, or a flair for the dramatic. Are you La Femme Nikita or Laura Ingalls Wilder? Will a short skirt short-circuit or recharge your career? Are you wearing yours compromise knee-length? Consider your legs: should you be showing them off or gracefully hiding them? Proportion is also a consideration, in terms of both how you top your skirt and in choosing the right shoe heel to complement it. Slim skirts to the knee generally need a tapered heel for visual balance, while a slender high heel will often look too fragile with a full, loose skirt. If you're making a statement with your skirt length, decide on what makes you feel comfortable. Then wear it with confidence.

SHORT CHANGED

Bare legs for women started in 1928, when shorts were first worn on the tennis courts at Wimbledon. Twenty years later, women vacationing in Bermuda adapted the knee-length shorts of the local police to circumvent an anti-shorts law, and Bermuda shorts were born. Culottes, a skirtlike adaption of Bermuda shorts, were introduced by the 1930's designer Charles James, famous for his evening gowns. Skorts are shorts hidden under a skirtlike panel of fabric.

Look for shorts that are cut below the widest point of your leg. Pleats and styles gathered at the waist accentuate the hips.

SKORTS

SHORTS

Hemmmmm?

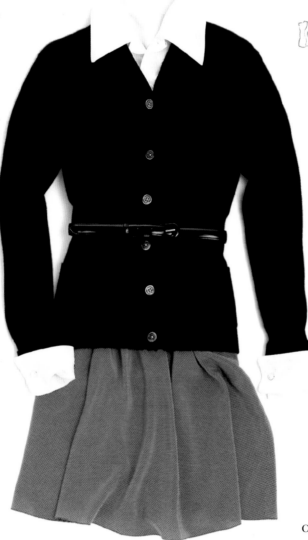

HOSIERY
Pair a skirt with dark hose or hose of the same color to lengthen the silhouette and diminish the importance of hem length.

SWEATER
Opposites often attract. Short skirts work well with long tops, which also visually elongate the body.

SHOES
Short skirts look good with flats or heels, but avoid ankle boots and ankle straps, which shorten the line of the leg.

SWING SKIRT
Its fullness is best paired with a fitted top.

SHORT SKIRTS

The shortened hemlines of the 1920's exposed more leg than society had seen in centuries—and helped women master the rubber-limbed moves of the Charleston. But Mary Quant was responsible for raising hemlines to provocative heights in the 1960's, thereby inventing the mini-skirt. These days, short skirts are considered a basic by many: they're comfortable, easy to wear, and often flattering.

Short skirts are not appropriate for job interviews with conservative firms or religious events.

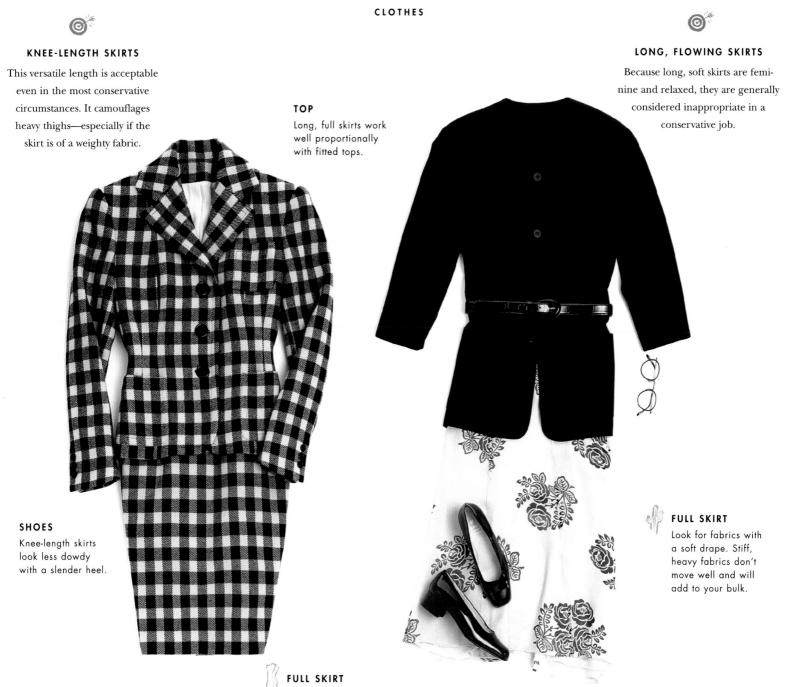

KNEE-LENGTH SKIRTS

This versatile length is acceptable even in the most conservative circumstances. It camouflages heavy thighs—especially if the skirt is of a weighty fabric.

TOP

Long, full skirts work well proportionally with fitted tops.

LONG, FLOWING SKIRTS

Because long, soft skirts are feminine and relaxed, they are generally considered inappropriate in a conservative job.

SHOES

Knee-length skirts look less dowdy with a slender heel.

FULL SKIRT

Look for fabrics with a soft drape. Stiff, heavy fabrics don't move well and will add to your bulk.

FULL SKIRT

Full skirts flatter most body types unless you are short or thin-boned—then they may overwhelm.

SHOES

A stiletto heel usually looks too delicate under a long, loose skirt.

PANTS

WHETHER IT'S THE HOLY GRAIL OF PANTS—

THAT PERFECT PAIR OF JEANS—

or just a well-tailored pair of grey flannel slacks, pants that flatter the body are often hard to find. So when you come across some that fit, remember who made them, what the style was, and where you got them. Chances are you'll be back for more. We expect pants not only to fit over many of our worst flaws, but also to disguise them. We want them to be durable, to stretch, to hold pleats and cuffs, and to billow about our legs. We want them to make us look like men, vixons, rappers, genies, jockeys, and cowgirls. We wouldn't be upset if they did for us what they did for Dietrich and Bacall, but we know that's a tall order.

JACKET
A full jacket works better on full bodies. It can dwarf the thin and petite.

KHAKIS
The ultimate weekend pant, khakis get their name from the Urdu word for "dust-colored." They can be dressed up with a blazer and scarf, or dressed down with a sweater or T-shirt. They are low-maintenance— just toss them in the wash— and seasonless, making them good travel pants. As for durability, soldiers throughout the world have worn them for decades.

SCARF

A scarf in an evening fabric dresses up even the simplest of sweaters.

PANTS

A simple sweater and jacket can change personalities with a change of pants.

PALAZZO PANTS

The ultimate party pants, palazzo pants became popular in the 1930's, when they were also known as beach pajamas and worn with a loose top over a swimsuit. They have a comfortable feel that can be casual or dressy, depending on fabric and accessories. In metallic silk with a cashmere sweater and a scarf, the look is cool, understated evening. In cotton or linen with a T-shirt and a pair of sandals, it's pure summer.

WOOL SLACKS

"Slacks" is the general term for the loose-fitting sport pants that have been worn by women since the 1920's. Their tailored silhouette lends them a slightly formal air, though they can work in casual situations as well. Pair them with a cashmere sweater set for a softer look.

One Leg at a Time

No matter the cut of the pant, each style creates its own unique silhouette.
Be sure that the profile is the one you are seeking.

Choose a zipper over a button-front fly if a bulging tummy is a problem.

Basic wardrobe: blue, white, and black denim.

Jeans flatter wide-waisted bodies with thin legs, and flatten a protruding stomach or rear.

A side or back zipper-closure is slimming for tight pants.

Avoid pockets in body-conscious pants—they create lines and bulges.

JEANS

The name derives from the French word for the people of Genoa, whose workers wore pants of this straight-legged, rugged style.

Jeans are the ultimate casual pants. Perfect for hacking around in the country, they can also be dressed up with loafers and a blazer.

Tight pants work well with loose tops, jackets, and tunics, all of which favor top-heavy figures.

A fabric with some stretch can make tight-fitting pants more comfortable and help follow the line of your body better.

In the 1950's, pants tapered to the mid-calf became a popular summer style. They were known as Capri pants, named after the Italian island resort, a vacation spot at the time, where Emilio Pucci was inspired to create these pants.

Slits at the cropped hem add a feminine detail, but they also draw more attention to the ankle.

CAPRI

SLACKS

Tailored pants, often finished with pleats, a waistband, and sometimes cuffs. Pockets should lie flat and pleats should not pull.

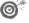 Slacks are equally acceptable at the office and at a fancy weekend lunch.

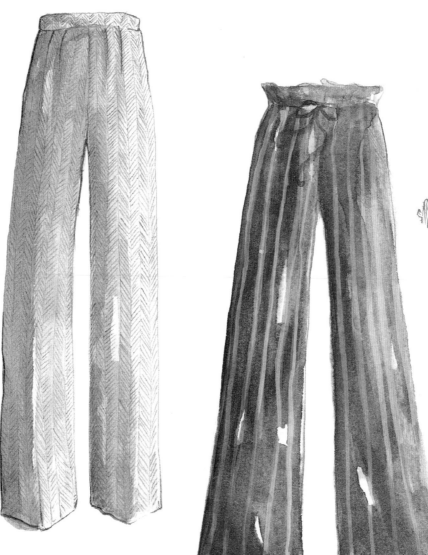

Palazzo pants can conceal a host of lower-body problems: short legs, thick legs, thick ankles, a protruding stomach, and large buttocks.

These pants are long and flowy by nature: fabric should have excellent drapability.

Elastic or drawstring waist is comfortable and forgiving.

PALAZZO

"I always wear slacks because of the brambles and maybe the snakes. And see this basket? I keep everything in it. So I look ghastly, do I? I don't care—so long as I'm comfortable."

KATHARINE HEPBURN

COLLIER DU CHIEN

Founded in Paris in 1837 by Thierry Hermès,
originally a prestigious manufacturer of
harnesses, Hermès has been creating a range of
desirable goods for men and women ever since.
Collier du chien is French for dog collar,
the inspiration for their now-classic belt,
which was introduced in 1928.

If your belt is the same color as your top, it will visually lower your waistline; if it's the same color as your skirt or pants, it will help to shorten your waist and lengthen legs; and if it's a different color from the rest of your clothing, it can cut you in half, especially if the top and bottom of your outfit are the same color and texture.

You will wear a basic brown belt and a basic black belt forever, so invest in quality and subtle style. Look for even stitching, good leather, well-finished holes, and solid or well-plated hardware.

A wide belt shortens the upper body and works well on most women. A loosely slung belt lengthens the torso.

A metal buckle can turn a belt into a piece of jewelry. A buckle made from the same material as the belt will complement a variety of jewelry.

Buckle Up. The belt was originally drafted for the military, to support clothes and hold weapons. Today, belts usually aren't as aggressive—their main job is to add color and texture to an outfit.

JACKETS

INSTANT RESPECTABILITY. MAYBE IT'S THE CRISP LINE OF

A WELL-SEWN COLLAR, OR THE GENTLE BEND OF A SLEEVE. MAYBE

IT'S THE ESSENTIAL MASCULINITY OF EVEN THE MOST FEMININE JACKET OR BLAZER

that gives us that feeling of control. The double-breasted blazer has its roots in naval history—the navy blazer is

a stylized version of the British Royal Navy's "reefer" jacket and was invented by the captain of H.M.S. *Blazer*

to be worn by his crew on the eve of the coronation of Queen Victoria. We use the more casual single-breasted

version—an American cousin of the jacket worn by English university boating and cricket clubs—to dress up

jeans or maintain the formality of a pair of trousers. Jackets build up our assets and hide our flaws. Shoulder pads

and fitted styles give shape; bulky "boyfriend" cuts allow us to be whatever we want inside their boxy silhouette.

As for style, it depends on yours. Do you want the drama of a long, fitted hacking jacket? The easy, casual feel of a

blazer? The perfect line of an attention-getting couture cut? Is it form-fitting and short for Saturday nights? A

well-cut jacket is the essential wardrobe item, and it should have a long and active life. Spend the time and the

money to get what works for you and your wardrobe. If you can get only one suit, choose style over trendiness.

Pick a color that can work with other pieces in your closet. Look for quality fabric (preferably one that's season-

less), fine workmanship, and something so good you can't imagine ever loaning it—even to your best friend.

Quality Control

True fashion longevity depends on classic style, comfortable fit, and fine workmanship, down to the details.

COLLAR

Should lie smooth and flat around the neck.

SHAPE

Look at the drape of the fabric. Is it too soft to hold the structure of the jacket? Is it too stiff or thick to hang well?

LAPELS

Button jacket to make sure lapels lie flat and are equal in size. If they spread or gap, try a larger size.

SHOULDERS

Whether or not the jacket has shoulder pads, shoulders should be even and natural-looking.

LINING

A silky rayon lining should be full-length.

POCKETS

They should be lined, lie flat, and be stitched closed until you open them for use.

BUTTONHOLES

Hand-sewn buttonholes are a mark of top quality—rough on the inside and smooth on the outside.

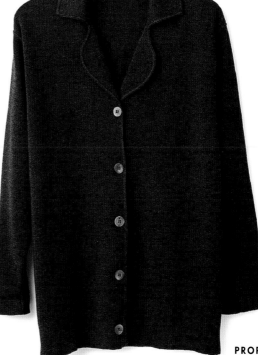

CLASSIC BLAZER

In the 1920's, women took to men's blazers and reworked the lightweight sports jacket in an abundance of fabrics and cuts.

KNIT BLAZER

In a knit, the blazer becomes less structured and less defining. It takes on a more casual, relaxed feeling—just a few steps up from an oversize cardigan.

PROPORTION

Jackets that hit just below the top of the leg are standard. Short, boxy cuts can truncate a long torso, while a long cut can make a short woman appear even shorter.

Unless it is lavishly beaded, the simple lines of a bolero are a great backdrop for bracelets and necklaces with multiple strands.

In the 1950's, bolero jackets were commonly made from the same fabric as the dress they were covering. Contemporary versions are in a variety of materials and can be worn with contrasting evening pants, dress, and sometimes jeans.

BOLERO

Of Spanish descent, the true bolero was worn open, sleeveless, and cut just above the waist. A short, boxy version with sleeves is often used as an evening jacket.

Fitted through the arms and torso, the collarless jacket looks better on thin or petite bodies.

Multiple patch pockets with button-down flaps make safari jackets ideal for traveling.

A multi-pocketed jacket originally designed for military use in hot, dusty climes, the safari jacket was traditionally made from a lightweight, khaki-colored twill.

The loose and unstructured fit lends itself to comfort and flatters a range of body types.

SAFARI JACKET

Give Me Shelter

SHAWL COLLAR

A shawl collar is a rolled collar that extends from the back of the neck into a curved lapel ending at the front closure of the jacket.

The gentle flare below the waist and the longer length work to camouflage hips and behinds. These jackets elongate the torso, and look better on taller, long-legged women.

MODIFIED HACKING JACKET

The single row of buttons extend only to the waist in hacking (or riding) jackets, to prevent buckling while riding—or sitting at a desk. Equestrian women have worn versions of this jacket since the nineteenth century and the non-horsey set adapted it in the later end of this century.

Looks best with long, slim skirts and slender pants.

JACKET WITH FLARE

The fitted body and waist of the jacket give the illusion of a small waist and help shape boyish figures.

The peplum is the fabric that flares from the waist and gives this jacket a stylized look. It works best with a bottom in matching fabric.

COLLARLESS JACKET WITH ZIPPER

BESOM POCKETS

Besom pockets can be interior pockets with edging or stitching around the slot opening. When used as outside pockets, they are often minimally decorated with a thin band of piping.

Zipper closure creates a minimalist, modern look. The color or detailing of the zipper pull may limit the choice of jewelry.

S U I T S

A SUIT IS A BIG INVESTMENT—

AND A MAJOR CLUE TO YOUR PER-

SONALITY AND LIFE STYLE. DO YOU NEED

the sculptured tailoring of a power suit to underline

your authority? Or would you be happier in a suit that is

less about control than it is about comfort and subtlety

of line? Maybe you prefer a more traditionally feminine

knit suit. Or a fitted, dressy mixed suit, with components

you can easily match with other parts of your wardrobe.

The ultimate question: Which suit suits your style?

The Soft Pantsuit. The neutral color and

soft lines of this suit call attention to the wearer, not her

clothes. The simplicity of the cut demands that the design

be perfect and that the fabric drape well. But body

shape is left undefined. Pants give the suit a more casual

look. The effect is one of sophisticated understatement.

"Those who think that pants and pantsuits are still synonymous with an androgynous look are missing the point."

GIORGIO ARMANI

A fitted jacket and loose pants in the same fabric creates a flattering, continuous line, similar to that of a long, one-piece dress.

Suited for high-powered, "creative" jobs, a soft, well-tailored pantsuit is a virtual uniform in Hollywood. It is less appropriate for more conservative workplaces.

Cutting on the bias imparts a suppleness to the fabric that suggests long legs and sensuous movement.

PANTS

Eliminating pleats on the pants brings new definition and precision to the shape.

ACCESSORIES

This understated look requires little if any jewelry. Keep it small and let your personality shine.

SHOES

A comfort suit requires simple flats.

 SUIT

Soft shoulders and a slightly cinched waist create a feminine and timeless silhouette, perfect for church, weddings, business, charity events, and travel.

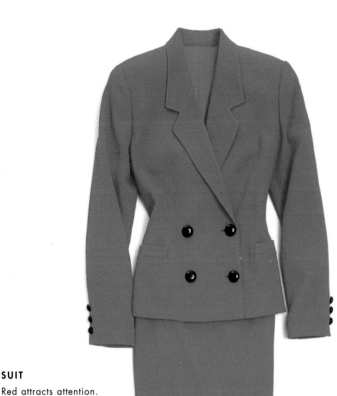

SUIT

Red attracts attention. Wear it if you want to take center stage, especially in a group of people or on television. Be aware, however, that too bright a red may vibrate in the camera's eye.

ACCESSORIES

A dramatically structured suit needs heels and important, high-quality accessories: a structured handbag, substantial jewelry. Anything cheap or wimpy will look tacky, or will simply be overwhelmed.

SHOES

A suit this elegant yet practical demands a moderate, 1½-inch heel. Higher would be sexier, and lower would be dowdy—unless the skirt is hiked up.

The Fitted Suit. The built-up shoulders and defining lines of this boldly feminine, well-tailored suit demand attention in any color. Red signals additional power and authority. The effect: extreme control.

The Versatile Suit. The unmatched top and bottom of a suit gives it flexibility. Each can be mixed with a variety of pieces from your wardobe. The effect: a slightly dressy elegance.

The light pastel color makes it an ideal suit for spring, summer, and warm winter climates.

THE CHANEL FACTOR

This suit is one of the many contemporary interpretations of the cardigan-styled one Chanel introduced during World War I. The use of decorative buttons (Chanel favored lion's heads) and trimming (Chanel used braid and chains) dresses up casual fabric without making the wearer suffer any discomfort for the sake of formality.

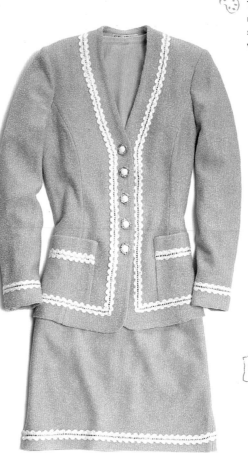

ACCESSORIES

Wear a comfortable heel and jewelry that complements the decorative buttons—gold or pearls, for example.

An unconfining suit whose forgiving fabric fits many body types.

The Knitted Suit. It strays from the traditionally masculine lines of a suit and stands on its own. But don't underestimate its power—the knit suit has been a favorite of former first ladies Nancy Reagan and Barbara Bush. The effect: feminine chic.

INSTANT WORK

SURVIVAL IN THE OFFICE OR AT THE INTERVIEW. IT'S ABOUT

HAVING A PAIR OF SHOES THAT LIVES UP TO YOUR DEPENDABLE SUIT.

A CLASSIC WATCH—ONE THAT WON'T DISTRACT FROM YOUR BRILLIANCE, BUT

quietly comments on your elegant style. And jewelry? The simpler, the better. You've pared down the accessories,

so quality and the ability to match them with everything in your work wardrobe are important. Together with your

suit, they create a uniform that will give you the confidence to not think about what you are wearing, thereby not

distracting you from the job at hand. Use them to play it safe—until you know what you can get away with.

AGENDA AND PENS. An agenda should impose calm and order. Make sure yours is made from good-quality leather and stitched well—it will get a lot of daily wear and tear. How big should it be? Just ask yourself how busy you are, how many phone numbers you need to jot down, how many lists you prepare (and then promptly ignore). How large is your bag? Do you plan by the minute or the month? Do you like writing on blank pages or filling in slots? And what do you like to write with? Pens can be neat, utilitarian, and anonymous, or rich in material and detail.

SHOES

Black is reliable. It doesn't attract attention and goes with everything. The style? A simple, classic pump with a 1- to 1½-inch heel.

HOSIERY

Keep your leg neutral with sheer black, brown, or nude hosiery.

WATCH

The Cartier Tank watch was designed for the Brazilian aviator and balloonist Alberto Santos-Dumont, so that he could avoid fussing with a pocket watch while manning the controls of his biplane. A word of warning: look out for fakes. The Cartier Tank is perhaps the most copied watch in existence.

SHOES

Buy quality. Your shoes are the first clue that you are well dressed. A cheap-looking pair only brings down the rest of your outfit.

JEWELRY

Classic pearl studs. Elegant and understated, pearls complement every skin color and work with any outfit.

JEWELRY

Avoid flashy or noisy jewelry in the office. It attracts too much attention.

WATCH

Buy quality, as this will probably be the most used piece in your work wardrobe. A black band will work with everything.

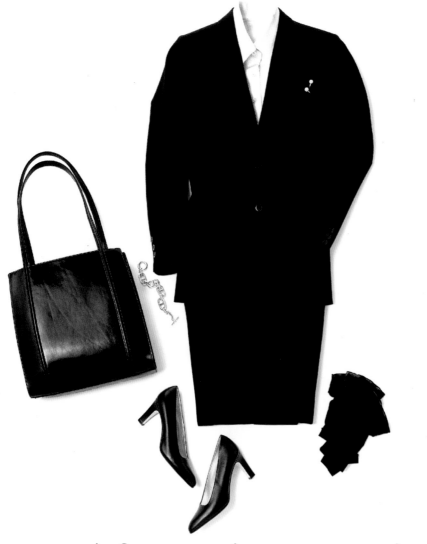

> "I have heard
> submission the
> the lady who
> the sense of
> well dressed
> of inward tran
> religion is
> bes
>
> RALPH WALDO

A few evening accessories can transform a

A.M. It's early to work, and you don't want to think about what to wear. You have a meeting, a presentation, an interview on your mind. You reach for your fail-safe uniform. A well-tailored and sensibly cut suit. Skirt length? To the knee. Color? Neutral. A white shirt adds crispness and flatters your coloring. Accessories? Classic, of course, with the quiet confidence good quality bestows on any object: it leaves you and your work in the starring roles. And you still have time to eat breakfast with your kids.

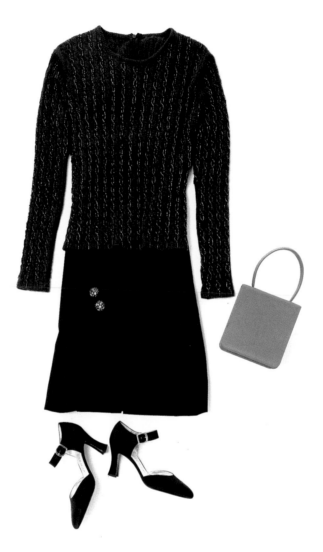

with admiring experience of declared that being perfectly gives a feeling quillity which powerless to tow."

EMERSON

tailored suit from work day to night play.

P.M. The transformation: from the office to a dinner party. Hang up the jacket and the white shirt. You have an evening blouse that would work. You also can consider wearing the jacket over nothing but a strand of pearls, or perhaps a camisole. In the end, you decide on a beaded evening sweater for extra glitter, and besides, it's easy to pack in your work tote. Don't forget to jazz up your earrings, trade in the tote for an evening bag, and dress up the heels. Add a little perfume and perhaps some red lipstick. Presto.

TOTE

The ultimate traveling office, with room for your laptop, agenda, makeup kit, and assorted papers. It's bound to get heavy—make sure it has a shoulder strap that's comfortably long and allows your hands to be free.

SHOULDER BAG

The reliable shoulder bag, with a handle, just in case. Clean lines outside, lots of pockets within. Durable and practical. Made from a sturdy leather in a neutral color. A bag that can travel as easily to the office as to the stadium.

Pockets allow easy access to tickets, hotel reservations, and other travel documents.

Keep it neutral. Black is often more dressy than brown. Look for fine leather, neat stitching, and quality hardware.

 LARGE ENVELOPE

Sleek and minimalist—this bag is a good one for important documents, and is a feminine, lighter alternative to the traditional briefcase your father may have carried. The style is neat, tailored, and elegant. The only drawback? No handles or strap means it leaves you one-handed.

SMALL CLUTCH

A great small bag to throw in your tote during office hours and use on its own at night or for important lunches. The clutch is a classic, so invest in quality and good design. It should last you for years.

Baggage. It's the stuff of life—both literally and emotionally. Do you set out each morning with enough gear in your tote to run a Fortune 500 company from your taxicab? Or do you pare things down to the barest survival-kit essentials—wallet, agenda, keys, lipstick, and a packet of Kleenex?

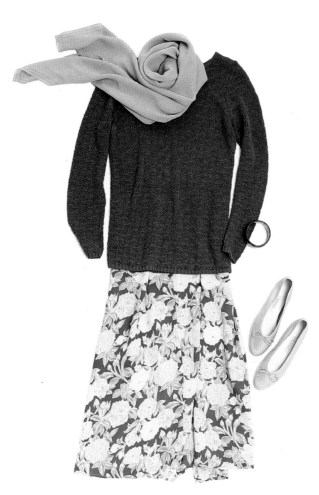

Casual dress for

Loose Skirt. Long, flowing skirts with large patterns are comfortable and pretty, but less formal than a suit skirt. A sweater reinforces the casual look but keeps things looking tidy. A silk scarf, understated jewelry, and simple flat leather shoes add polish.

Sweater Set. Sweater sets look neat, yet appear more relaxed and feminine than a suit or blazer. It's a classic that adds sophistication to a pair of casual khakis. Most companies frown on employees wearing sneakers to work. Loafers are a comfortable alternative.

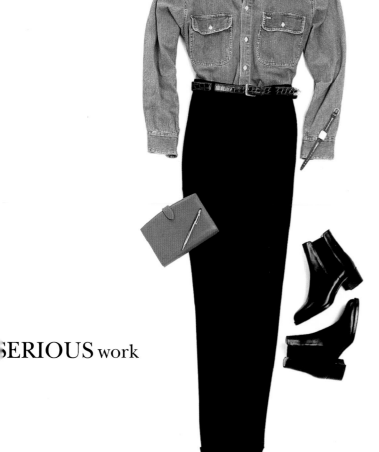

SERIOUS work

Denim.　Denim can work as a subtle accessory, especially when dressed up under a blazer or with tailored slacks. Quality accessories—like a silk scarf, a crocodile belt, a classic watch, and leather boots—give this casual look a neat, pulled-together appearance.

Blazer.　A well-tailored blazer confers instant respectability; cotton pants keep things from getting too stuffy. The pearls and belt formalize this resort look. Two-tone loafers are a little too flashy for more formal work wear, but here they add pizazz and easy style.

HOOP DREAMS

Roman women threaded them
with a single precious or semi-
precious stone. Pirates were
known to wear just one. Gypsies
and fortune-tellers always seemed
to display a set beneath their
kerchiefs. Larger hoops go with
the more casual look of summer
and resort dressing. Smaller
hoops are more versatile—as
easy at the office as they are
at a beach party. The classics
are done in gold or silver.

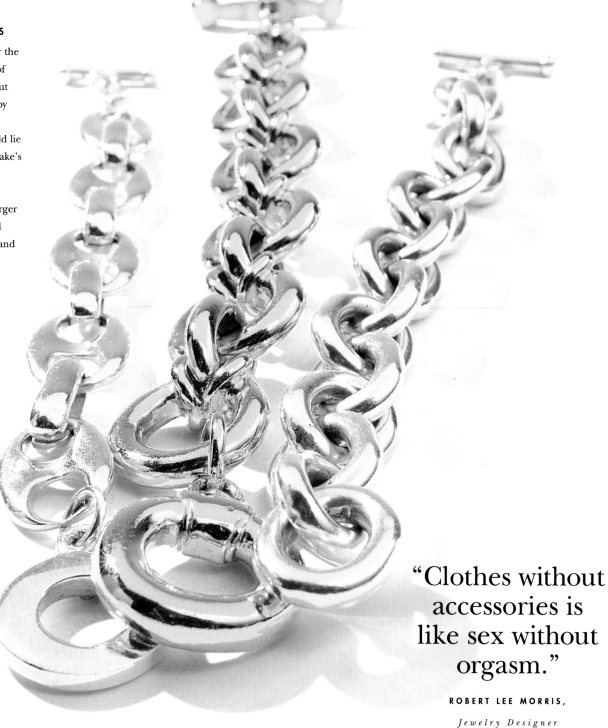

CHAIN CHAIN CHAINS

Worn around the wrist or the neck, they have the feel of chain mail. They are about heft—they're often sold by weight—and design. The links, gold or silver, should lie smooth and feel like a snake's underbelly when you run your finger over them. As with hoop earrings, larger links are more casual and festive—great for drama and fun. Smaller ones are more conservative.

"Clothes without accessories is like sex without orgasm."

ROBERT LEE MORRIS,
Jewelry Designer

D R E S S E S

"GIRLS WEAR DRESSES." THIS, WE ARE TOLD AS YOUNGSTERS, IS WHAT SEPARATES THE SEXES—AND WE BELIEVE IT, UNTIL THE DISCOVERY OF MORE SUBTLE AND MEANINGFUL DIFFERENCES. BUT WE GROW

up and learn that women wear dresses, too. Flowery, church-appropriate affairs that inspire us to look sweet or elegant. Short, sophisticated cocktail shifts that make us feel like smoking even if we don't. Strappy sundresses or comfy wool tunics. A cakelike wedding gown. A casual shirt-dress. Dresses make many different statements and save the time

it takes to mix and match separates. Jewelry can be used to adapt a simple dress to various occasions, and a dress under a jacket can look suitlike yet sexy on its own—perfect for taking day to evening. And as anyone who's seen *The Seven-Year Itch* can attest, dresses are quintessentially feminine, even when you're not standing on a subway grate, your hem aflutter.

DRESS TIPS: A solid-colored dress easier to transform with accessories than a dress covered with a decorative pattern. • Large patterns will make you appear larger than small, subtle patterns.• If you hate your upper arms, steer clear of sleeveless dresses. • If you're wide in the middle, avoid dresses with waistlines.

DRESS

A summer dress is usually not worth spending a lot of money on. It's casual and you don't want to worry about spilling lemonade or perspiring in it.

JEWELRY

Big hoop earrings are summer classics that complement dresses and bathing suits alike.

BARE LEGS

Summer is a time of liberation for your legs. Tanned legs don't need stockings—except at the office. Otherwise, do as the Europeans do, and bag the nylons. Self-tanning lotion can work wonders on skin that rarely sees the sun.

SUMMER DRESSES

Even if you never wear dresses during the rest of the year, come summertime there's nothing better. The easy coolness of a summer dress is irresistible. Nothing to mix and match. No rules as to how long or short it can be. Look for lightweight fabrics that drape well and breathe. Color? Summer is full of it—take your pick. Pattern? Stripes, dots, flowers—anything goes, as long as it's relaxed, loose, and pretty.

BAG

Relaxed summer dresses like unstructured bags. A big one in straw or canvas can hold plenty of summer gear.

SHOES & FEET

Your shoes should be as light and easy as your dress. Try flip-flops or strappy sandals—and perhaps try painting your toenails for extra summer color.

A-Dressed

BIAS DRAMA

Wide straps flatter the shoulders and arms.

Plunging V-neck elongates the neck and torso and emphasizes the collarbone.

If it is not indented at the waist, the sheath can hide a protruding tummy. But it does not flatter large buttocks.

Dresses cut on the bias show off the body through draping, so the material should not be too thick or stiff.

SHEATH

Like the casing for a sword, the sheath is tailored to fit snugly. The style became popular in the 1930's when actresses wore it on-screen. (Gloria Swanson's costume designer, Norman Norell, is credited with its sequined debut.) The sheath enjoyed a resurgence of popularity in the 1950's.

Layer it under a matching jacket for a suit look for day. Remove the jacket and change your accessories for dressier evenings.

"You can say what long dresses, but multitude

SLIP DRESS

By definition, a slip dress is a simple bias-cut dress with a fitted top and no waistline. A common style of the twenties and thirties, it was revived in the 1960's.

 Exposed neckline and skimpiness of straps make this dress difficult to wear for those with heavy upper bodies and arms.

Ballet slippers or strappy sandals complement this delicate dress.

CHEMISE

A straight-cut dress that was inspired by fashions of the 1920's, the chemise was popularized by Norman Norell in 1944. The chemise was reinvented once again in 1957 by Hubert de Givenchy. In 1958, Yves Saint Laurent introduced his similarly styled "trapeze" dress.

Layer a T-shirt under a slip dress for day. Keep it bare and sexy for evening.

Despite its loose fit, this dress works well on pear-shaped bodies. Not recommended for large bustlines.

WRAP DRESS

In 1973, Diane Von Furstenburg introduced cotton-knit print wrap dresses that have since made the style synonymous with her name.

Make sure the overlap is generous enough not to open when you are sitting down.

Defines the waist and flatters any size bustline. Deep V-neck can elongate neck and torso.

A knit or jersey will comfortably hug the body on top and fall nicely below the waist.

you like about they cover a of shins."

WEST

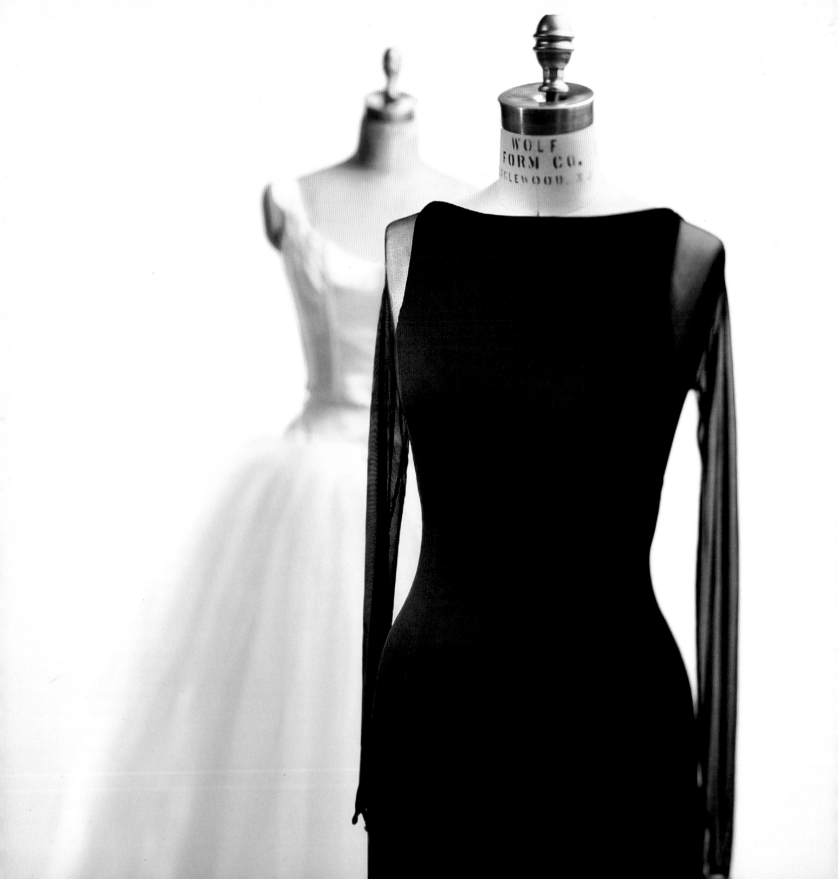

F O R M A L

FORMAL WEAR IS SIMPLE FOR MEN. BLACK TIE, WHITE TIE:

IT'S A PRETTY SPECIFIC UNIFORM. FOR US, THE INVITATIONS MIGHT AS

WELL READ: LOOK CLASSY, ELEGANT, AND JUST PLAIN INCREDIBLE. WE DO THIS

in any number of ways. We glitter and shine. We show our most breathtaking expanse of skin with plunging necklines or swooping backlessness. For dramatic entrances, we tend toward black or white or cream or midnight blue—sometimes red. We dress long in a grand ballgown or an understated sheath. We dress short—a martini glass is, of course, optional. With the occasional exception of white tie, we don't necessarily need a

SIMPLE ELEGANCE

As a rule, formal wear is not something many of us want to shop for often. If that's your situation, then consider buying classic. Elaborate dresses inevitably date quickly. Buy quality and workmanship, and with the proper care, a formal dress should last for years. If the design is spare and the color neutral, it will be easier to transform with accessories and different hair styles. You'll be able to wear one dress to several parties and dazzle differently each time.

CHEAP ELEGANCE

Alternatives to buying new: vintage-clothing stores, rent-a-gown stores, borrow from friends with good taste, take a couture design to a seamstress, rummage through the attics of stylish relatives.

dress—Marlene Dietrich and Catherine Deneuve both dabbled in androgynous black tie. And Yves Saint Laurent made *le smoking* feminine by designing dinner jackets to be worn with collarbones bared. A timeless long black skirt worn with an unforgettable evening jacket or blouse gives us flair and flexibility. Whatever the trappings, our basic aim is the same: glamour, sophistication, elegance, and the feeling that we are exquisite.

"Startled, she pulled her garment closer to her until it covered her again, draping over her body in a most delight-ful way, revealing nothing that was but suggestive of all that had been and that might be again."

CATHLEEN SCHINE, *Rameau's Niece*

ACCESSORIES

These are things you may buy just once in your life, so it's worth investing in high quality and classic design.

ACCESSORIES

Year-round, black is an evening basic no matter what color the outfit is.

SHOES

Satin, velvet, and silk faille dress things up.

JEWELRY

Pearls, rhinestones, or diamonds can be understated or attention-getting. In earrings and necklaces, they brighten the face by adding sparkle.

Formal Accessories. Cinderella had a fairy godmother to thank for her instant formal attire, glass slippers and all. Again, those little details are what make an outfit memorable or mundane. A tiny satin bag to put your lipstick in. Earrings, a necklace perhaps, and maybe a bracelet—leave the anklet at home. Think high, sexy heels—they did wonders for Cinderella.

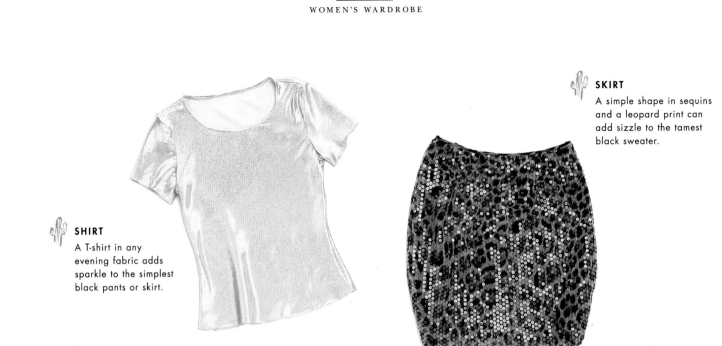

SKIRT
A simple shape in sequins
and a leopard print can
add sizzle to the tamest
black sweater.

SHIRT
A T-shirt in any
evening fabric adds
sparkle to the simplest
black pants or skirt.

INSTANT EVENING

EVENING DRESSING IS ABOUT FUN AND FANCY AND SEDUCTION.

PRACTICALITY IS NOT REQUIRED, OR EVEN DESIRED. WHETHER YOU'RE

ENTERTAINING AT HOME OR GOING OUT ON THE TOWN, IT'S A TIME TO DRESS UP AND

play with the colors, textures, and daring cuts that you would never consider in broad daylight. Slip into a

little black dress, satin jeans, or a sequined T-shirt. Swathe yourself in an iridescent silk wrap. Change into

your party shoes and very sheer stockings. Finish the look with sparkly earrings and make a night of it.

DRESS

Black dresses don't have to be expensive to look like a million. Their elegance often lies in their very simplicity, which often costs less.

HANDBAG

A tiny bag, just large enough for essentials, adds attitude after work.

JEWELRY

Festive earrings take a plain dress into evening.

SHOES

Mules are meant for entertaining, especially in a decorative fabric. They're sexy and as comfortable as a pair of slippers.

THE BLACK DRESS. Inspired by the utilitarian uniforms of maids and shopgirls, Coco Chanel introduced the black dress in the 1920's. At the time, *Vogue* magazine likened its invention to that of the Model T. Rechristened the "cocktail dress" in the 1950's, it was immortalized in the 1961 movie *Breakfast at Tiffany's* by Audrey Hepburn, who accessorized it with sunglasses and a martini. Its color is the foundation for its success. Once symbolic of mourning, black slims the body, frames the face, and hides imperfect tailoring. The embodiment of sophistication, simplicity, versatility, and timelessness, the well-fitting black dress is one of the few pieces you will never give away.

MAKEUP

YOUR FRAGRANCE, YOUR MAKEUP: THEY LIE CLOSER TO YOUR SKIN THAN THE TIGHTEST POSSIBLE TUBE DRESS. WHO ARE YOU, REALLY? OTHER MAMMALS WOULD KNOW YOU BY YOUR SMELL, ALTHOUGH THEIR scenting methods aren't necessarily advisable for humans. Maybe you have chosen a signature perfume, one that permeates your clothes and surroundings, and becomes familiar to those who know you. Or perhaps you treat perfumes like clothes and have built a wardrobe of them to suit your mood, the occasion, or the season. Makeup works much the same way. You may want a natural look by day but desire a little drama at nightfall. Extend your personal style to these most personal habits. Everyone's complexion supports cosmetics differently. Find out what is the least you can get away with. Start by simply evening out your skin tone with a base and some powder. Then build from there to create your own style—a gash of red lipstick on an Ivory Girl face? Be careful not to overdo. Makeup sometimes has the capacity to make us look like female impersonators. Handle it with care.

"I think women see me on the cover of magazines and think I never have a pimple or bags under my eyes. You have to realize that's after two hours of hair and makeup, plus retouching. Even I don't wake up looking like Cindy Crawford."

CINDY CRAWFORD

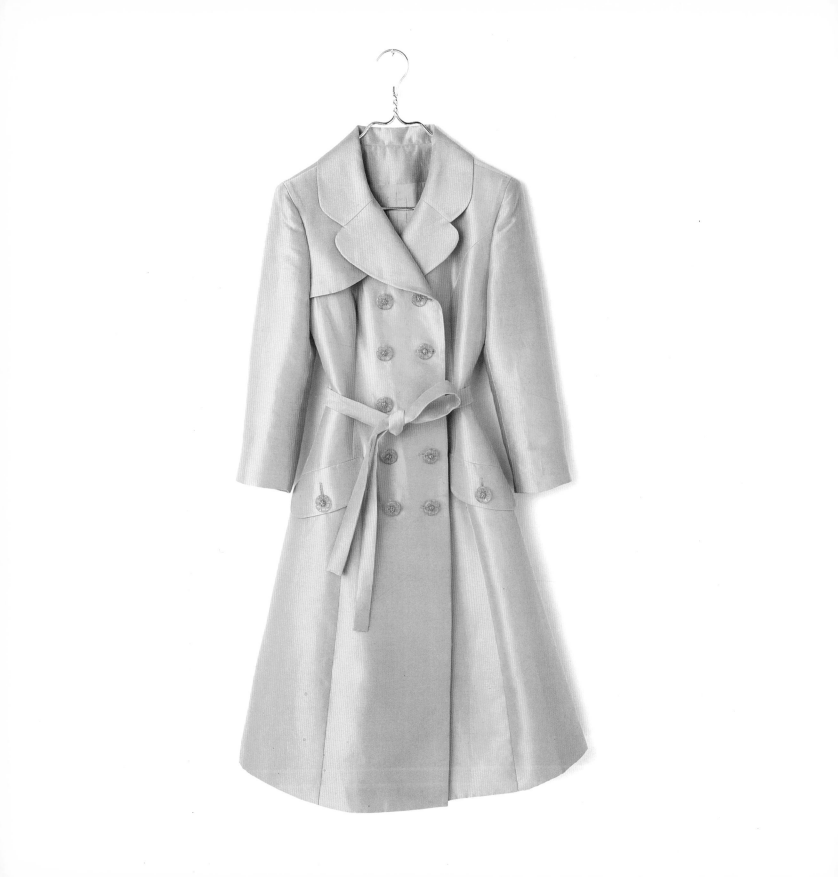

OUTERWEAR

FOR CENTURIES, WE HAVE WORN IT AS PRO-TECTION FROM THE WIND, SNOW, AND RAIN. WOOL WARMED US. RUBBER KEPT US DRY. TODAY MICROFIBERS DO IT ALL, SO WE CAN STAY STYLISHLY WARM AND DRY WITHOUT THE BULK.

Classic Trench. It started life in the nineteenth century as a soldier's coat. Two world wars imprinted the trench on our minds: we saw it in misty railroad stations, saying stoic good-byes. Bogart wore it best. He seemed to fill the familiar khaki shape—its military-style epaulets and separate back yoke—with just the right dose of tragic romance. We can appreciate the nostalgia and practicality of a trench coat without requiring it to be long, beige, heavy, and lined. After all, unlike Captain Roald Amundsen, we're not looking to lead an expedition to the South Pole in it. The staple of office workers of the Western world, those who invest in styles with removable linings may wear it three seasons a year. The trench's classic style also lends itself beautifully to wild reinterpretation. It can be short and sexy, in a featherweight microfiber or a delicate silk gazar. It can shock with color: daring in leopard, dramatic in gold. When it's worn luxuriously long, the trench will cloak all that it covers, so you need not worry about warring hemlines or clashing with what's underneath.

IN THE TRENCHES

In 1856, the British sportswear manufacturer Thomas Burberry came up with the trench coat, a breathable alternative to the rubber-lined mackintosh. Improving upon the shepherd's closely woven linen smocks, he wove wool with cotton in a gabardine twill. The trench was a virtual uniform for nineteenth-century adventurers: Burberry outfitted balloonists, expeditions to the poles, and travelers to India and other British colonies. Lightweight and strong, his trench coat has sold more than a million since 1917.

Barn Coat. Farmers have been wearing this practical roomy jacket for generations. Today, whether made from traditional canvas duck or an updated microfiber, the barn coat has a rugged sensibility that makes it an ideal weekend jacket. Profile? Corduroy collar. Large patch pockets. Loose, boxy fit. Flannel or wool lining. Big buttons.

Leather Jacket. Bikers wear it for protection. Others are content to soak up its attitude without straddling a motorcycle. No matter how refined the design, in black the leather jacket signals rebellion. In brown, it is friendlier and reminiscent of the bomber jackets worn by aviators in both world wars. But either way, leather only gets better with age, so choose a classic cut you'll want to grow old with.

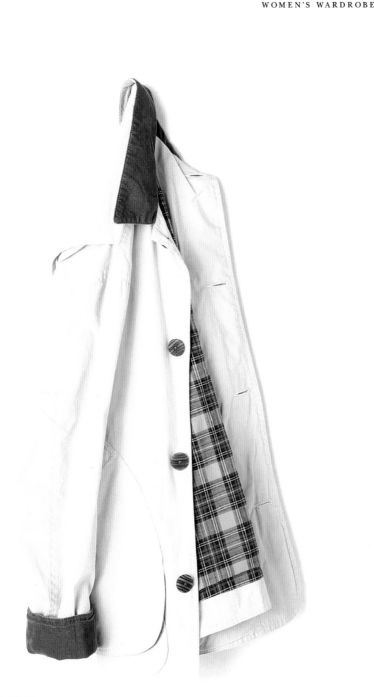

BARN COAT

LEATHER CAR COAT

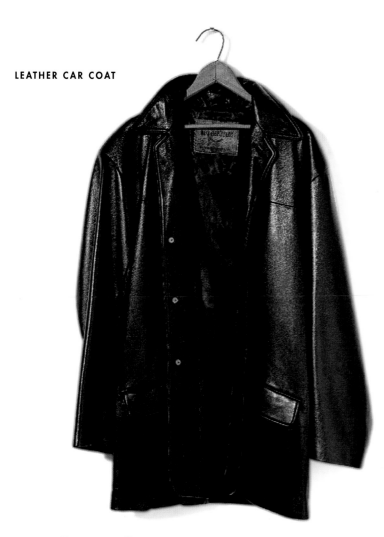

PEA COAT

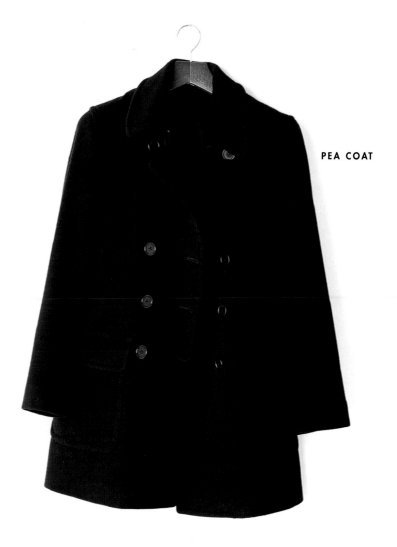

Pea Coat. Like so many great articles of clothing, the pea coat was created for a purpose—it was the heavy wool short coat worn by sailors and fishermen. In the 1920's, Coco Chanel, who loved yachting, was inspired to turn the pea coat into an everyday classic. It has both swing and a kind of maritime crispness. Depending on what you wear it with, it can look sexy or sporty, traditional or contemporary. Identifying traits? It's double-breasted, with big anchor-insignia buttons. Material? Anything from wool to cotton piqué to sharkskin. Color? Navy-black is classic, but anything goes.

DENIM JACKET

The denim jacket or jean jacket also known as a Levi jacket due to Levi's classic design. It is a Western basic piece of functional clothing that now transcends any region or work-related origins.

Blue denim is the classic fabric, though other colors and materials—white, black, velvet, leather—are also available. "Stone-washed" refers to the way the denim is washed with enzymes to "naturally" pre-fade and soften the fabric before it is fashioned into clothes. "Acid-washed" is a process of washing denim with acid to impart a textured fade.

The jean jacket can be worn by a wide range of body types, but it is short, and affords little coverage to large behinds.

"Bar tacks" are short lines of repeated stitching at stress points where two pieces of fabric are joined.

Classic detailing includes a gusset, a V-shaped panel of fabric just below the flap pockets. Originally, the jackets may have been pieced together from discarded scraps of denim, hence all the seams. Though the gusset does allow for a slimmer fit through the torso, it endures today more for style than for fit.

Metal shank buttons are the traditional closures for this jacket. They are riveted by machine and are so sturdy that the jacket will rot before the buttons will fall off. Buttons should be stainless steel to prevent rusting and staining.

Elemental Defense

SWING

A popular adaptation of the 1950's "topper," the swing coat is a generously cut coat that flares from the shoulders.

A good shape for all body types. Keep lines of underlying outfit simple and clean, with no shirttails or suit jackets protruding below the hem of the coat.

Raglan sleeves are joined to the bodice of the coat on a diagonal line from the neck to the underarm. This cut was originated by Lord Raglan, a British military officer who wanted to afford greater mobility of the arms and body to the troops he commanded during the Crimean War.

PRINCESS

The princess line is distinguished by its nipped waist, which is achieved without a horizontal waist seam. This style first achieved popularity in the mid-nineteenth century and has reappeared at various hem lengths during the thirties, fifties, and sixties.

Tweed has a neutral quality that makes it harmonize well with a wide range of other colors.

BALMACAAN

A loose-fitting, calf-length tweed overcoat that was originally worn by men in the nineteenth century. The balmacaan was adapted for women in the early part of the twentieth century.

Rounded sleeves with diagonal seams draw the eye toward the torso, minimizing broad shoulders.

Buttons extend from waist to collar only. Skirt is unfastened for simplicity and easy leg movement.

Fitted lines can give shape to a range of body types but large, square figures may look pinched in this coat.

MICROFIBER

THE TERM HAS NONE OF THE ROMANCE OF, SAY, CASHMERE OR SILK. ITS CONNOTATIONS ARE MORE RUGGED, MORE ABOUT MODERN TECHNOLOGY THAN ANCIENT TRADE ROUTES. THIS IS A FABRIC TO BE RECKONED

with. Microfibers are exceptionally thin—four times thinner than wool and twice as thin as the finest silk—making them incredibly lightweight, but they are also very durable. They can be extremely soft—perfect not only for rugged outerwear and athletic clothing but also for more refined, urban designs. The cut and color are what determine where you'll be wearing it—on a rafting trip down the Grand Canyon or at the opening of La Scala. Like polyester

ISOTONER GLOVES
They first appeared in the early 1970's and are known by their trademark chevron. The most ubiquitous model is made from a blend of Lycra spandex and silky nylon. While the linings vary, a Teflon coating helps Isotoners weather the toughest rain and stains. Inner palm strips supply grip, and lightweight stretch fabric gives them flexibility. Designed for a snug fit—perfect for nimble maneuvering.

blends, microfibers don't wrinkle, they're easy to care for, and they're seasonless, which makes them great traveling companions. Other advantages? Microfibers tend to be extremely fluid and silky, allowing excellent drapability. The density of the filaments in each strand of yarn enables designers to create remarkably vivid patterns and rich, lasting colors. So what if the name sounds like you're buying a spacesuit? Microfibers epitomize modern technology at its best.

166

Weather-resistant red microfiber on one side, urban black alpaca on the other. There aren't many places this coat can't go.

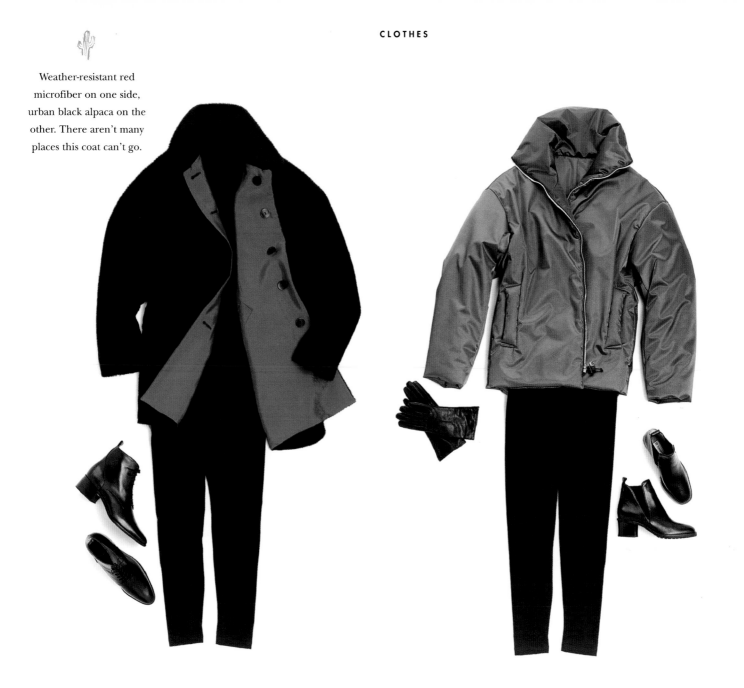

Reversible Coat. The value of a reversible coat lies not only in its versatility but in the flash of color or rich texture it reveals with a turn of the collar or a glimpse of the lining.

Microfiber Ski Jacket. A classic parka in a subtly colored microfiber is warming on the slopes. Teamed with handsome black accessories, it becomes dressier for *après-ski* evenings out.

STORMY WEATHER

UNLESS YOU'RE INTO BEING A DOMINATRIX, BOOTS ARE MOSTLY ABOUT PROTECTING YOUR FEET IN BAD WEATHER. THEY SHOULD BE WATER-RESISTANT AND ABLE TO STAND UP TO SNOW, RAIN, AND salt. Soles should be thick and slip-proof. Whether sleek or bulky, boots should keep you warm, or at least be able to accommodate fuzzy innersoles. They should have an air of invincibility about them.

"I'm singin' in the rain, just singin' in the rain, what a glorious feeling, I'm happy, again…just singin', and dancin', in the rain."

GENE KELLY in *Singin' in the Rain*

WORK BOOTS. Sturdy and slip-proof, these boots have made their way from construction sites into many fashionable closets. Their Vibram soles—the gripping, rubbery material that takes ounces off boots—were invented by the Italian mountaineer Vitale Bramani in 1938 in response to seeing fellow climbers slip to their deaths. They have more recently been used on street shoes. **LEATHER BOOTS.** When high, they're dressy and look great with skirts. When short, they have more attitude and work well with pants. With the proper care, quality leather boots can last for years. **RUBBER BOOTS.** The British call them "wellies," after the Duke of Wellington, who shod his soldiers in sturdy rubber boots and saw victory on the muddy battlefields at Waterloo. Designed to make water irrelevant, they'll keep your feet dry, but you must take care of keeping your feet warm. Try a thick wool sock over a thin silk or capilene liner. Or cushion the insides with a sheepskin innersole. Whether they're cut high or low, the soles should be slip-proof.

The long, boxy, double-breasted cut of a traditional camelhair coat can overwhelm a short or petite body, and its pale color is not slimming.

If you already own a long, dark coat, a camelhair one is a good alternative.

CAMEL HAIR
IN THE LATE 1800'S,
POLO PLAYERS WORE A LONG, ROBELIKE COAT MADE OF CAMEL HAIR WHILE RESTING between periods. The comfort and warmth of this garment, combined with polo's prestige as an elegant rich man's sport, turned the camelhair polo coat into a classic in the 1920's. Originally woven entirely from the underbelly hair of the Bactrian camel, camelhair was an expensive and delicate fabric. By the end of the 1920's, it had been mixed with lambswool to make a warmer and more durable coat. At the same time, an even cheaper alternative, camelhair cloth, was being manufactured from a blend of wool and cashmere dyed a yellowish beige.

"The fifty-three-year-old Mr. Burger runs the coat room alone in winter months but has a staff of four helping him now in his time of need. And during the recent snow storms, when galoshes and other paraphernalia clogged his checking system, he was forced to call in emergency relief. He closely monitors weather reports for approaching storms. After the New York Philharmonic Orchestra completed its performance Thursday night, Mr. Burger's coat room kicked out 110 coats in ten minutes, or one coat every 5.45 seconds."

WILLIAM E. GEIST

"Coat Checking at the Philharmonic"

Camelhair coats show dirt more quickly than darker coats.

SCARVES

A scarf can pack a big punch, giving new life to your existing wardrobe. Distillations of color, pattern, and texture, they can hide flaws or attract attention. In cotton, a scarf can wipe the sweat off a cowboy's brow. In silk, it can dress up a cast by serving as a sling, as Grace Kelly proved. In wool, it can warm you. Scarves can replace a necklace and frame your face. Tied long and loose, it can create a slimming silhouette. Rolled, it can belt your pants. Cut large and tied around the waist, it can cover a skimpy bikini bottom. The simplest use for a scarf is to stuff one into an empty blazer pocket and wait. An opportunity is bound to come up sooner or later. If nothing else, it will add the unexpected.

Silk organza, crinkled or with a satin trim, provides a richness usually reserved for nighttime. It can be a mark of personal style if mixed with daytime pieces.

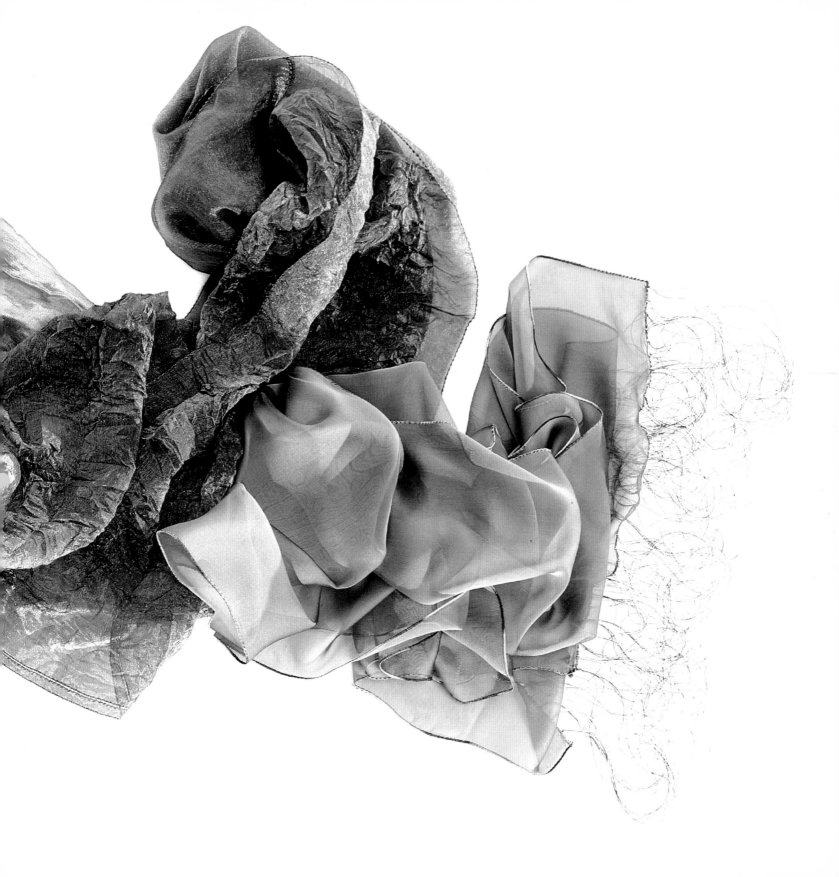

THE BLACK COAT
THE MOST VERSATILE OF
COATS, IT LOOKS AS APPROPRIATE

covering a business suit as it does an evening dress. Length? It should be long, so that it covers any dress or skirt you might decide to put under it. Style? It can be straight, fitted, or have a little swing— whatever works best for your body and style, as you will have this coat for years. Fabric? The best, especially if it's going to be your one good coat. A wool-and-cashmere blend has beautiful drape, a luxurious softness, and wears well. Changing the personality of a black coat can be as easy as wrapping a scarf around your neck.

Hats. Sometimes we wear them for style. The glorious summer wedding hat of finely woven straw, silk, and flowers. The pillbox, cloche, and boater—even the names are evocative. Sometimes, even in this day and age, we wear them as a sign of propriety—in churches, or at horse races. But mostly we wear them for protection, from the sun or from the cold. Then they conform to guidelines of size or fabric, with large brims or warm fabrics.

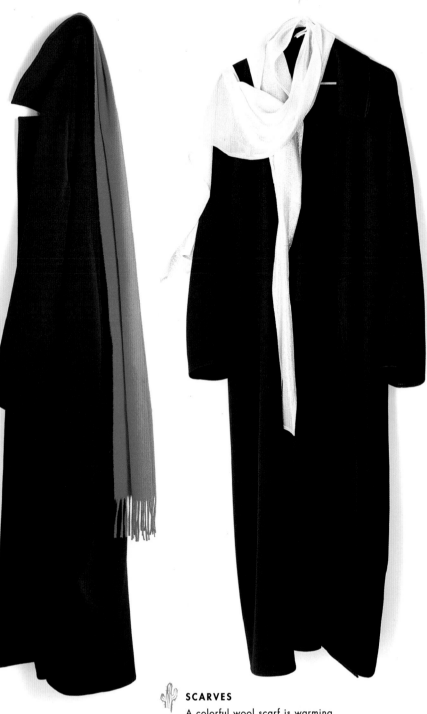

SCARVES
A colorful wool scarf is warming. In fragile metallic silk, a scarf becomes a luxury reserved for dressy nights.

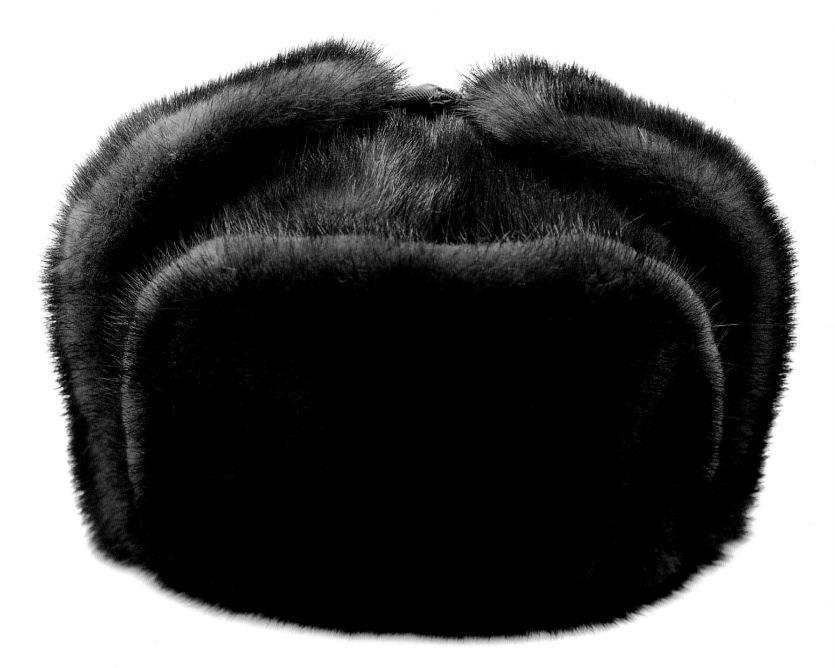

TRAPPER'S HAT

With fuzzy earflaps and a brim that can be flipped up or down, this is the hardiest of hats. A descendant of the beaver-fur hat that has been worn since the seventeenth century, it now comes in a variety of furs—mink, sable, otter, muskrat, and raccoon, to name a few—as well as in more animal-friendly materials like synthetic fleece.

CHECK IT OUT

IF ALL YOUR CLOTHES WERE LOST BY AIRLINE PERSONNEL

TOMORROW, WHAT WOULD YOU REPLACE FIRST? IN THE END, THE

ASSESSMENT IS SIMPLE. WHAT DO YOU HAVE? WHAT DO YOU NEED? IT'S NOT ABOUT

buying more; it's about buying smart. Your wardrobe is valuable for the pieces that make it personal—the

vintage dress you got at a summer tag sale, your mother's silk scarves, your boyfriend's leather jacket.

Maximize it with a few well-chosen new basics. You probably have more than you think—you just need

to look at things in a different light. Dejunk, and everything else will shine. Add a short black skirt,

a sweater set, a classic bag—all of a sudden, you've got ten new outfits. Best of all, if you've chosen

pieces that you feel great in, you'll wear every single one of them over and over again, year after year.

"Personal style is being able to say no. No one who
we think of as a woman of great personal style was a fashion
victim. They are women who are very aware of their
bodies, their features, and what works."

MICHAEL KORS

Survival Gear

UNDERPANTS
- ❏ nude, black, and white (three in each color)

BRAS
- ❏ strapless and with straps: nude, black, and white (three in each color)
- ❏ athletic bra

PANTYHOSE OR STOCKINGS
- ❏ Sheer nude and black; opaque black and navy. (enough to count on a run a day) Note: If you wear stockings, you will need at least two garter belts

SOCKS
- ❏ white athletic socks
- ❏ neutral knee-highs to wear under pants (the heavier the weight, the more casual the look)

SHOES
- ❏ walking shoes or athletic shoes
- ❏ black pumps: leather for day, silk or satin for evening
- ❏ flats
- ❏ sandals
- ❏ boots: leather and waterproof

T-SHIRTS
- ❏ white (big for sleeping in, small to wear with a suit)

SHIRTS
- ❏ white cotton for day; silk for evening

TURTLENECKS
- ❏ light cotton
- ❏ woolen or cashmere

SWEATERS
- ❏ lightweight to wear under suit jackets or over summer dresses
- ❏ heavy for cold weather, exercising, and lounging (black works best for matching with tops by day and for exercising)
- ❏ sweatshirt

PANTS
- ❏ leggings
- ❏ jeans: white, blue, and black
- ❏ khakis
- ❏ black slacks
- ❏ evening pants
- ❏ shorts or skort for summer

BLAZER SUIT
- ❏ pantsuit
- ❏ skirt suit (black or beige if it's the only one)

SKIRTS
- ❏ black

DRESSES
- ❏ Something simple (black if it's the only one) that can be dressed up or look or look respectful at a funeral
- ❏ a summer dress

OUTERWEAR
- ❏ long coat (black if it's also your evening coat)
- ❏ evening coat
- ❏ cashmere or wool wrap
- ❏ raincoat
- ❏ jacket

JEWELRY
- ❏ earrings: pearl, gold, silver, diamond
- ❏ necklace: pearls, gold, silver
- ❏ bracelet: gold, silver (look for good fakes)

BELT
- ❏ black or brown

SCARF
- ❏ square: silk
- ❏ oblong: silk or wool
- ❏ cotton pareo

VEST
- ❏ functional (Synchilla or down)
- ❏ decorative

BAG
- ❏ medium shoulder bag for day
- ❏ small black beaded or fabric bag for evening
- ❏ leather or canvas tote for everything

SUNGLASSES

BATHROBE

PERFUME

MAKEUP

HATS
- ❏ summer
- ❏ winter

GLOVES
- ❏ black leather

WATCH
- ❏ work
- ❏ sport

first aid. So now you have the

wardrobe of your dreams, but how to keep it looking new? What do those cryptic care label symbols mean? Where to stash those extra pairs of shoes? How to beautifully camouflage a double chin? How to remove those stubborn stains? What to wear for that television interview? How not to offend in a foreign country? The information here should help.

WASH & DRY

WASHING

Get ahead of the laundry-sorting dilemma by hanging mesh laundry bags in the closet or bathroom for whites, colors, darks, and garments that must be dry-cleaned or washed by hand. • Be sure to unbutton garments before putting them in the washing machine. • Wash dark colors, anything with lettering, and fleece garments inside out. • Anything elastic, and undergarments of all kinds, should be hang-dried or dried in a machine on a no-heat setting. • Hang-drying is better than machine-drying for preserving the richness of dark-colored clothes. • Old-fashioned wooden drying racks save energy, keep your house cooler than a machine dryer, and prolong the life of clothes. • Don't overcrowd clothes in the washer or dryer: they won't get clean, and will wrinkle excessively. Always remove clothes promptly from the washer and dryer. • If clothes are forgotten in the wash overnight and smell musty, rewash them immediately (with bleach if the clothes can tolerate it) to prevent mildew.

WHEN TRAVELING

Most hotels can do laundry in a matter of hours, but the charges can leave you feeling wrung out. Try hanging especially wrinkled clothing in a bathroom made steamy by letting the hot water in the shower run. Socks and underwear can be washed in your bathroom sink using shampoo—just rinse well.

BLEACH

Use to whiten white fabrics. Check the care label on colored and synthetic fabrics before washing with bleach. • Never bleach garments containing silk, wool, or other specialty hair fibers. Spandex, leathers, and some nylons must not be bleached. • Always use bleach with a detergent, in the hottest water allowed for that item of clothing.

DECIPHERING CARE LABELS

When washing a garment for the first time, be sure to check its care label. Some labels do list all the satisfactory care methods, but a manufacturer or importer is required only to list one method of safe care, even if other safe methods exist. If a garment has a care label with washing instructions, it may or may not be dry-cleanable, and vice versa. If a garment is marked "Dry-Clean," as opposed to "Dry-Clean Only," and it is constructed simply, you may have the option of laundering it after you have tested for color-fastness. ("Wash in cold water and hang to dry" is a good rule of thumb.)

"Never relinquish clothing to a hotel valet without first specifically telling him you want it back."

FRAN LEBOWITZ

COMMON CARE LABEL SYMBOLS

WASHING

Do not wash.

MACHINE-WASH in lukewarm water (up to 40° C/100° F) at a gentle setting (reduced agitation).

MACHINE-WASH in warm water (up to 50° C/120° F) at a normal setting.

HAND-WASH gently in lukewarm water.

MACHINE-WASH in warm water at a gentle setting (reduced agitation).

MACHINE-WASH in hot water (not exceeding 70° C/160° F) at a normal setting.

1 MACHINE: very hot (85° C/185° F) to boil, maximum wash; HAND-WASH: hand hot (48° C/119° F) or boil; spin or wring; white cotton and linen articles without special finishes.

2 MACHINE: hot (60° C/140° F), medium wash; HAND-WASH: hand hot (48° C/119° F); spin or wring; cotton, linen, and rayon articles without special finishes where colors are fast to 60° C/140° F.

3 MACHINE: hot (48° C/119° F), medium wash; HAND-WASH: hand hot (48° C/119° F); cold rinse, short spin or drip dry; white nylon, white polyester/cotton mixtures.

4 MACHINE: hand hot (48° C/119° F), medium wash; HAND-WASH: hand hot (48° C/119° F); cold rinse, short spin or drip dry; colored rayon, polyester, cotton, and nylon articles with special finishes, acrylic/cotton mixtures, colored polyester/cotton mixtures.

5 MACHINE: warm (40° C/104° F), medium wash; HAND-WASH: warm (40° C/104° F); spin or wring; cotton, linen, and rayon articles where colors are fast to 40° C/104° F., but not at 60° C/140° F.

6 MACHINE: warm (40° C/104° F), minimum wash; HAND-WASH: warm (40° C/104° F); cold rinse, short spin; do not wring; acrylics, acetate, and triacetate, including mixtures with wool, polyester/wool blends.

7 MACHINE: warm (40° C/104° F), minimum wash; HAND-WASH: warm (40° C/104° F); spin; do not wring; wool, including blankets and wool mixtures with cotton or rayon; silk.

8 HAND-WASH ONLY: warm (40° C/104° F), warm rinse; hand-hot final rinse; drip dry; washable pleated garments containing acrylics, nylon, polyester or triacetate, glass-fiber fabrics.

DRYING

Dry flat after removing excess water.

Drip-dry—hang soaking wet.

Hang to dry after removing excess water.

Tumble dry at low temperature and remove article from machine as soon as it is dry. Avoid overdrying.

Tumble dry at medium to high temperature and remove article from machine as soon as it is dry. Avoid overdrying.

IRONING

Do not iron or press.

Iron at low temperature (up to 110° C/230°F).

Iron at medium temperature (up to 150°C, 300°F). For example, this is recommended for nylon and polyester.

Cool (120°C/248°F).

Warm (160°C/320°F).

Hot (210°C/410°F).

Iron at high temprature (up to 200°C/ 390°F).

DRY-CLEANING

Do not dry-clean.

Dry-clean.

A Dry-clean with any solvent.

P Use any solvent except trichlorethylene.

P Underline indicates "sensitive." Reduce cycle and/or heat.

Dry-clean; tumble at a low, safe temperature.

F Use petroleum or fluorocarbon only.

F Underline indicates "sensitive." Reduce cycle and/or heat.

BLEACHING

Do not use chlorine bleach.

Use chlorine bleach with care. Follow package directions.

PILLING

Pilling is caused by abrasion during regular use; it often develops on elbows, on the seat of skirts, and in areas rubbed by a bag or briefcase. • Unfortunately, it's impossible to tell when buying a sweater or other garment whether it's going to pill. Good-quality clothes should be made of superior fibers that are less likely to pill; soft, fuzzy surfaces are more susceptible than others. • To remove pills, manually pick them off (very time-consuming) or invest in a small hand-held electric shaver specifically designed for depilling.

CLEANING CASHMERE

Cashmere can be washed in Woolite and cold water, rolled in a towel to remove excess moisture, and then spread flat to dry on a towel. Cashmere can also be dry-cleaned, even if it is not labeled as such.

CLEANING SILK

Generally, silk scarves should be dry-cleaned. If it is washed, the consistency of the silk may be altered, depending on the finishing treatment used to give it sheen, and colors may run. Chlorine bleach damages silk and causes it to yellow. • Prewash treatments have made more silks washable. Silks that are often safe to wash include raw silk, China silk, India silk, crêpe de Chine, pongee, shantung, tussah, doupion, and jacquard weaves. Roll in a towel to remove excess moisture, then hang to dry on a padded hanger. Machine-drying silk will cause it to disintegrate. Instead, iron it on a low setting while slightly damp.

CLEANING WOOL

Chlorine bleach will damage wool fibers. Hand-wash woolens in Woolite. Roll them in a towel to remove excess moisture, then lay them out to dry on a flat surface away from direct heat or sunlight. Steaming woolens can refresh them.

HOW TO CHECK FOR COLORFASTNESS

To check for color-bleeding on dyed fabrics, run this simple test. Find an inconspicuous area on the garment (inside hems are good places), wet the fabric, and blot it with a white cloth. Allow it to air-dry to determine if the dye and sizing are disturbed. If any color bleeds onto cloth, or the fabric seems damaged once it's dry, dry-clean only.

DRY-CLEANING

Always dry-clean all pieces of an outfit of the same material at the same time, even if one part is not dirty. • Be sure to check with your dry cleaner before cleaning precious items (getting your money back for a ruined garment is something you can't count on). Items known to be troublesome include sequins, metallics, decorative buttons, and permanent pleats. • Recycle hangers by returning them to your dry cleaner.

IF YOUR CLOTHES COME BACK SHINING

Dry-cleaning doesn't make clothes shine, but when clothes are pressed incorrectly at too high a heat, the cloth becomes glazed. Some fabrics, such as dark gabardines, can become glazed by wear alone (especially at stress points such as the seat and the elbows). The only way to correct the situation is for an expert to work over the garment with very fine grade sandpaper to restore a more matte appearance. Unfortunately, this remedy is only temporary.

SEQUINED AND BEADED GARMENTS

If sequins or beads are glued onto a garment, it must be dry-cleaned. The garment should first be tested to ensure that beads don't come loose and that the bead color doesn't run, and a net should be used in dry-cleaning. If the sequins or beads are sewn onto a washable fabric, it can be hand-washed in cool water and Woolite.

CLEANING METALLIC FABRICS

Fabrics containing metallic thread should be cleaned with petroleum or fluorocarbons rather than standard dry-cleaning fluid.

CLEANING ACETATE

All-acetate fabrics require dry-cleaning. Some blends are hand-washable in cool water and Woolite. Avoid soaking, as acetate is not colorfast. Drip-dry and press while still damp with a cool iron. Do not use steam.

CLEANING ACRYLIC

Wrinkle-free and fast-drying, acrylics can be washed by hand or machine in cool or warm water with a mild detergent. If machine washing is recommended, use a gentle setting. Iron with moderate heat if necessary.

CLEANING NYLON

Wash separately or with like colors in a mild detergent. Wash by hand or machine using a gentle cycle. Do not dry white nylon in the sun, as yellowing could occur. White lingerie should be washed separately; nylon is a dye magnet, even from other light-colored fabrics, and can easily become grey and dingy. Nylon whiteners are available at most supermarkets.

CLEANING RAYON

Also known as viscose, rayon is fragile. Whether it is washable depends upon the finish and construction, and on the other fibers it may be blended with. Do not use chlorine bleach. Rayon can be stained by water spots.

CLEANING VELVET

Velvet must be dry-cleaned unless otherwise indicated. Steaming and brushing with a soft brush can keep velvet fresh between wearings. Steaming helps fluff pile that has been crushed. Never iron velvet. Hang velvet garments on padded hangers; don't fold them.

"Lily Wynton wore, just as she should have, black satin and sables, and long white gloves were wrinkled luxuriously about her wrists. But there were delicate streaks of grime in the folds of the gloves, and down the shining length of her gown there were small, irregularly shaped dull patches; bits of food or drops of drink, or perhaps both, sometime must have slipped their carriers and found brief sanctuary there."

DOROTHY PARKER,
"Glory in the Daytime"

STAINS

Success in stain removal, professionally or at home, is determined by the degree to which dyes and sizings (the finish applied to fabric in manufacture) are colorfast when wet. Do not try to remove a stain yourself if the care label says "Dry-Clean Only" or if the garment is not colorfast. Because dyes and sizings tend to discolor with moisture, attempting to remove stains with water is not recommended without first testing the garment for colorfastness. Removal of a concentrated food or beverage stain is difficult. Try to absorb stains before they set by using the tip of a white paper towel to soak up excess liquid. Never scrub or press; doing so could ruin the fabric's texture. To assist in the professional removal of stains from nonwashable fabrics, take a stained garment promptly to the dry cleaner, and tell him what caused the stain. It is sometimes possible to restore areas damaged by attempts to remove stains at home. The recommendations below are mostly for washable fabrics. When in doubt, take the stained garment to the dry cleaner for professional attention.

PROTEIN STAIN (WATER-BORNE)

These stains include blood, baby formula, deodorant, diaper stains, egg, meat juices, perspiration, and urine. Apply detergent to stain and soak in cool water; then launder. If stain persists, wash again in an appropriate bleach and the hottest water the garment can withstand. Enzyme presoaks can also help.

COMBINATION STAINS

These stains include chocolate, gravy, ice cream, and milk. First apply a dry-cleaning solvent, then air dry. Treat the protein component of the stain by applying liquid detergent and rinsing with cool water. Then use a prewash stain remover. Wash with detergent in the hottest water the garment can withstand. If stain persists, wash again with detergent and appropriate bleach.

TANNIN

These stains result from coffee, ketchup, tea, wine, vegetables, soft drinks, fruit juice, and mustard. Soak the garment in cool water. Put detergent and white vinegar on the stain, flush with water, and allow to air dry. If stain persists, wash with detergent and appropriate bleach in the hottest water the garment can withstand.

CHEWING GUM AND TAPE

Carefully scrape as much as possible without damaging the fabric (harden it first with an ice cube and it will come off more easily), apply dry-cleaning solvent, and peel off the stain; then launder. If stain persists, try using a grease solvent.

GREASE

Typical grease stains are caused by oils, butter, margarine, crayon, mayonnaise, medicines, candle wax, and oil-based cosmetics. Dabbing on talc right away (allow to sit at least a half hour) will help lift the stain. Brush off talc, apply a stain remover, and wash in the hottest water the garment can withstand. For stubborn stains on synthetic fabrics, your dry cleaner can usually handle the problem.

FINGERNAIL POLISH

Apply banana oil (amyl acetate) directly to stain. Flush with more banana oil, then follow the garment's care label. Don't use nail-polish remover on acetate.

GRASS

If stain is fresh, try an enzyme presoak, a heavy-duty detergent, or white vinegar on washable fabrics; then rinse. If the stain has already set, try a cleaning fluid. For nonwashables, use a dry-cleaning fluid or, if colorfast, try rubbing alcohol.

TYPEWRITER CORRECTION FLUID AND TAR

Use banana oil (amyl acetate) or dry-cleaning fluid on washable fabrics. With tar, chip off the excess and sponge (the inside first) using turpentine.

INK

For washable fabrics, try a laundry presoak, rubbing alcohol, lemon juice, or dry-cleaning fluid; then rinse with cool water. Take nonwashables to the dry cleaner.

LIPSTICK

For washable fabrics, first use dry-cleaning fluid, then soap and water.

MILDEW

Treat as soon as possible. Wash washables thoroughly and dry them in the sun. If stain persists, try chlorine bleach (if care label allows). Take nonwashables to the dry cleaner.

PAINT

Read the paint-can label carefully. If the paint is water-based, use soap and water on washables if the paint is still wet. If the paint is dry, or it's oil-based, try turpentine. Take nonwashables to the dry cleaner.

PERSPIRATION

The longer it remains, the harder it is to remove. Silk is especially vulnerable. Dry cleaning removes only the oily component of the stain; an expert should administer detergent with a little added water, bleach, or acid or alkaline solutions. If you're concerned about damaging a garment, sew in protective underarm shields.

PERFUMES, TOILETRIES, AND ALCOHOLIC BEVERAGES

Perfume, hair spray, and other toiletries often contain alcohol, which can cause some dyes on silk to bleed or change color. Allow these products to dry on the body before you dress. Remove stains caused by alcoholic beverages as soon as possible. Some silk dyes, especially blue and green, are sensitive to alkalis found in facial soaps, shampoos, detergents, and toothpastes. If color loss results from contact with these products, bring the garment to your dry cleaner to discuss restoration.

SCORCHING

Severe scorch marks are permanent. If a scorch mark is minor and the garment is washable, wash shirt in a solution of three-percent hydrogen peroxide.

YELLOWING AND BROWN "AGE" STAINS

Launder washables with bleach, if it is safe for the fabric, or try a rust remover. If stain is small, try dry-cleaning fluid on nonwashables. Otherwise take it to the dry cleaner. Do not store whites in dry-cleaner bags—it will promote yellowing.

IRONING

To avoid back pain, adjust your ironing board to the best height for you. • Use a plant mister to dampen the clothes you intend to steam-iron. A little spray starch can work wonders for cotton shirts. • Iron items that require a cooler iron, such as silk, first. • Iron nonshowing parts of garment (underside of cuffs and collar) first. • Pull fabric taut as you go along; it makes for smoother ironing. • Iron around buttons, not on top of them.

REPAIRS
SEWING ON BUTTONS

They will break. They will come off when you are late for dinner, or on the road. So it's a good idea to know how to sew a button back on. Most quality clothes come with extra buttons, so don't panic. • Use a piece of thread one to two feet long that matches the thread of the other buttons, and thread the needle. (When attempting to push the thread through the eye of the needle, some people find it easier to move the needle toward the thread.) • Pull both ends of the thread even and tie them in a knot. Use double-thread thickness for strength. • Start by sewing underneath the fabric, pushing the needle up through the button. • With each stitch, cross to the button hole diagonally opposite (for a four-hole button). Two or three times through should do the trick. • Then poke the needle through the fabric without going through the buttonhole, and wind the thread around the stitches under the button several times before pushing it through once more to the back. This will reinforce the button. Finally, knot on the inside.

> "You may turn into an archangel, a fool, or a criminal—no one will see it. But when a button is missing—everyone sees that."
>
> **ERICH MARIA REMARQUE**

FIXING HEMS

Even if you've had the foresight to stash some safety pins in your change purse in case of emergency, one day you are going to have to fix a hem. (Most dry cleaners that do alterations can also fix it.) • Pin up hem to correct height. • Thread needle (see directions above) and knot thread. Use a single thread if you're working with delicate fabric. • Working from the inside of the garment, start by pushing the needle through the edge of the hem. Then sew it to the desired height by catching just a few threads. Check the outer side of the garment to make sure you didn't make too visible a stitch. • Then return to edge of the hem. • Repeat this process until finished, then knot on the inside.

Accessories

GENERAL CARE

If there is a grease stain on polished leather, first blot with a dry cloth; if the stain persists, try lifting it with a little white vinegar.

SHOES
GETTING FITTED

Feet never shrink, so don't buy tight shoes. Lined shoes are even less likely to give than unlined ones. Buy shoes at the end of the day, when your feet have naturally swelled to their full size (which can be up to a ten-percent increase). Also keep in mind that feet can widen with age, pregnancy, or inactivity (sitting on a plane or at a desk). • Try on shoes on both feet; most of us have feet that vary slightly in width or length. There should be a thumb's width between the end of the shoe and the longest toe. • Be sure that you're trying on shoes with the kind of socks or stockings that you'll be wearing with them. • Heels should fit snugly. If your heels are narrow, affix a heel liner.

BUYING NOTES

Polished leather is the most practical material for dress shoes; it resists dirt, and a good polishing job can compensate for a lot of minor scratches. • Oiled natural finishes may nick and scratch, but they are more durable than polished finishes, and ideal for work boots. • Patent leather resists dirt but can easily dry out and crack. • Suede can naturally repel some dirt and water but still soils easily; don't get caught in the rain. Never wear suede on a day when salt or sand has been applied to sidewalks and roads. • Exotic leathers, such as lizard, ostrich, and alligator, are many times more durable than leather; reptile skins can be ten times tougher. • Athletic shoes should always be bought with a particular sport in mind—tennis requires more support for lateral movement, while running demands more heel cushioning. Studies have found that high-top aerobic and basketball shoes really don't offer superior ankle support; what seems to be more important is supportive cushioning. For the best protection, replace shoes as soon as they begin to run down.

QUALITY POINTS

Heels made of layered leather, sometimes with a rubber insert at the outside edge. • Smooth, even, and close stitching throughout. • A soft lining with inverted seams. • A smooth insole. • A noticeable curve in the last. • No traces of glue. • Shoes that bend freely when flexed, then resume their shape.

HEEL HEIGHT

Elevated heels should be worn judiciously, as they can cause foot, calf, hip, and back pain. If you plan on wearing heels often, vary heel heights throughout the day—i.e., wear flatter shoes for commuting. • Consider putting padded inner soles in shoes, especially under the balls of the feet. (Thin ones are available for dress shoes.) The cushioning will help prevent the foot from sliding forward in the shoe and cramping toes painfully. • From a medical standpoint, the safest heel height is one inch or less.

FOOT CRAMPS

To relieve foot cramping, which is usually caused by standing for long periods of time, slowly clench and unclench the toes to help loosen the tightened muscles. Also try loosening your laces; your feet may have swelled since you tied the laces that morning.

> "High-heeled, thin-strapped sandals have been known to drive some men to frenzies, but they're often men who want to tie you up so be careful."
>
> CYNTHIA HEIMEL,
> *Sex Tips for Girls*

SHOE CARE

PROMOTING SHOE LONGEVITY

Leather breathes, and it needs a day or two after being worn to dry out. The same shoes should not be worn day after day. Alternate shoes if you want them to last. Polishing leather helps to keep it from cracking; shoe trees maintain shape. Disposable inner soles cushion each step and absorb odor and sweat. Reheel and resole when necessary. Avoid wearing down heels by having taps placed on them immediately after buying (this costs a lot less than having to fix the heels later).

THE PERFECT SHINE (POLISHED LEATHER)

1. Place shoes on a sheet of newspaper. Brush off surface dirt with a rag, paper towel, or soft brush. 2. Apply a thin layer of cream polish in appropriate color or neutral. Use circular strokes, rubbing in the polish as you go. Do not leave an excessive amount on the surface. 3. When shoes are dry, buff them with a brush or soft cloth. 4. If not satisfied, repeat. 5. Between polishes, you can rebuff with a soft cloth.

LOW-TECH CANVAS SNEAKERS

Machine wash in warm water—mild soap, no bleach. • Sneakers will be protected in the spin cycle if washed with a towel. • For best results, place in the dryer immediately after washing. • Machine-dry for approximately 45 minutes on highest heat setting. *[Courtesy of Keds]*

ESPADRILLES

Apply an appropriate protective fabric spray, as with other cotton or canvas shoes. Spot-clean canvas with mild detergent. Stuff with paper towels to dry. Espadrilles are generally considered to be disposable shoes (if you get caught in the rain, the glue and rope soles will be ruined), so they aren't worth spending a lot of money on.

PATENT LEATHER

Wipe shoes clean with a soft cloth. Use shoe products made specifically for patent leather to prevent cracking.

SUEDE

Spray suede shoes with silicone spray before wearing them for the first time. Be aware that the spray will waterproof but may dramatically darken the color of the shoes. Silicone spray is best suited for black or hiking shoes. Fluoro-polymer, non-silicone spray also waterproofs, repels stains, and preserves the color and look of the shoe and is well suited for dress shoes. Consider reapplying either spray frequently if shoes are worn often. If you develop a bald spot on a shoe, use a very fine grade (00) sandpaper gently on the area until the nap lifts. You can

also lift the nap by holding shoes over a boiling kettle and brushing them gently with an old toothbrush.

WESTERN BOOTS

Use saddle soap according to directions. Allow to dry a full day between wearings.

BELTS AND HANDBAGS

BASIC CARE

Clean and apply protective spray to canvas, leather, and suede, as you would shoes. Never use colored polish on smooth leather belts and handbags—it could stain clothing. Instead, use neutral-colored cream polishes.

HANDBAGS

Be careful not to overstuff handbags with heavy objects, as this could distort the bag's shape. (This is especially true for structured bags.) Be careful to put any liquid toiletries into a waterproof cosmetics case.

BELTS

Don't wear your belt too tight; it may deform the shape of the belt and enlarge the holes.

GLASSES

SHOPPING FOR UVA PROTECTION

There are three kinds of ultraviolet rays: harmless UVC rays; UVB rays—the sunburn rays that can irritate the cornea; and UVA rays, which over the long term cause cataracts. In large amounts, infrared rays—the sun's heat rays—cause retinal burns. Sunglasses should transmit only fifteen to thirty-five percent of available light to the eye. Test them in the store by trying them on and looking at your eyes in a mirror: if you can see your eyes through the lenses, the lenses are probably too light. Photochromic lenses would be an exception to this rule, as they lighten and darken with exposure to the sun.

SHOPPING FOR LENS COLOR

The color of lenses determines how they filter light. **GREY** prevents distortion; colors remain true. **GREEN** enhances acuity of vision and allows high levels of green-yellow light—the light wave to which the eye is most responsive. **BROWN** and **BROWN-AMBER** absorb blue light, which is refracted in the air on hazy days. They improve contrast and reduce glare.

SHOPPING FOR LENS TYPE

CONSTANT DENSITY LENSES: designed for bright sunshine and glare. **PHOTOCHROMIC LENSES:** suited to a variety of conditions, they lighten or darken according to the amount of light. **ALL-WEATHER PHOTOCHROMATIC:** for sport. On hazy days they shift from grey to amber to improve contrast and detail. **MIRROR LENSES:** glare protection for water sports or snow sports. **POLARIZING LENSES:** eliminate direct and reflected glare and are good for driving. Check all lenses for surface distortion: they should be perfectly smooth.

CASES

If you're taking your glasses off for a moment, place them carefully on a surface with the bridge down or the lenses up. Never let the lenses come in contact with a hard surface. If you're putting your glasses away for a while, keep them in a case, ideally a hard one. A soft case is useless if you sit on it. A floating case will help prevent a sea of troubles. Cases can also make a style statement—like luggage for eyeglasses. Some antique cases, especially those that are bejeweled, are collectibles.

CLEANING HOW-TO

1. Hold the glasses by the bridge. **2.** Carefully wipe the lenses with warm water and soap (glass cleaner can damage the frame), rinse, then dry with a tissue or soft cloth. **3.** Glasses are easily scratched when dry. If you can't use soap and water to clean them, a specially treated lens cloth, such as Luminex, is recommended.

"Do what's right for you, as long as it don't hurt no one."

ELVIS PRESLEY

Wildlife Products

Over 120 countries, including the United States, are members of the Convention on International Trade in Endangered Species (CITES), which was established in the 1970's to uphold banning the import and export of certain plants and animals on the verge of extinction. This means that even if you buy something legally in a non-CITES member country, you run the risk of being fined and having your property confiscated upon returning to the U.S. To keep yourself clear of legal hassles when shopping abroad, keep these guidelines in mind—and when in doubt, don't buy! • Be suspicious if the merchandise in question is brought out to be shown to you and is not on regular display. • Never buy any products made from the following: spotted cats, seals, polar bears, coral (jewelry), ivory (jewelry and artistic objects made from elephants, walruses, narwhals), and tortoises (combs, leather, cosmetics). • When buying domestically, you can be

fairly confident that alligator products (handbags, shoes, belts, watchbands, wallets) are legal. Crocodile products, however, are usually illegal. Although it's difficult to distinguish crocodile from alligator, crocodiles always have a follicle gland, which appears as a pinpoint at the bottom of their scales; alligators have a crease at the bottom of their scales. • Lizard and snakeskin products from South America and Asian countries are usually illegal. • If you are buying an antique item made from any species that is now protected, you must be sure to get paperwork, authenticated by an appropriate official in the country of origin, that confirms the merchandise is over one hundred years old.

"My weakness is wearing too much leopard print."

JACKIE COLLINS

Storage

CLOSETS
To make space for new clothes, periodically give away to friends, charities, or thrift shops all the clothes and accessories that you no longer wear, that don't fit, and that you don't like.

SORTING THINGS OUT
Shaky reasons to hold on to something: **1.** I paid for it. **2.** I got it as a gift. **3.** It still works. **4.** It reminds me of my ex. **5.** It might come back into style. **6.** It's not mine. **7.** I'm saving it for my children (especially if you're still single). Then store all off-season clothing, if possible. It's important that your closet be laid out so that you can easily see your available choices.

DEEP STORAGE
Before storing valuable items in basements or attics, check carefully for leaks, dampness, and sunlight. Bags should be labeled on the outside with sizes, styles, and colors. A master list can then record where it all is. Fold clothes or pack them neatly in tissue paper, since most natural fabrics stiffen and lose their drape over time.

CLEANING BEFORE STORAGE
This is recommended, as fresh stains that may not yet be visible will oxidize and become fixed during storage. Furthermore, storing clothes without first cleaning them is like curing food for moths.

SEASONAL ITEMS
Storing off-season items makes selecting from your closet each morning easier by affording more space for your current wardrobe and cutting down on visual distraction. Storage method is dictated by the type of garment, its shape, and its fabric, as well as the space. Exposure to air, dust, moths, and sun can damage fabric. Zippered fabric garment bags protect antique or delicate clothes best. Remove all dry-cleaner plastic. Wrap in acid-free tissue or cotton muslin if clothing is made of silk, satin, or lace, or is beaded or sequined. Try to store off-season items in remote areas. Space can be created with collapsible garment racks or rods installed in alcoves. Consider storing: In fabric garment bags set up in an extra room • in boxes on wheels under the bed • on shelves in garment bags • in clear plastic boxes stacked on closet shelves • in a dresser or trunk in an extra room • in an old suitcase or trunk.

STORING WITH PLASTIC
Natural fibers, especially silk and linen, need to breathe. Storing white fabrics in cellophane will cause them to yellow from oxidation. Keep them uncovered, or cover with a cloth. Dry-cleaner plastic keeps dust away, but beware of moisture if the climate is humid or storage is likely to be long-term.

FADING
Many brightly colored fabrics fade from exposure to sunlight or artificial light. Some blue and green dyes fade exceptionally fast, especially on silk. Store garments in closets away from light.

MOTH PROTECTION
Moths have a discerning palate; they feast only on natural fabrics. Mothballs (naphthalene) and cedar chips are standard protection from moth infestation of woolens. Mothballs work best in small, tight spaces. The parachlorobenzene they give off can leach color from fabrics and cause respiratory problems in people, so be careful how you use them. Cedar doesn't kill moths—it only repels them—but it is a natural substance without the chemicals used in mothballs. Cedar also smells much better than mothballs and is easier to use. Cedar strips nailed inside a closet are an alternative to the cedar chest or cedar-lined closet. Cedar blocks do not have to be replaced; they only require sanding to freshen their smell. However, according to Jeeves of Belgravia, a luxury dry cleaner in New York City, the most certain protection against moths is naphthalene, a mothproofing product sold under different brand names in hardware and housewares stores. Garments that are suspected of having a moth problem can sometimes be frozen to get rid of the pests.

STORAGE SOLUTIONS
Your space may be limited, so consider the following ways to store your wardrobe. Remember to keep like things together by color and season if you are unable to store off-season clothing. And, of course, don't hang damp clothing in a closet—it may develop mildew.

BELTS
Do not store belts in pants, skirts, or dresses, as this can damage the fabric or shape of a garment. The best way to store a leather belt is to

let it hang from its buckle on a mounted racks, on a hanger-shaped rack, or from a hook. Coiling it inside a shoe caddy also works well.

"Elegance does not consist in putting on a new dress."

COCO CHANEL

DRESSES

If dresses are made of a knitted or wrinkle-free fabric, consider folding or rolling and placing them on a shelf or in a drawer. Otherwise, hang them on plastic, metal, or contoured wood hangers, or on padded hangers with tissue in the sleeves. Hang them inside-out. If dresses are structured and prone to wrinkling, be sure to hang them in a closet that has enough room for the dresses to drape naturally so that wrinkles aren't made by other clothes hanging nearby.

GLOVES

Make sure leather gloves are dry and clean before storing. Antique gloves should be wrapped in acid-free tissue or cotton muslin, and placed inside acid-free boxes. Otherwise, consider these options: Store gloves in a drawer near the door. • Store them in clear plastic bins, or labeled bins, without lids, on a shelf in the coat closet. • Hang kids' mittens on a string on the back of the closet door for easy drying.

HANDBAGS

Handbags should be snapped or zippered shut and stuffed with tissue to hold their shape. As with all leather goods, store them away from

heat sources to avoid excessive drying-out. If the bags are delicate, do not hang them by their straps, but fold the straps, place them inside the bag, and store the bag in a soft fabric bag. Otherwise, hang bags from their straps on hooks on a closet or bedroom wall. • Stand them upright on a closet shelf between vertical dividers. • Stow them in clear plastic storage boxes on a shelf in the closet or under the bed. • Stand them upright in shallow wire-mesh drawers.

HATS

Hang on hooks or pegs along a wall. Stack on a closet shelf. • Stack or place individually in hat-boxes on a shelf or under a table. • Hang from a coat tree.

JEWELRY

Rings, necklaces, and bracelets can be stored in a divider tray that separates pieces by category. Necklaces can be hung on decorative hooks or from a custom-designed closet rod. • Small items can be stored in their original boxes in a shallow drawer. • Hang jewelry from pushpins on a bulletin board. • Hang pierced earrings on a piece of framed screening.

PANTS

Consider these options: Folding and placing on plastic, metal, or wooden hangers. • Folding and placing on a multiple hanger that swivels out for easy access. • Hanging from skirt-hanger clips. • Folding and placing on a shelf. • Hanging from hooks.

SHIRTS AND BLOUSES

Fold in tissue on a closet shelf. • Place inside stacked plastic sweater drawers. • Stack on shelves inside garment bags with clear plastic fronts. • Stack on open canvas shelves that hang from a closet rod. • For short-term storage, plastic hangers may be used: padded satin hangers are good for silk and other delicate fabrics. Otherwise, use sturdy, smooth hangers made from wood, or from steel coated with rubber.

• Hang from metal hooks or wooden pegs on the inside of a closet wall. • Arrange in the closet next to other shirts in like colors.

SHOES

Always store with a shoe tree, or packed with tissue, to preserve the shape of the shoes as they dry after wearing. Never store near a heat source because it will dry out the leather. Leather can mildew, so store in a dry place. The area should also be ventilated: don't store shoes in airtight containers or with mothballs. Consider storing shoes: In shoe caddies. • Stacked inside their boxes with a packet of salt to absorb moisture and a photo of the shoes or a label taped to the box. • On shoe racks placed on shelves or the floor. • On the floor underneath coordinating outfits. • In shoe bags. • In clear plastic boxes (ventilated with holes). • In unexpected places that are little used: for example, non-cooks can take advantage of empty kitchen cabinets or an unused oven, so long as the oven doesn't have a gas pilot light that's on at all times. • The bottom of a garment bag with special-occasion dress, suit, or tuxedo. • On a shoe rack on rollers. • On an adjustable shoe

"Unpolished shoes are the end of civilization."

DIANA VREELAND

carousel. • Sandals in baskets. • Thongs with beach equipment in a canvas duffel. • In wire-mesh drawers. • Hang athletic shoes from their

laces on hooks inside the door. • Put slippers under your side of the bed. • In flannel, cotton, or any other breathable-fabric shoe bags hung from hooks. • In portable shoe cubbies.

T-SHIRTS

There never seems to be enough room for T-shirts. Consider storing: In deep drawers or wire-mesh drawers, rolled and placed upright. • Stacked horizontally on shelves. • Hung on hangers. • Hung on hooks. • Framed to commemorate an event.

SKIRTS

Store: On a single hanger with clips. • On metal multiple-skirt hangers with rubber clips. • Hung under a suit jacket. • Draped over a hanger, if long and wrinkle-free. • If cotton or knit, fold or roll skirts and place in a drawer or on a shelf.

SOCKS

Throw out orphan socks and give mates a home in a drawer. Use plastic dividers; fold socks and stand them upright, with an edge showing; categorize by use—work, sports, casual—or by color, from dark to light. Store in: • Shoe caddies • Shoes. • Wire-mesh drawers. • Baskets. • Plastic shoe boxes.

STOCKINGS

Store in a drawer, categorized by use or color. Your best bet is to roll them up into a tight ball. Warning: Because they snag easily, stockings require special treatment. Make sure non-laminated wood drawers are sanded well enough to be snag-free. Drawers can also be scented or cedar-lined. Store: • In mesh bags hung inside the closet door (also for dirty stockings—you can wash them inside the bag). • In shoe caddies. • In a plastic box. • In a satin envelope. • Inside shoes.

SUITS

Double-hang on wooden suit hangers. Hang: In closet with other suits. • In cloth garment bags. • On collapsible garment racks in a makeshift closet. • On a telescoping rack.

UNDERWEAR/LINGERIE

Consider storing: Folded and stacked in drawers with plastic dividers. • In lingerie bags, separate bras from panties. • In shoe caddies. • In mesh bags, each designated for garment type. • In scented drawers—spray scent lightly or leave scent samples in drawers. • In an open hatbox on a closet shelf. • In an open basket on a closet shelf. • Hung from notched hangers. • In plastic drawers. • Hang bras by straps on hooks in closet.

HANG-UPS

Generally, the heavier the garment, the heavier the hanger. Wire hangers are less sturdy and more likely to snag clothes. Uniform plastic hangers are sturdy, as are contoured wooden suit hangers. Padded hangers work well for delicate fabrics like linen and silk, and cedar hangers can help repel moths. Scented hangers can be revived by spraying them with your own scents, but it's more practical to use hanging sachets. Two-piece outfits save horizontal space if they are hung together. Pants, unless they are knit, should always be hung. If you don't have the height for double-hanging, consider using swivel hangers that hold five or six pairs at once. The same is true for multiple-skirt hangers. Make sure blouses, skirts, and jackets are partly, if not completely, buttoned. Pants, however, should not be buttoned; fold them along creases.

FABRIC SPA

The ideal environment for storing fabric is a stable 70 to 72°F, with 50 to 55 percent relative humidity. There should also be adequate ventilation. Extreme fluctuations in temperature are harmful. If you live in a warm climate, beware of particle-board shelving. Particle board, which is made of chopped-up bits of wood, expands in high humidity and may cause boxes stacked on top to become glued there. This will not happen with ventilated shelving.

"In olden days, a glimpse of stocking was looked on as something shocking, but now, God knows, anything goes."

COLE PORTER

S H O P T A L K

Fashion jargon can be as impenetrable as the most singular patois. Who, after all, would think that "frog" and

"capri" could stand for anything besides a slimy amphibian and a luxurious resort? Below, a glossary of terms.

Clothes

BARREL CUFFS: Shirt cuffs that close with a button. More casual if there are two buttons.

BANDEAU: A narrow, strapless brassiere or bikini top. The word derives from the French term for band or bandage; originally, bandeaus were just unstructured strips of fabric tied around the bust.

BIAS (CUT ON THE BIAS): A woven fabric that is cut on the diagonal; when expertly done, the resulting drape can be exquisite.

BUGLE BEADS: Tubular glass beads used to ornament dresses and other formal garments.

CAPRI (PANTS): Tight pants that are cropped a few inches above the ankle. Emilio Pucci (famed for his psychedelic fabric designs) created a line of beachwear in honor of a young woman he met on vacation in Capri, the idyllic resort island off the coast of Italy.

CARDIGAN: A button-down sweater named for the Earl of Cardigan, who led the Charge of the Light Brigade.

CHEMISE: A loose-fitting dress designed to hang straight from the shoulders without definition at the waist. The word means "shirt" in French.

CIGARETTE (PANTS): Straight, skinny pants; also called "stove pipe" pants.

FRENCH CUFFS: The dressiest kind of shirt cuffs; they fold over on themselves, away from the wrist, and require cuff links.

FROGS: Decorative Chinese closures made out of intricately knotted cord or fabric.

JODHPURS: Named for the former state in India, jodhpurs have lost their exaggerated flare at the thigh to fit snugly in contemporary stretch fabrics, with suede padding along the inside of the knee and calf for traction while riding.

MAILLOT: A close-fitting one-piece bathing suit; derives from the French term for swaddling clothes.

NOTCHED COLLAR: A design characterized by a triangular notch on a jacket or blouse at the point where the collar ends and the lapels begin.

PALAZZO PANTS: Named for the Italian word for "palace," palazzo pants were worn by the wealthy while vacationing on the French Riviera in the 1920's and thirties. Also known as beach pajamas, these widely flared pants with an elasticized or drawstring waist emphasized the boyish flapper figure popular at the time.

PASSEMENTERIE: French for "trimming"; in English it refers to ribbon appliquéd onto clothing, usually in elaborate patterns.

PEPLUM: The portion of a jacket or blouse that flares out from the waist over the hips.

PLACKET. The fabric strip on which shirt buttons are sewn; gives a shirt a clean center line.

SARI: A sari is made of one piece of material six feet long, tucked into a slip, pleated, and worn over a very short blouse.

SARONG: A loose-fitting, skirtlike garment formed by wrapping a strip of cloth around the lower part of the body. Worn primarily in the Malay archipelago and on some Pacific islands. The Tahitian word for a similar garment is "pareo," or "pareu."

SHAWL COLLAR: A rolled collar and lapel that curves from the back of the neck down to the front closure of the garment.

SHEATH: A close-fitting, unbelted dress with a straight drape.

SHIRRING: Decorative gathers that are held in place with parallel stitching.

SILHOUETTE: The line and outer shape of an outfit.

SINGLE-NEEDLE STITCHING: A single needle is used to sew one side of the garment at a time. It produces durable seams that fit better against the body than double stitching.

SPLIT-SHOULDER YOKE: A yoke made of two pieces. This allows for movement in the shoulder. This feature is usually found only in the finest (often custom-made) dress shirts.

SURPLICE: A form-fitting blouse that wraps diagonally around the torso.

SWAGGER BACK: A jacket back that is unfitted and drapes straight from the shoulders.

YOKE: The part of a garment from which the rest of it hangs; i.e., the piece of fabric that runs over the back of the shoulders or a curved waistband.

Shoes

ESPADRILLE: A shoe with a cloth upper and rope sole. They are traditionally flat but now can be stacked.

LAST: The wood or metal form around which shoes are shaped; also refers to the final shape of the shoe.

MULE: A backless shoe, usually an evening slipper; basically, a more elegant version of the clog. Characteristically ladylike; connotes lounging in a boudoir.

NUBUCK: Typically made from cowhide through a process that abrades the hide's outer grain to make it mimic the look and feel of buckskin. It tends to feel tougher than suede.

ORTHOTICS: Any device that helps correct and relieve skeletal problems and supports the foot. Commonly used to refer to specially designed inner soles for the shoes of those suffering from chronic foot pain.

PADDOCK (BOOTS): Named after the fenced-in enclosure for animals, and worn for recreational riding, the paddock boot laces up to provide adjustable ankle support. It works with breeches, jeans, or jodhpurs. Less expensive than the dress boot, it's a preferred choice for young riders with growing feet. The sole of the authentic riding boot is always sewn, never glued or bonded.

PUMPS: Perhaps derived from the word "pomp," it is the classic dress shoe women wear both day and evening. It exposes the instep and usually has a heel. (The male version of the pump is more like a flat ballet slipper with a heftier sole and is worn only with formal evening attire.)

THONG: Minimal sandals with a leather strip holding the sole of the shoe to the foot. Also refers to the minimal underwear that many women prefer because it doesn't cause panty lines.

VAMP: The part of the shoe that covers the toes and instep.

VIBRAM SOLE: Lightweight rubbery outsole that adds spring and slip resistance.

WELLINGTON: Classic rubber boot, originating in Britain.

WELT: An extra piece of fabric or leather that reinforces a seam, usually between the upper and the sole.

Fabrics

ARAN: A knit associated with the people of the Aran Islands, off the west coast of Ireland. Coarse, handspun wool, usually in a natural, off-white color, is knitted in cables, twists, and bobbles down the front and sides of a sweater. Often the designs take on symbolic meanings; they are the Irish equivalent of the Shaker quilt.

ARGYLE: Multicolored diamond pattern knitted in the style of a Scottish tartan; most often appears on socks and sweaters.

BOUCLÉ: Decorative, nubbly knit, appropriate for colder weather.

BREATHABILITY: Refers to the ability of the fabric to release body heat. Loosely woven, highly "breathable" fabrics like linen feel good in the summer. The more waterproof the fabric, the less breathable; the more breathable, the less waterproof.

BROADCLOTH: When technology first allowed for larger looms, the fabrics produced were dubbed broadcloths. Today the term refers to plain- or twill-woven wool or cotton (usually preshrunk and/or mercerized).

BROCADE: A formal fabric woven with a detailed embossed pattern, often with metallic threads. The term is now used interchangeably with "jacquard."

CHALLIS: A soft, nappy twill fabric (made of wool, rayon, or cotton), usually with a small pattern. Though it's available in many weights, it's most often worn in cold weather. The name derives from the Indian word "shalee," meaning "soft to the touch."

CHAMBRAY: A plain-weave fabric (made of cotton, rayon, silk, or linen) woven from white and colored threads to create a muted, frosted appearance. Most frequently used in cotton and linen sportswear and nightwear.

CHARMEUSE: Originally lightweight silk worked in a satin weave in France. Now also refers to easily draped fabrics made of cotton, rayon, and other synthetics, with a shiny face and matte back.

CHENILLE: Textiles woven or knit from very narrow strips of pile fabric (cotton, silk, or synthetics). The word is derived from the French for caterpillar.

CHIFFON: A sheer evening fabric woven from twisted fibers of nylon, silk, or rayon.

CHIMNEY EFFECT (HIGH-TECH FABRICS): When ventilation is built into the design of a garment by means of zippered necks, high collars, open cuffs, or vents that allow hot air to rise and moisture to evaporate.

COLOR-BLEEDING. If the manufacturer has been negligent, the dyes on fabrics may not be colorfast enough to withstand the procedures listed in the care instructions. Articles labeled as dry-cleanable will sometimes contain dyes that bleed when dry-cleaned. Deep colors may transfer onto lighter areas. Garments labeled as washable may also bleed and lose color, especially darker colors. If an article is multicolored, test it for colorfastness before washing.

COLORFAST: Maintaining color without fading or running.

CREPE: A lightweight, seasonless fabric (made of silk, cotton, wool, or a blend) with a matte, finely crinkled, textured finish that resists wrinkling. Ideal for day-to-day business wear.

CRÊPE DE CHINE: A lightweight fabric (made of silk or a synthetic) that is woven from twisted yarns to create a slightly textured, lustrous surface. Less wrinkle-prone than broadcloth, but more expensive.

DAMASK: A satin fabric (made of silk, cotton, linen, rayon, or synthetics) produced on a jacquard loom with elaborate patterns integrated directly into the weave. Can be reversible.

DENIM: A sturdy twill cotton fabric woven from white and colored threads (traditionally indigo blue). Though denim is considered the world over as American as apple pie, its name derives

from the phrase "serge de Nîmes," a town in the south of France.

DOUPION: When two silkworms spin close together, their fibers unite, making an irregular thread. The slubby texture of the silk is considered desirable.

FAILLE: A lightweight evening fabric (made of silk, acetate, or rayon) with a gentle horizontal rib; a thinner version of grosgrain.

FAIR ISLE: A sweater, often yoked, with a multicolored geometric design, named after one of the Scottish Shetland Islands, where it originated. In the twenties, the Prince of Wales played golf while wearing sweaters of this design.

FLANNEL: A soft fabric, usually made of cotton or wool. In wool or wool blends, it's a quality suit fabric. In cotton (also known as flannelette), it's popular for cozy casual wear like pajamas, infant clothing, and plaid shirts. Because of the cotton fabric's fuzzy nap, which cannot be ironed smooth, it's more appropriate for grunge-rock concerts than boardrooms.

FOULARD: A lustrous, delicate twill fabric originally made of silk (now made of acetate and other synthetics) and used for handkerchiefs; usually printed with paisley, floral, or similar motifs.

GABARDINE: A tightly woven diagonal twill with a matte finish that comes in many weights and fibers. Can be multiseasonal. When made of wool or silk, it has a beautiful drape. Be careful when pressing, especially with dark wool fabrics, because you could easily glaze the smooth fabric and create permanent shiny areas.

GAZAR: A stiff silk fabric of loose construction.

GEORGETTE: An exceptionally sheer, wrinkleless crepe (usually made from rayon or silk), appropriate for evening wear.

GINGHAM: High in thread count, this fabric (made of cotton, wool, or synthetics) is often checked and is forever associated with Paris bistro tablecloths, picnics, and down-home life on the range. The name is derived from the Malaysian word *gin-gan*, meaning variegated.

GROSGRAIN: Literally "large grain" in French, this is a type of heavy, stiff, ribbed cloth or ribbon (made of silk, rayon, or synthetics).

HAND: The characteristic quality of the textile: how it feels to the touch.

JACQUARD: Fabric whose pattern has been woven in on a special loom, rather than printed on. The original loom was created by the French inventor J. M. Jacquard (1757–1834).

JERSEY: A lightweight, fine knit, invented on the Isle of Jersey.

KNIT: Knits are more elastic than woven fabrics and therefore better for activewear. Highly comfortable, they are ideal for infant clothing, sweaters, bathing suits, hosiery, and underwear. Unless the fabric is of high quality or hand-knit jersey, knit garments tend to be casual and less expensive than woven garments. Knits are easier to clean and pack than woven fabrics because they're more porous, less rigid, and less likely to wrinkle. Knits are not flattering for overweight women because they can easily stretch out of shape and they drape close to the body, rather than being structured to mask flaws. Knits are good for summer because they allow the body to breathe, and they're less likely to stick to the skin when damp. Never pin things to tightly knitted garments, as you may start runs.

LAMÉ: A decorative, formal fabric in which metallic threads, usually gold- or silver-toned, are woven with silk, wool, rayon, or cotton. Term derives from the French *laminer*, to flatten, because flattened metal was used in the fabric.

MELTON: Tightly constructed cloth that is finished with a smooth face, concealing the weave. Originally wool fibers were used, but melton can also be made using synthetic blends. The name originates from Melton Mowbray, a town in Leicestershire, England, where the cloth was first produced in the early 1800's.

MEMORY: The ability of certain materials to return to their original shape after being stretched or deformed in some way.

MERCERIZED: Cotton that has been specially processed to become mildew-resistant and stronger, with improved sheen and dye-absorption properties. The process derives its name from John Mercer, a nineteenth-century calico printer.

MOIRÉ: Easy to identify by its distinctive watermarked appearance. The effect was originally achieved though a special process of weaving silk taffeta; now it's usually made in a pressing process called calendering.

MUSLIN: A cotton cloth of various weights. Unbleached muslin is off-white in color and has a rough, stiff texture. "A muslin" can also refer to the first version of a custom-made dress that a dressmaker creates before cutting up more expensive fabric for the final version. Its production dates back to thirteenth-century Iraq.

ORGANDY: A translucent, fine, stiff, plain-woven fabric made from specially prepared cotton yarns and processed with a permanent finish that never requires pressing. Commonly made into evening dresses and billowing curtains.

ORGANZA: Fabric made from specially processed silk to have qualities similar to organdy.

PAISLEY: Pattern born in the 1800's as an attempt by the mills of Paisley, Scotland, to imitate the spade pattern of Kashmiri shawls.

PANNÉ: A fabric (made of silk, wool, or blends) with pile longer than velvet that has been pressed flat during the finishing process to have a high luster. The word is French for "plush." Sometimes it refers to satin that is heavy, highly lustrous, and usually made of silk.

PILE: Fabric with a surface made of cut (like velours and velvets) or uncut (like terry cloth) yarns, so that it has a plush, "furry" texture.

PIQUÉ: Usually made from mercerized cotton, piqué fabrics have a raised appearance, typically a waffle design, and connote smart summer evening dress (men's white-tie waistcoats and bow ties are also made from this material). Piqué is from the French verb *piquer*, meaning "to pierce."

PLY: The thicknesses of yarns that have been twisted together to be knit or woven into fabric.

POPLIN: This heavy ribbed fabric (made of cotton, rayon, silk, or wool) was originally known by the French word *popeline*, so named because it was created in the French papal city of Avignon. It comes in many weights and is commonly used for dresses and drapes.

SANFORIZED: The trademarked name of a fabric that has been specially processed to prevent shrinkage.

SATEEN: Fine cotton woven in a satin weave. It is not as smooth as silk but it has a glossy finish.

SEERSUCKER: A striped cotton fabric (usually white alternating with a color) with the colored stripe being permanently crinkled or blistered. The word derives from the Persian term *shir o shakar,* meaning "milk and sugar."

SERGE: A twill (made of wool, cotton, rayon, silk, or blends) created in a variety of weights, textures, and finishes to achieve great hand and drapability; a typical fabric for business suits.

SHARKSKIN: This term refers to two different fabrics with a durable, sleek, pebbled texture. When made of acetate, rayon, or blends, it has a duller appearance. When made of worsted wool, it is a fine twill, often used for suits.

TAFFETA: A stiff, gently ribbed fabric (made of silk, rayon, acetate, or other synthetics). Derives from the Persian word *taftah.*

TERRY CLOTH: An absorbent fabric made from looped, predominantly cotton yarn. Most often used in bathrobes and beach coverups.

THERMAL INSULATION (HIGH-TECH FABRICS): Fabrics that keep you cool (such as Coolmax) or warm (such as Thermax), in part by keeping you dry through the wicking of perspiration. Some thermal fabrics are woven in a 3-D manner, often called "waffle weave," designed to trap the body's natural heat and keep you warm in cold weather; often made into long underwear

TRICOT: French for "knit," tricot generally refers to fabric that has been knitted to produce ribbing.

TULLE: Named for the French town where the fabric originated, this textile is fine, machine-made net (made of acetate, nylon, rayon, or silk). Most often used for brides' veils, ballgowns, and ballet dancers' tutus.

TWEED: Coarse wool cloth, in a variety of weaves and colors. First woven by crofters near the Tweed River in Scotland; name is derived from *tweel* or *tweed,* the Scottish word for "twill."

VELOUR: Knit fabric (made of rayon, wool, and synthetics) with a pile; usually heavier than velvet and doesn't have velvet's luster and drape.

VOILE: A plain-woven cloth (made of wool, silk, rayon, or cotton) that is seasonless and translucent. The word is French for "veil."

WEAVES: Tighter weaves are more durable and less likely to shrink. The higher the thread count per square inch, the more durable the fabric. Before buying a garment, note whether the weave is straight and whether there are any broken yarns. **Warp:** The taut lengthwise yarns on a loom; also known as the "end." **Weft:** These yarns traverse the warp; also known as "filling" yarn. **Plain:** This weave is where it all began: simple vertical threads holding threads running horizontally in place. Easy to launder and dry-clean, drapes well, is comfortable, and is usually inexpensive. Loose weaves (especially basket-weaves) are more prone to shrinkage than close ones. **Satin:** A shiny, slippery fabric (made of acetate, rayon, nylon, or silk) with loosely interwoven threads that are widely separated to create its smooth finish. It is not a durable fabric and is most appropriate for evening wear, undergarments, and linings. **Twill:** A sturdy weave (made of any fiber) characterized by diagonal ribbing. "Broken" twills are those whose diagonals are manipulated into different patterns: herringbones, zigzags, diamond patterns, and so on.

WICKING (HIGH-TECH FABRICS): The ability of a fabric to disperse moisture away from the body. Fibers are treated to be either hydrophilic (to draw water) or hydrophobic (to repel water). "Push/pull" fabrics do both.

NATURAL FIBERS

GENERAL PROS. Natural fibers have wonderful luster, feel, and general appearance. They tend to be more stain-resistant than synthetics. They also feel good to wear in all different weathers, depending on the weight of the fabric.

GENERAL CONS. Natural-fiber clothing often does not last as long, may fade and wrinkle more easily, may require more careful (and costly) maintenance (especially for some wools and silks), and tends to be more expensive than clothes made of synthetic fibers.

COTTON (NATURAL)

A vegetable fiber, cotton comes from the seed-hairs of the plant. It takes about six months for a cotton boll to mature. The highest-quality cottons are Sea Island and Egyptian because they are made from the longest, thinnest fibers, or staples, and are slightly sheer. Pima cotton is also made from a long-staple cotton but is not as expensive.

QUALITIES. Absorbent and comfortable in hot weather; irons well; moth-safe; doesn't produce static. Wrinkles easily. A man-tailored shirt of a quality fabric will last many wearings. Cotton knits fade easily and are not very durable, so it doesn't make sense to spend a lot of money on them.

TYPICALLY MADE INTO. All kinds of knits, jeans (denim), athletic clothing, business shirts, twill suits, canvas, mercerized cotton and piqué dresses, terry cloth, flannel, dress shirts in various weaves.

LINEN

Linen is a vegetable fiber; the fabric is woven from the stems of flax.

QUALITIES. More absorbent than cotton; not durable; poor dye retention (especially on shinier varieties); wrinkles very easily. Linen tends to become whiter with use. Unless the air is very polluted, line-drying in the sun will whiten it further.

TYPICALLY MADE INTO. Summer clothing: shirts, pants, dresses, jackets.

SILK

It is said that silk was discovered when a cocoon from the larva of a *Bombyx mori* moth fell from a mulberry tree into the teacup of the Chinese Empress Hsi Ling-shi in the third millennium B.C.; she opened it and found a glistening thread. Cultivated silkworms must eat thirty thousand times their weight in mulberry leaves; their cocoons, which are made from secretions from

the worm's head, make up the silk fiber. Wild silkworms eat oak leaves and produce a silk of a coarser and less lustrous quality. If the worm's natural gum is not cleaned from the fiber, it is known as "raw silk." **Pongee, tussah,** and **shantung** are all unevenly woven, undyed, raw, naturally tan silks, with pongee being the palest and lightest weight and shantung the heaviest.

QUALITIES. A very fine fiber and the strongest of the natural fibers (it is as strong as nylon and is often compared to iron wire of the same thickness); wrinkle-resistant (hangs out well); holds shape well. Very elastic, it will stretch up to 120 percent of its length before snapping; retains pleats well; retains color well (yet more susceptible to light than cotton); lightweight, year-round fabric; expensive; high-maintenance; can burn while being ironed; can be damaged by the aluminum chloride in antiperspirants. When metallic salts are added to pure silk, the silk drapes better but may deteriorate sooner. When rayon is blended with silk, the fabric attains the elasticity that rayon lacks. "Washable silk" is silk that has been washed throughout its production process so that it is preshrunk and can be safely washed by the consumer at home.

TYPICALLY MADE INTO. Business suits, dresses, blouses, skirts, pants (knits, satins, sateens, plain-weave crepe, velvets), long underwear, lingerie.

SEWING TIP: Always use silk or cotton thread on silk garments; the thickness of a polyester thread can cause puckering.

WOOL

Wool is made from the fleece of animals. **Lambswool** comes from animals sheared at eight to nine months old. Angora is made from the fur of Angora rabbit. **Mohair** comes from Angora goats. **Camelhair** is really from camels but may be mixed with wool and/or cashmere. **Cashmere** is from the soft undercoat of goats that live on the cold high plateaus of inner Asia. Cashmere is finer, lighter, and stronger than other wool, and more expensive. The finest cashmere comes from the Tibetan mountain goat. The number of plys (hairs twisted together) indicates the weight or thickness of the cashmere—the higher the number, the thicker the fabric. What

affects softness most is the length and fineness of the fibers. **Pulled** wool is from slaughtered animals. **Worsted** wool is wool that has been combed and tightly twisted; it's so named for city of Worthstede, England, where it first was made in the Middle Ages.

QUALITIES. Because of wool's natural crimp, it has built-in elasticity and resiliency; it is wrinkle-resistant (hangs out well) and naturally water-repellent, stain-resistant, and soil-resistant. Wool is warm because its fibers trap air, creating an insulating effect; it also retains color well. Wool requires careful maintenance and storage to hold its shape and to prevent it from becoming food for moths. Quality wools are smooth and springy to the touch, usually "virgin" (never made into clothes before). Cashmere is prized for its softness; unlike other wools, it feels great against the skin. Low-quality wool is stiff, abrasive to the touch, and lackluster; it may also be "reprocessed," meaning that it's been recycled from scraps or old clothing.

TYPICALLY MADE INTO. All kinds of fabrics (crepes, knits, piles, twills, broadcloths); lightweight wool can be worn year-round, but heavier weights are appropriate only for cold weather. Casual and formal tailored clothing, knits, coats, hats.

SYNTHETIC FIBERS

GENERAL PROS. Manmade fibers tend to be incredibly durable, wash-and-wearable, and wrinkle-resistant. They dry quickly, have good pleat retention and excellent color retention, are mothproof, and are less expensive than natural fibers. With new technological developments, manmade fibers are improving in feel, or "hand," and appearance.

GENERAL CONS. Compared with natural fibers, synthetics tend not to breathe very well, which can make for discomfort, especially in warm weather. Knits may "sparkle" when they should appear matte and may pill easily. Manmade fibers may also be highly heat sensitive (don't allow them to dry close to heat sources like radiators or fireplaces) and sometimes discolor in sunlight.

BLENDS

When buying basic clothing, natural fibers are the best investment. However, when synthetic fibers are added in small quantities to natural fibers, the quality of the fabric can actually be enhanced.

GENERAL PROS. If the blend is in the right proportion, the fabric takes on the best attributes of each fiber: a cotton T-shirt with 2 percent Lycra has a sexier shape than a 100-percent-cotton shirt.

GENERAL CONS. When the blend is done for economy rather than strength, the wrong fiber becomes dominant. In the case of a cotton/polyester blend where the polyester content is high (over 35 percent), the garment will feel uncomfortable—more like polyester than cotton.

ACETATE

Acetate was invented in 1869 but wasn't used commercially until after World War I.

QUALITIES. Drapes nicely and dries well, but is not very colorfast, is prone to melting, wrinkling, and stretching, and requires dry-cleaning.

TYPICALLY MADE INTO. Satins and sateens for lining fabrics or for outer garments.

ACRYLIC

Orlon acrylic was developed by Du Pont during World War II but wasn't marketed until 1950.

QUALITIES. Resists wrinkling and is machine-washable, but can pill badly, absorb oil-borne stains, and shrink under heat.

TYPICALLY MADE INTO. Knits and fabrics resembling wool.

MODACRYLIC

This fiber, also known as Dynel, was first put on the market by Union Carbide in 1949.

QUALITIES. Lightweight, warm, and abrasion-resistant.

TYPICALLY MADE INTO. Pile clothing, fake furs.

NYLON

Du Pont launched nylon in the form of stockings; marketing on a large scale didn't begin until the 1940's, when nylon was marketed to

replace silk, which was needed for parachutes during World War II.

QUALITIES. Strong; not easily abraded; resists staining and wrinkling; washes and dries easily; doesn't need ironing; has good "memory"; doesn't absorb moisture. But tends to pill, can feel clammy, and generate static (though this effect can be minimized by new finishes). In sunlight, nylon weakens, and whites can turn grey. When a small percentage of nylon is mixed with natural fibers, it can greatly enhance the durablity of the garment.

TYPICALLY MADE INTO. Swimwear (knits), hosiery, lingerie (knits, satins, sateens), and as a blend in crepe and twill fabrics.

POLYESTER

Polyester was developed by Du Pont in 1951 and is now the world's most widely used fiber.

QUALITIES. Holds shape well; resists shrinking, stretching, and wrinkling (it adds these qualities to whatever fiber it's blended with); tough and durable; can withstand abrasion and rubbing; easy maintenance (usually machine-washable); dries quickly; fade-resistant (especially an asset for blacks and other dark colors); inexpensive; no ironing necessary. But generates static; weakens in sunlight; draws oil stains and soil from other clothes in the wash; pills develop easily and are tenacious because of the strength of the fiber. When added to cotton and wool, it reduces wrinkling and weight, and adds strength. Chlorine bleach turns it grey. **TIP:** To get rid of the grey tint, soak garment overnight in a solution of dishwashing detergent in warm water. Machine-wash garment before drying.

TYPICALLY MADE INTO. All sorts of daily-wear clothing: shirts, pants, suits, and so on. Also can be made into evening-wear fabrics like satin.

RAYON

Rayon was called artificial silk when it was invented in 1891, and although it is made from organic components such as plant fibers (cellulose, wood chips, cotton linters), it is considered the first artificial fiber. Viscose is a type of rayon, so named for the viscous solution from which the threads are spun.

QUALITIES. Can mimic wool, silk, linen, cotton; as a crepe, it's lightweight and seasonless; inexpensive, absorbent, and comfortable. Not durable; wrinkles and pulls easily; doesn't hold its shape well. When blended with acetate, it holds its shape better—a good attribute for fitted clothing.

TYPICALLY MADE INTO. Rayon alone can be made into suits, shirts, and dresses. When blended with acetate as a knit, it is used in bathing suits. When blended with wool, it makes seasonless garments: suits, skirts, and pants.

SPANDEX

Spandex was first manufactured in the United States in 1959; by now, it has replaced rubber in many fabrics. **Lycra** is the trademarked name of the spandex produced by Du Pont.

QUALITIES. Its excellent elasticity means it holds its shape well and resists shrinking, stretching, and wrinkling. Tough and durable (even stronger than rubber), it can withstand abrasion and rubbing, but can generate static. Spandex is fade-resistant (especially an asset for blacks and other dark colors). Spandex requires little maintenance, but never wash it in strong detergent or bleach; hand-washing in Woolite is recommended to preserve the fabric. Always drip-dry or use nonheat setting on dryer.

TYPICALLY MADE INTO. Blended fabrics (with cotton, acetate, etc.) for exercise and beachwear (knits). Appropriate for colder weather.

OUTDOOR HIGH-TECH FIBERS

CAPILENE

Capilene is a Patagonia polyester fiber worn by explorers of the frontiers of wilderness and space. It is the astronaut's fabric of choice.

QUALITIES. An inner core attracts moisture to wick it off the body; an outer layer distributes moisture so that it dries quickly. It is flammable.

TYPICALLY MADE INTO. Underwear, linings, socks.

ENTRANT

Entrant is an elastic, waterproof coating of polyurethane.

QUALITIES. The more layers that are applied, the more waterproof and the less breathable the fabric becomes. Like all coatings, it tends to be more breathable than a laminate.

TYPICALLY MADE INTO. Winter outerwear.

GORE-TEX

Gore-Tex (invented in the seventies) is a synthetic laminate that comes in many forms: as a thin insulation and waterproofing coating applied to the outside of fabrics; and a microporous membrane sandwiched between the outer shell and its lining.

QUALITIES. Laminates in general tend to outperform coatings in terms of waterproofing, but they also tend to be less breathable. Gore-Tex is unusual in that it provides both waterproofing and breathability. If a laminate is on the outer layer of a piece of clothing, it may stiffen in the cold.

TYPICALLY MADE INTO. Outerwear, rainwear, sportswear.

MICROFIBER (MICROWEAVE

Finely woven synthetic fibers; brand names include **Super Microft** and **Versatech.**

QUALITIES. Unusually for a synthetic, they breathe and offer warmth; can have a great feel and a sueded or sand-washed-silk texture.

TYPICALLY MADE INTO. Outerwear, sportswear, stockings.

POLARTEC FLEECE

Polartec is made by Malden Mills in different weights: polyester pile, two-sided microfiber, and Lycra stretch. **Synchilla** is Patagonia's brand name for Polartec fleeces. It is made from shredded plastic bottles.

QUALITIES. It's not only lightweight and warm but breathable; not good under windy conditions.

TYPICALLY MADE INTO. Mostly used garments worn in the place of sweatpants, sweatshirts, sweaters, and vests.

DRESS CODES

Who came up with them anyway? For everything we do there is a precedent, a right or wrong turn to take at the cross-

roads. How do you break a rule successfully? By knowing what it is. Shattering a custom shows originality, daring, and

confidence. It's what personal style is all about. So here they are: rules. Lots of them. Do with them what you will.

"Good clothes open all doors."

THOMAS FULLER

Social Rituals

Do's and don'ts are the essence of rituals. So before you show up the bride or shock your mother, you should know that's what you're doing.

WEDDINGS AND BAR MITZVAHS

As a guest, you can wear white to a wedding, although you should probably avoid anything that looks remotely like a bridal gown. • It was once considered bad luck to wear black at a wedding; now, it's not. Remember that weddings are supposed to be festive events, so anything in the Morticia Addams category is probably a bad idea. • You can keep your hat on inside—in England they do—especially if the alternative is

a hairstyle that resembles a fright wig. And certain religions require covering the head with a scarf or hat while attending a service. • Conventional wisdom has it that upstaging the bride is a bad idea—although scorned girlfriends do have some leeway here. • Dress suits are acceptable at both day and evening weddings; usually pants are not. • Save the bright lights—sequins, beading, rhinestones—for after dark. • Sundresses are usually fine for summer weddings, although a sweater or shawl is a good idea, both for covering bare shoulders in church and for the party after.

GRADUATIONS AND CHRISTENINGS

Suits or dresses; no excessive ornamentation. In other words, look smart.

FUNERALS AND MEMORIAL CEREMONIES

It is traditional to wear black or dark clothing. Many women wear dark hats and sunglasses so they can grieve quietly during the ceremony.

EVENING ATTIRE

INSTANT EVENING

Hot colors and rich jewel tones can look instantly glamorous, especially as an accent to a black ensemble. • Black always works. • Glitter and sheen: gold, silver, velvet, lamé, and iridescent fabrics • Evening attire denotes drama: try fun costume jewelry, palazzo pants, an off-the-shoulder top, mules or high heels.

HOME ENTERTAINING

Feel free to outdress the men at your gathering. You'll have fun doing it; they'll have fun appreciating it. • If you're the host, you can wear any-

thing you want, no matter how extravagant. Just make sure you can toss a salad in it.

INSTANT COCKTAIL PARTY

Black is the traditional cocktail-party color. • Dress up a work suit with a lacy camisole, an evening sweater, or even bare skin in place of your usual office blouse. • Strappy shoes or higher heels can dress up work clothes. • Change your jewelry. • Put on sheerer stockings.

BLACK- AND WHITE-TIE

You can get away with a lot at black-tie events—short dresses, pants—that you can't at white-tie ones. White-tie is the kind of no-holds-barred formality usually reserved for state dinners and debutante balls.

EXTRAS

An evening wrap. • Gloves. • Your best jewelry. • High-heeled shoes in satin, in velvet, in silk faille, or jewel-encrusted. • The basic rule: look and feel great.

PRIVATE CLUBS

Private clubs may be opening their doors to women (finally), but many of them do so under their own terms.
• Some clubs will not allow a woman to wear pants in the dining room. • Dinner is often quite formal, with dresses or skirts required for women. • Sports clubs often ask that you change out of your sports clothes before entering the dining room. • Sports clubs often have rules that govern how you should look while you're in action, so proper golf and tennis attire may be obligatory.

DINNER AND THEATER

People do not dress up as much as they used to, but it can be nice to differentiate your clothing slightly from everyday office wear.
• Instead of a blouse, wear a camisole or bare skin under your suit. • As far as your hose and shoe heels are concerned, think sheerer and higher. • Throw on a decorative scarf—to dress up and to keep you warm in excessively air-conditioned theaters and restaurants. • Pants

are acceptable: pants suits, black pants, and evening pants all work well.

REGIONAL GUIDELINES

Geography isn't nearly as important as it once was in determining how we dress. We're all exposed to more and more of the same influences, and inevitably our tastes have become more global, less local. This is particularly true when it comes to casual dress. Formal dress is where geographical distinctions still apply—not so much in what we choose to wear as in how we wear it. A few general trends:

> ## "I come from a country where you don't wear clothes most of the year. Nudity is the natural state."
>
> **ELLE MACPHERSON**

MIDWEST (CHICAGO)

Women are sensible; they want what looks good on them. • Dresses, blazers, and slacks work well for their life style. • Women embrace tailored "power" clothing. • They enjoy having their personal style; designer devoteeism is rare. • It can snow in the fall, so a woman's wardrobe includes a lot of cold-weather clothing. • Bare midriffs aren't popular, nor is underwear worn as outerwear, perhaps because it's not practical and it's usually too cold.

NORTHEAST (NEW YORK)

Women are fashion-conscious yet iconoclastic. New York is the fashion hub of the country, so many trends start there. The city has international and cosmopolitan influences, which allow for the development and acceptance of an individual's personal style. On the street you see a diverse range of fashion, from conservative suits to ethnic garb to hip-hop trendiness.

• Women are aware of what labels they're wearing and are often resourceful about mixing and matching wardrobe separates. Typically, a woman will wear at least one "status" piece of clothing (a designer jacket, handbag, scarf, or shoes) with something more casual and anonymous. • The color spectrum is urban standard: black, charcoal, and beige. • There are four distinct seasons here; women have heavy winter coats. • For evening functions, what they wear depends on the crowd they're with: for most formal parties, the little black cocktail dress with quality accessories will do nicely; the old-money society set dresses simply and elegantly for black-tie charity functions; for glitterati-literati openings and events, women dress dramatically, and not necessarily in a traditionally formal manner. • As in most big cities, people wearing casual shorts are assumed to be tourists.

> ## "The wilderness has a fashion code as rigid as the chicest neighborhood in New York."
>
> **CLAUDIA SHEAR**

NORTHEAST (BOSTON)

There's a large rift between suburban and urban women. The suburbanite tends to wear more conservative clothes in a brighter palette, and her hemlines tend to remain low. The city woman prefers trendier fashions, in more subdued colors and with higher hemlines. • Linen is considered high-maintenance and is worn predominantly in the city. • Popular colors include navy, grey, fuchsia, turquoise, and taupe. • There are numerous colleges and universities in the area, and many students enjoy dressing fashionably. There is a large population of wealthy Middle Eastern students who dress in the most elegant cutting-edge styles. Fashion in New England no longer means preppy. • Unstructured, tailored suiting is favored; women generally wear skirts to work, though pants are slowly infiltrating the career woman's

wardrobe. Women buy designer clothing because it makes them look good; they don't care so much about flaunting a label. • Women favor real, precious-metal jewelry. Antiqued gold or gold mixed with silver are both popular. By and large, everyday jewelry is understated; a women will wear an expensive brand-name watch and maybe one other low-key piece of jewelry. • For handbags, nylon backpacks are ubiquitous. Recently there has been a revived appreciation for the traditional structured handbag with a handle (often with a detachable shoulder strap as well). • For evening wear and charity functions, most women will wear a little black evening dress but personalize it with an evening jacket—say, a lace bolero. The younger set wears black-tie formal attire when going clubbing. • Because of the cobblestone streets and the periodically inclement weather, women most often wear low heels.

PACIFIC NORTHWEST (SEATTLE)

In general, the All-American clean-cut look prevails. Women are more concerned with being comfortable and presentable than with being on the fashion cutting edge. • Career women favor the elegant, soft-silhouette, minimally structured skirt suit in navy or black. • Though many businesses have a casual dress code, recently employers have been trying to restore more formality in the workplace. Typical casual looks include denim shirts under jackets, and leggings with oversized sweaters. • Precious high heels and suede shoes don't last long in a city where it rains constantly. Many women wear sneakers on the street to preserve their dress shoes. • As in other cities, fitter women wear barer fashions and shorter hemlines. Many women live up to the West Coast stereotype of being slim and health-conscious: they may even walk or go to the gym during their lunch hour. However, because of the notoriously bad weather, there's an equal number of women who avoid the outdoors and sports altogether and tend to be overweight. • For formal evening occasions, women tend to wear a classic little dress (narrow-cut, hem to just above the knee; not a cocktail suit) in black

or jewel tones. • Leather backpacks and soft Coach and Dooney & Burke shoulder bags are popular. Structured handbags are considered overly formal • Accessories are where women indulge in being fashionable: this season's tasteful costume jewelry or narrow belt will be the way a woman updates an outfit.

THE ROCKIES (DENVER)

The overall aesthetic is relaxed and sophisticated. • Women favor elegant, unstructured suits—though they tend to wear them with skirts more often than with pants. • Weather is fluky—it can be 70 degrees at Christmas and 40 degrees at Easter—so multiseasonal fabrics like gabardine are preferred. • Because the West is oriented toward outdoor athletics, women like showing off their good figures with short hemlines and form-fitting clothing. In the eighties, many Texans moved to the area, imparting some of their characteristic fashion flashiness to the social scene. • There are more charity functions per capita in Denver than in any other city in the country, so there are many occasions for formal dress. Women's evening wear is understated and elegant. The little black cocktail dress predominates, but women will wear ankle-length gowns for very grand events. • Currently, there is an economic upsurge and real estate boom; a lot of the real estate brokers are women, who wear traditionally styled knit suits in urban colors like black, navy, and taupe, but with higher hemlines. • The jewelry is simple: perhaps a diamond engagement ring, a good watch, and earrings with real jewels. Otherwise, women do without adornment. Southwestern silver jewelry—without the turquoise—is popular. • Shoes are considered important accessories, and women invest in elegant brands.

SOUTHEAST (ATLANTA)

Women are practical, but not prissy. • Style is always ladylike. • Women wear suits, not separates. • Big gold earrings are popular basic accessories. • Tailored feminine elegance is admired more than trendy extremes. Huge ballgowns are considered excessive. • Dresses, not pants, are worn

for evening. • Traditional taboos are respected: after Memorial Day and before Labor Day is the only time of year to wear black patent leather or white shoes. Wearing black to a wedding is unwelcome. • It's too hot to wear a lot of makeup; besides, it's considered unladylike.

SOUTHWEST (HOUSTON)

While subtler fashions are also in evidence, big blond hair, bright clothes, and big jewelry are popular. • Genuine 24-karat gold jewelry is worn at all times of day: gold earrings, necklaces, bracelets, and watches can be worn all at once. • Accessories are taken seriously: the right scarf or bag is considered important. • No day-to-evening looks. Every occasion has its own requirements: there are distinct looks for brunch, lunch, cocktails, dinner, balls. • Separates are popular, and women do mix new items with pieces in an existing wardrobe. • White-tie is commonplace. Men wear a "Texas tux"—a tuxedo with cowboy boots. Women wear proper full-length "statement" gowns. • Hats are worn; they are simple and unadorned. • When the temperature is below 50 degrees, women wear fur. • Bold colors are popular (red, purple, yellow, pink, bright green). For neutrals, women wear grey instead of black.

TROPICAL (MIAMI)

Miami is distinct from much of Florida because it is no longer simply a resort destination but a burgeoning year-round community. Miami has been called "The Capital of the Caribbean." Several looks are prevalent: "safe" suburban, South Beach trendy, wealthy society, and urban cosmopolitan. • Typical career women wear skirts to just above the knee and traditional pumps (no stiletto heels). • Popular colors are bright, and women favor off-white for winter, stark white for summer. Electric pastels are not the norm anymore. Because of the influx of South American business people, the business-wear taste is swinging toward a cosmopolitan preference for dark colors. • Sunglasses are an essential status accessory • Evening dress for the South Beach set tends toward barer styles. The less fashion-forward wear

full-length evening dresses to the ankle for black-tie functions. Formal evening events tend to take place from October through June. • Women who have fur coats will wear them once it gets below 60 degrees—even if it's a full-length black mink. • Classic precious jewelry is worn day-to-day. Dramatic, real jewelry with large precious stones is worn to formal affairs. • Few women wear suede clothing or shoes, which is more common in colder climates.

WEST COAST (LOS ANGELES)

Women like progressive fashion and tend to respond to each season's new trends. • Matte gold jewelry—especially in earrings, bracelets, and signet rings—and silver jewelry with semi-precious stones are both popular. • Backpacks are a popular fashion accessory. • Women wear short dresses or tuxedos for formal occasions. • Clothes gravitate toward the anonymous urban palette: black, white, beige. • Pants suits are popular for work wear, but women usually buy both the skirt and pants with a jacket for flexibility. • Women buy multiples of their favorite shoes. • The weather is predominantly warm, but wealthier women will buy furs for travel.

> ## "Clothing in Los Angeles is not for amateurs. There is a whole local aesthetic addressing the issue of sunglasses alone."
>
> SUSAN ORLEAN

WEST COAST (SAN FRANCISCO)

Women are sophisticated, formal, and European in style. • Weather is variable (long springs, cool summers; September and October are the warmest months) and demands a seasonless wardrobe. Light wool crepes and seasonless silks are favored; there is little need for heavy winter overcoats or clothing for steamy climates. • Women here enjoy forward-looking style and structured clothing—they're not scared of corsets. • Day-to-evening looks are popular because so many people go to early dinner straight from work. • Sweater sets work well because the temperature drops at night. • People look pulled together and would rather overdress than dress too casually. Men will wear ties to informal private dinner parties.

MOVING TO A NEW NEIGHBORHOOD

If you're worried about what your neighbors will think of you, maybe you should consider living somewhere else. But here are a few thoughts to keep you from losing too much sleep over keeping up with the Joneses. • Wear your more conservative clothes until you get a sense of the local style and culture. • If climate or environment require you to overhaul your entire wardrobe, you might want to wait until you arrive in your new town before buying new outfits. • When you shop, take along a local friend whose taste you admire. • Even if you have to change colors or fabrics to suit a different climate, remember that the basics are always going to serve you well.

Career

THE JOB INTERVIEW

You have two objectives here: survive the interview and get the job. A few words about living through the experience: • Look your best. You will act more confident. • Play it safe. Wear something you don't have to worry about. Short skirts, wrap skirts, very tight tops, fabrics that wrinkle easily—save these for a less pressured situation. Skirts should be of conservative length and cut (narrow and to the knee, or just above). • Just Say No to sarongs, bare legs, exposed toes, flashy jewelry, facial piercing, fishnets, high-cut slit skirts, and grunge fashions. Avoid sheer clothing, tight clothing, wrinkles, excessively high or clunky shoes, or overtly sexy clothing. • Keep an extra pair of hose in your purse. • Safe suits: charcoal, beige, grey, navy, burgundy, black. • Safe shoes: those with 1½-inch heels or lower. • Safe hair: neat, and out of your face. • Safe makeup: neutral and subtle. • Scrutinize yourself in the mirror before you go. How does it look when you sit down? Do you have to do a lot of tugging to look decent in a standing position? Do you look at ease in your clothes? • Try to fit your style to the style of the place at which you are interviewing, but don't wear something you would never normally wear—your discomfort will show. Looking respectful and mature, and erring on the side of conservatism, are more likely to get you through. • If you think you look too young, conservative business attire can make you look older and more serious. • Don't worry if you look more formal than your interviewer. He or she has a job, and you don't. • Don't assume that one gender is more forgiving of sartorial indiscretions than the other. Both sexes can be brutal.

TRADITIONAL FIELDS

Business, law, medicine, insurance, banking: Tailored, conservative outfits are best. Nothing should distract from your main purpose: to do the job well and efficiently. You do not need to dress like a man—you are not a man, and that's something to be proud of.

> ## "Nearly every glamorous, wealthy, successful career woman you might envy now started out as some kind of schlep."
>
> HELEN GURLEY BROWN

CREATIVE FIELDS

Journalism, publishing, multimedia, advertising, graphics, art galleries: Your own style is more important here. You are being hired for your creative talents, so show them off in a subtle way, by dressing with personal flair. While on the job, journalists in particular should learn to match their wardrobe to their assignments.

SERVICE-ORIENTED JOBS

Retail, restaurants: These jobs are all about looking presentable. Try and get a sense of what the company's style is before you go in for your interview. Then adapt your own.

PUBLIC SPEAKING AND TELEVISION APPEARANCES

People often form their impression of you within the first seven seconds of your meeting, so think about what your clothes are communicating and whether it's helping you get your message across.
• Appear at ease. Wear comfortable clothes that you feel look good on you. You will appear comfortable with who you are. • Wear safe colors: neutrals like navy and beige look well on television. Dark colors are always slimming. Black can give definition if there is shape to the garment, or it can be accented with a bright-colored blouse or scarf. White is too bright for television. Blues, dusty pink, magenta, sunny yellow, and deep reds all show well on TV. On-camera, bright red may cause some dissolution in a garment's silhouette, but the color does register strongly, attracting attention and signaling power. • Beware of patterned fabrics—they may create a moiré pattern on the television screen. Muted vertical stripes, however, can have the effect of elongating your body, and because they are subtle, they tend not to wreak havoc on the screen. • Wear sleeves—bare arms catch the light and distract. • A scarf can add a complementary splash of color and be a good camouflage for a thick neck. • Avoid hats. • Wear glasses with a nonglare coating. • Jewelry should have a matte,

textured, or florentine finish. Shiny jewelry may flash under intense lighting. Under bright lights, gold and pearls have a warmer reflection and tend to look better than silver. Steer clear of dangling earrings and jewelry with multifaceted stones, which catch the light and are distracting. • Hair looks best off the face. Bangs may make you look young, but they can undermine your authority. If you have a tendency to toy with your hair, pull it back. • Television makeup is more dramatic than everyday makeup. Remember that the camera adds weight to your face, so accentuate your best attributes. • Dress the part. Don't wear something that distracts from what you are saying. When delivering your message, always consider who your audience is.

GETTING THE MESSAGE ACROSS

Don't fidget—even small movements are noticeable, especially on television. • Watch your posture. It can affect everything from how your suit looks to the strength of your voice. • Choreograph your gestures to correspond to what you are saying. • Maintain eye contact with the interviewer, not the camera, during a television interview, shifting your focus from one eye to the other of the interviewer. (This adds sparkle to your face.) Remain calm enough to remember what others are saying. Don't recite scripted phrases—you will sound insincere and robotic. • Make sure your voice has a round, resonant sound. End your sentences on a solid note, so that they have the air of statements, not questions. Practice talking into a tape recorder to work on articulation.

[Experts consulted: Kathleen Ardleigh, Senior Vice President, Ailes Communications, New York, and Dorothy Sarnoff, Chairman, Dorothy Sarnoff Speech Dynamics, New York]

"listen:there's a hell of a good universe next door;let's go"

e.e. cummings

Travel

Unless you're traveling for business (in which case basic business attire is almost always what is called for), you are traveling to see and experience other cultures. Respect is the operative word. Some general notes:
• Most countries—especially developing countries—are more conservative in dress than the U.S. Longer skirts, no shorts, no low-cut blouses, no tight clothing, some kind of head covering, shoes on your feet—these are the basic rules. Read a guidebook before you go to find out the specific customs of the place you are visiting. You will feel more comfortable, and so will your hosts. • Generally, women should dress more conservatively when traveling alone. Sometimes wearing a wedding band can discourage unwanted attention. • Style in cities is often less conservative than it is in rural areas. • Be prepared for very specific rules regarding dress whenever you are visiting a religious site. The usual code involves covering your head, arms, legs, and feet—or some combination thereof. Slip-on shoes can be very useful for visiting shrines and mosques, as you will be expected to wear slippers or socks inside. A scarf can be an instant hat, convenient for respecting local customs. • Steer clear of native dress unless you learn otherwise. It can look patronizing and silly. • Bring at least one bathing suit that has some coverage, until you're sure about how much skin is too much on the beach. • Bring something nice for the evening. It doesn't have to be fancy, but in most places outside the U.S. people change clothes for dinner. In some countries you may be eating on a floor or mat; it's important that you dress appropriately and comfortably so that you will be able to bend your legs to the side without being too revealing.

AFRICA

Generally, in rural areas skirts should be below the knee. Arms, underarms, and shoulders should be covered. Jeans and shorts are usually

appropriate in the city, and formal wear is only very rarely required.

• Dressing neatly and cleanly is a sign of respect. It is important to wear well-pressed clothing, particularly when visiting a private home or a business office. • Throughout the Ivory Coast, the residents dress primarily in French style and are very fashion conscious. Loose pants and dresses are both stylish and comfortable. • In Zimbabwe, dress is quite Westernized. Loose-fitting pants or skirts that are not revealing are most appropriate. • Tennis shoes and sandals are often not appropriate for restaurants, which may have a dress code. • In Uganda, unlike many other African countries, it is appreciated when Westerners wear the national dress on special occasions. This long cotton gown with a sash is called a *busuti*. At other times, a dress or skirt is most appropriate, especially in villages. • It is crucial not to wear camouflage or military dress. In some countries this dress may be perceived as that of a mercenary, while in others it is actually illegal. • For viewing game, wear jeans and a parka or windbreaker. • Shorts are generally acceptable on the beach or in a private home, but otherwise should not be worn outdoors. • There are some topless beaches in Senegal and South Africa. However, be sure to check ahead of time about how conservative the dress on a particular beach will be. In Uganda, Nigeria, Kenya, and Ghana, for example, going topless would be considered offensive or shocking.

> "From the earliest times, cavemen in South America and Africa covered their bodies with mud, applied in decorative swirl and circle patterns. This first fashion effort is protective as well as attractive—the mud helps repel insects."
>
> LYNN SCHNURBERGER

ASIA

Many Asian countries can be very hot and humid, so you will want to pack clothing made of natural, not synthetic, fibers. Because they breathe, fabrics made of natural fibers are much more comfortable. Cotton, linen, and silk are best.

• Hosiery may not be necessary in countries where it is extremely hot. • In China, pants suits are particularly appropriate, since Chinese women often wear pants. • High heels, expensive purses, and flashy designer clothes are viewed as extravagant and unnecessary. • Wear as little makeup and jewelry as possible. • In China, rubber-soled shoes are a must for visiting factories and communes, which may be muddy. • White should not be worn to a traditional Chinese wedding, since this is the color associated with death. • Wearing saris is acceptable in India, but they can be difficult to put on. • In Malaysia, yellow is the color of royalty and should not be worn to formal functions or when visiting the palace. • Wearing the native dress is welcomed in Pakistan. This consists of a long blouse, called a *kameez*, worn over pants, called *salwar*. Jeans are also perfectly acceptable on the street. • Black should not be worn in Thailand, where it is considered funereal unless strongly accented with color.

JAPAN

In general, women are stylishly dressed.

• For business, all neutral colors are appropriate, except black, which is viewed as funereal. Red is considered flashy and inappropriately sexy. • Overcoats are considered unclean, so it is important to remove them in the hallway and carry them, rather than wearing them into an office for a business meeting. • In private homes or restaurants, you may be seated on tatami mats during dinner. You will be expected to remove your shoes at the entrance. Wear good hosiery and a loose skirt, and sit with your knees bent and to one side. • Shorts should never be worn except at a resort. Going topless at the beach is against the law. • You may be lent a kimono while staying at an inn or private home. Be sure not to fold the right side of the kimono over the left side, since this is a traditional symbol of death. • Japanese are extremely fashion and designer conscious. Conservative, quality accessories (scarves, handbags, shoes) are respected status symbols.

LATIN AMERICA

Any dress that is not revealing or provocative is acceptable. Casual wear means a shirt or blouse with fashionable pants or a skirt. Formal wear is rarely necessary.

• Throughout Latin America, shorts should be worn only at the beach. Appearing nude or topless on beaches is extremely offensive, particularly in Costa Rica. • In Argentina, bathing suits should be conservative; in Brazil they can be more revealing. • Native clothing should not be worn in Bolivia or Peru. • Be sure not to wear green and yellow clothes together in Brazil, since these are the colors of the Brazilian flag. • In Colombian and Guatemalan villages, only dresses and skirts should be worn.

> "... I landed at Orly airport and discovered my luggage wasn't on the same plane. My bags were finally traced to Israel, where they were opened and all my trousers were altered."
>
> WOODY ALLEN

MIDDLE EAST

Throughout the Arab world, shoulders should be covered, with sleeves at least three-quarter length and skirt to mid-calf or longer.

• Should a formal occasion arise, a cocktail dress with sleeves is appropriate. • A shawl should be a part of daily wear in Arab countries, folded and draped over one shoulder and used to cover the shoulders and head when visiting a mosque. Long sleeves are also customary. • Women may want to wear sunglasses to avoid eye contact with men, a Middle Eastern taboo. When sitting, women should cover their legs completely. • Arabs will be offended if you point the soles of your shoes or feet toward them. This action traditionally signifies contempt. • Visitors should wear modest dresses that cover the knees. • Jackets are excellent business wear because they look professional and are not too revealing. • Israelis tend to be very casual. Jeans and shorts are appropriate, except when visiting a religious

site. But dresses and skirts should fall below the knee, and shoulders should be covered. • Formal dress is rarely required. • Sandals are appropriate as everyday footwear in Israel.

"The wise traveler [to Beirut] will pack shirts or blouses with ample breast pockets. Reaching inside a jacket for your passport looks too much like going for the draw and puts armed men out of continence."

P. J. O'ROURKE

PACKING TIPS

HOW TO PACK A JACKET

1. To begin with, empty all the pockets. 2. Hold the jacket facing you by placing your hands inside the shoulders. 3. Turn the left shoulder (but not the sleeve) inside out. 4. Place the right shoulder inside the left shoulder. The lining is now facing out, and the sleeves are inside the fold. 5. Fold the jacket in half, put it inside a plastic bag, and place it in your suitcase.

HOW TO PACK PANTS

1. Check to make sure all pockets are empty since keys or change may damage the fabric once the pants are packed. 2. Pants should always be the first item packed in a hard case, so place them on the bottom, with the waistband in the middle of the suitcase and the legs falling outside the bag. (If you are packing two pairs, place them waistband-to-waistband, with the legs extending in opposite directions.) 3. Pack the rest of your things on top, and then wrap the pants legs over the pile, placing one last remaining item over the legs to hold everything in place.

HOW TO PACK A SHIRT

1. Button all buttons, noting which front button falls below your waist. 2. Lay the shirt face down on a flat surface and fold the sleeves back at the shoulder seam. 3. Fold the tail up from the point of the button that is below your waistline. This will prevent the unpacked shirt from having a crease across your stomach. (Note: If you can plan ahead, have your shirts cleaned and folded at the laundry before your trip. Also: It's very hard to tell if a checked shirt is wrinkled.)

HOW TO PACK SHOES

1. Shoes should always go in a bag—either cloth ones that can be laundered, or disposable plastic bags. 2. Place shoes along the edge of a hard case to keep your folded clothes from shifting. In a duffel, shoes get packed first, at the bottom. 3. Shoes can carry socks, a coiled belt, extra eyeglasses, or overflow from the toiletry kit, like a tube of sunscreen (to be safe, wrap it first in a plastic bag). Tip: Always wear your heaviest shoes for traveling, since they are probably heavy because they're comfortable and sturdy—also, you won't have to carry them.

LAST ITEMS:

1. Pack your small camera, film, personal stereo, or travel alarm into shoes for protection. 2. Always take more socks and underwear than you think you'll need; also, they can take up space to keep clothes from shifting. 3. Pack more pants and skirts than jackets. 4. Pack a collapsible bag for items acquired on the trip. 5. Bring a light sweater or shawl for airplanes. 6. Always bring a pair of thick wool socks—at some point your feet will inevitably get cold.

"There is a time for departure even when there's no certain place to go."

TENNESSEE WILLIAMS

F I T T I N G S

THERE ARE MOMENTS WHEN WE THROW UP OUR HANDS AND SHAKE OUR HEADS IN DEFEAT. THESE TIMES OFTEN OCCUR WHILE WE LEAF THROUGH FASHION MAGAZINES FULL OF PERFECT BODIES IN perfect clothes. We know those women are airbrushed, but somehow that doesn't make us feel any better. Then again, there are the other times when we catch a glimpse of ourselves looking splendid. We are amazed. Others comment on our radiance. And chances are, we are wearing something that makes sense for our body. Consciously or unconsciously, we have considered which parts need the spotlight, and which ones would be better off left backstage. We've pulled a few other tricks out of the bag as well: standing a little straighter, touching up our makeup, and fixing our hair. But the bottom line is that we know we look great, and that's a good feeling.

Basic Tricks for Everyone

Dark colors are slimming. • From head to toe, monochromatic outfits create the illusion of height and de-emphasize individual flaws or lack of proportion. Separates in different colors break up the body and highlight each area. • Horizontal stripes emphasize the horizontal, making one look broader. Vertical stripes emphasize the vertical, visually elongating the body. • Be sure to keep it simple in your problem area, wherever it may be; elaborate attempts to camouflage a body part will often call more attention to it.

GENEROUSLY SIZED BODIES

There's nothing like an impeccable outfit, a flattering haircut, and good personal grooming to refute the uninformed perception that generously sized women are undisciplined.

BAGS. Avoid bulky shoulder bags that rest around the middle part of your torso; they only add bulk and call attention to that part of your body. Instead, carry flat bags, briefcases, or totes that draw the eye away from this area of the body .

BELTS. For hourglass figures, a belt can define the thinnest point.

FABRIC. Loose, long, flowing layers of lightweight fabric are flattering. Make sure that the fabric is tightly woven, however, because it will hold its shape better. Avoid large patterns. Keep in mind that dark colors are slimming. If you want to add a bright color, do so in a long, slightly fitted blazer, oblong scarf, or vest.

JEWELRY. Long necklaces, pendants, and dangling earrings can elongate the face; a pin at the shoulder can distract from a thick waist. If your neck is thick, avoid jewelry that calls attention to

it, like chokers. Wear one bold piece, not a battery of them. Rather than camouflaging a body part, jewelry calls more attention to it. (However, it is alleged that Coco Chanel draped herself in jewelry to detract attention from her body.)

PANTS. Avoid pants in general, and especially those with straight-cut legs; wear pants only if full-cut and topped with soft layers of vest and blouse, or a big soft sweater. A blazer that covers your hips and derriere also can create a good line.

SKIRTS. Unless your legs are fit, avoid short skirts and look for long, narrow skirts with elastic waists or loose, flowing skirts. Avoid flouncy skirts; the added fabric only enlarges the silhouette.

TOPS. Cover buttocks with either a loose top, jacket, vest, or sweater. Don't tuck in outershirts.

UNDERWEAR. Proper-fitting, structured undergarments can streamline a silhouette.

PETITE BODIES

STYLE. Tailored clothing defines the body. Avoid excessively oversized, boxy clothes, lots of pleats, and large volumes of fabric; they can swallow up a petite frame.

ACCESSORIES. Choose accessories carefully; small women can look cluttered and be easily overwhelmed by large pieces.

ALTERATIONS. Keep proportions in mind while preserving the intended style. For example, don't just hem pants that are too long; consider tapering the leg.

BELTS. If the waist is a strong point, favor narrow over wide belts.

DETAILING. Make sure details are in proportion: avoid large lapels, buttons, or cuffs.

DRESSES. Since well-fitting, matching separates may be hard to find, dresses are a good solution.

HAIR. A close-cropped hair style makes the head appear smaller and thus elongates the body.

PATTERNS. Large patterns can overwhelm; avoid plaids, polka dots, and stripes.

SKIRTS. Avoid stiff A-lines; they create a squat silhouette. If your legs are good, short slim skirts are flattering because they create the illusion of longer legs.

Above the Waist

DOUBLE CHINS/SHORT OR THICK NECKS

HAIR. If you have a narrow face and short neck, short hair can elongate the neck by exposing more of it. Wearing your hair up also gives the appearance of a longer neck.

JEWELRY. Wear long necklaces and small earrings. Don't wear chokers, attention-getting necklaces, or dangling earrings, all of which draw the eye to the neck.

SCARVES. Wear oblong scarves loose or knotted far below the collarbone. Don't wear scarves tied around the neck—they will diminish neck length and attract attention to the chin.

TOPS. Anything that shows more neck will visually elongate: V-necks, scoops, open shirts over a camisole, or strapless tops. Avoid jewel-necks and anything that ends at the collarbone. High turtlenecks will help to hide a double chin.

LONG NECKS

HAIR. Don't wear it super-short; if you want to shorten the appearance of the neck, wear hair that covers the neck.

TOPS. Look for high-necked clothing: cowls, ascots, Nehru collars, and turtlenecks, all of which minimize the length of the neck. Avoid off-the-shoulder necklines and V-necks. Also consider wearing a scarf at the neck.

> ## "I like a woman with a head on her shoulders. I hate necks."
>
> **STEVE MARTIN**

BROAD SHOULDERS

COATS. Unstructured dolman or raglan sleeves look good. Avoid any style that calls attention to the shoulders: trench, safari, coachman, or Sherlock Holmes.

PROPORTION. If you're slender, loose clothes below the belt will balance out the upper body.

TOPS. Break up the width of your shoulders with V-necks or deep scoop necks; wear fabrics that drape easily. If you wear straps (camisoles, spaghetti straps), choose ones that hang near the neck and draw the eye in from the shoulders. Avoid halter tops; they emphasize shoulder width. Don't wear anything that emphasizes shoulders, such as shoulder pads, stiff fabrics, horizontal lines, wide scoop necks, square necks, strapless styles, Western yokes, or epaulets.

NARROW OR SLOPING SHOULDERS

COATS. Look for coats that have a defined shoulder, such as coachman, Sherlock Holmes, trench, or safari.

TOPS. Wear shoulder pads, but be sure they rest comfortably on the shoulders—if they are too large or move around, they will look sloppy and overwhelming. Also effective are oversized tops, boatnecks, cap sleeves, epaulets, off-the-shoulder styles, and halters. Avoid drawing attention to the center of the body by staying away from neckties, long necklaces, oblong scarves, and tight tops; these call attention to the fact that the hips are wider than the shoulder. Soft-shouldered designs like kimonos, or raglan or dolman sleeves, do not help equalize the silhouette.

LARGE BUSTS

BELTS. Don't wear wide belts and other styles that shorten the upper body and therefore call more attention to it.

BOTTOMS. If you are slender below the waist, wear pants or skirts in brighter or lighter colors than the top, or patterns. This will deemphasize the top and make the bottom part of your body appear larger.

DRESSES. Avoid empire bodices.

TOPS. Draw the focus away from the upper body with V-necks, open collars, scoop necklines, or large but unfussy designs. Unlined, unstructured, flowing tops or jackets in gently fitted styles are flattering. Make sure there's enough room to move freely. Avoid tight blouses or bodysuits, boxy jackets, flap or patch pockets

over the chest, buttons over the chest, and off-the-shoulder, strapless, and halter tops.

UNDERWEAR. Wear a supportive underwire or minimizer bra with wide shoulder straps.

JEWELRY. Use jewelry to distract from your chest: wear bracelets and earrings. Don't wear pins, necklaces, or pendants that hang low.

SMALL BUSTS

TOPS. Tops should be of brighter or lighter colors than bottoms. Wear anything that accentuates the upper half of the body, such as loose tops with ornate detailing, layers, pockets, off-the-shoulder styles, and tight tops.

UNDERWEAR. Wear pushup, padded, and underwire bras to accentuate the bustline.

HEAVY ARMS

TOPS. Loose, long sleeves are best, or try bell or angel sleeves. Avoid anything that reveals the upper arm.

> "I think the human body is a glorious thing. But I really think it's more exciting for a woman to be dressed. It's sexier."
>
> **DYAN CANNON**

SMALL WAISTS

BELTS. Wear wide or plain belts that call attention to this feature, but beware of nipping in too much at the waist, as this can draw too much attention to the hips.

THICK WAISTS

BELTS. Avoid belts altogether if you can; if necessary, narrow or medium-width belts in dark colors are less attention-getting. Avoid brightly colored or contrasting belts.

COATS. Emphasize the shoulders to detract from the waist. Try straight, unfitted coats, or yoked or Sherlock Holmes styles.

DRESSES. Drop waists, empire bodices, and A-line or sheath dresses are recommended.

PANTS. Try sewn-in waistbands or elastic waists.

SCARVES. Oblong scarves that drape over the body will detract attention from the waist.

SKIRTS. Long and full skirts, or short ones, will help draw attention to the legs and away from the waist.

TOPS. Emphasize shoulders and neckline: oversized, blousy, loose-waisted tops are all good, as are tunics, or wrapped styles, and shoulder pads. Avoid tanks, tube tops, cropped tops, and fitted blouses.

UNDERWEAR. Control undergarments that cinch the waist are effective.

VESTS. Below-the-waist vests can be extremely flattering.

LONG-WAISTED FIGURES

BELTS. To visually shorten the upper body, wear plain belts the same color as pants or skirt .

PANTS. Wear high-waisted, fitted, or full-leg pants—pants that cover the foot's instep visually extend the leg. Avoid hip-huggers, low-slung men's jeans, or pants with cuffs.

TOPS. Tops should emphasize shoulders and arms. Off-the-shoulder, strapless, halter, or cropped styles are ideal, as are short-sleeved knits. Avoid anything frilly down the middle, anything long and fitted, belted tunics, and short vests, unless they're worn over an untucked loose blouse.

SHORT-WAISTED FIGURES

BELTS. To elongate the line of the upper body, wear belts the same color as ther top. If hips are narrow, wear belts low, below the natural waistline. Avoid flashy buckles or wide, colorful belts.

PANTS & SKIRTS. Hip-huggers or "low-rise" pants, no-waistband pants, or low-slung skirts look well. Avoid high-waisted pants and skirts, and those with wide waistbands.

TOPS. Wear jackets, vests, tops, and tunics that hang below the waist to elongate the line of the body. Deep scoops, belted tunics, and surplice tops also look well. Avoid tucking in clothing severely; let it blouse a little.

> "A dress has no meaning unless it makes a man want to take it off."
>
> **FRANÇOISE SAGAN**

Below the Waist

SHORT LEGS

COATS. Short coats elongate the leg.

SKIRTS. If the legs are in shape, short skirts are a good way to create the illusion of length.

PANTS. Leggings, stirrups, Capris, pedal pushers, and cigarette-leg, narrow, or cropped pants all enhance the line of the body. Avoid wide-leg pants, pleats, and cuffs.

TOPS. Short tops give the illusion of a longer leg.

LONG, THIN LEGS

PANTS. If you want to minimize their proportion, try wide-leg, pajama-style, bell-bottomed, palazzo, or harem pants. Overalls and pleated or cropped pants are also flattering, as are those with baggy pockets, patterns, stripes, or cuffs.

SKIRTS. Short skirts show off great legs. If you feel your legs are too thin to appear sexy, a long skirt with a slit or with buttons up the front can create allure.

WIDE LOWER BODY

DRESSES. Unless you have a small waist, choose dresses that are beltless, with straight lines. Tailored, structured dresses that drape from the shoulder, empire bodices, and dresses with long, slightly fitted jackets are also effective.

PANTS. Don't wear tight pants.

TOPS. Wear shoulder pads, loose, long vests, or blousy tops loosely gathered at the hips over leggings or a slim skirt. Avoid tight tops and short jackets. Don't tuck in clothes tightly at the waist.

BIG THIGHS

PANTS. Look for soft, minimally detailed, wide-leg pants; jodhpurs with the exaggerated upper leg (because it looks like the style of clothing, not you) or heavy fabric in a wide, straight-leg style. Avoid tapered pants that emphasize the difference between calves and thighs, and pants that are pleated or side-pocketed. Dark colors are slimming.

SKIRTS. Wear loose skirts with a drape or soft pleats. Avoid Lycra-blend narrow skirts unless your top covers your thighs.

TOPS. Wear loose and off-the-shoulder tops. Fitted jackets that flare over the thighs and long jackets can also work well. Bright, light colors and horizontal stripes draw attention away from your bottom half.

UNDERWEAR. Try slimming thigh undergarments.

TUMMY BULGE

PANTS. Narrow-leg pants under hip-length tops are flattering. Side and back zippers look better than button flys and front zippers. Avoid front pockets and anything tight.

SKIRTS. Try soft A-lines that drape nicely. Avoid clinging, tight waistlines, as well as anything with lots of pleats, and sarongs.

TOPS. Wear jackets, vests, and tops in roomy, boxy shapes that cover the stomach.

SADDLEBAGS

PANTS. Try baggy, waist-widening pants—if the waist appears wider, the hips will not seem so wide. Avoid slim, narrow-legged pants. Dark colors are slimming; avoid patterns.

SKIRTS. Pleats should start below the hips.

TOPS. Vests, untucked or long shirts with straight, narrow skirts and pants, scoop necks, décolleté, and off-the-shoulder necklines—all call attention to your upper half. Drawing attention to arms and shoulders distracts from hips: kimonos, dolman sleeves, epaulets, and blouses in puffed, peasant, or Gibson styles are all effective. Avoid anything that ends just at the hipline. Wear horizontally striped or brightly colored tops.

LARGE BUTTOCKS

COATS. Long coats, capes, or swagger-backed styles are best.

PANTS. Wear wide-leg trousers that minimize the difference between thighs and rear. Avoid back pockets or anything tight. Dark colors are slimming.

SKIRTS. Skirts are more flattering than pants, especially when loose and draped, and when paired with a jacket or vest that covers the rear. Avoid Lycra fabrics and bias-cut skirts.

TOPS. Wear vests and blazers that cover the rear. Avoid cropped tops.

FLAT BUTTOCKS

COATS. Belted coats impart shape.

PANTS. Seek out styles with pockets and pleats if hips are narrow. Avoid fitted styles, patterns, and back pockets (they just call more attention to the buttocks).

SKIRTS. Experiment with Lycra fabrics or anything tight; try bias-cut skirts.

TOPS. Peplums are effective, as is anything waist-emphasizing (if the waist is a strong feature). Pair vests that cover the rear with straight and narrow skirts and pants. Avoid anything cropped above the rear.

UNDERWEAR. Butt-boosting underwear gives buttocks a lift.

> "Boy, I wish buying clothes was about clothes. I hate character analysis in front of a three-way mirror, especially when I am looking at the back reflection."
>
> ANNA QUINDLEN

THICK ANKLES

HOSIERY. Dark is best.

PANTS. Avoid cropped and body-hugging pants.

SHOES. Solid-colored, unadorned. Low vamps elongate the foot; shaped medium heels make legs look longer. Avoid straps and detailing around the ankle, chunky heels, or stiletto or very high heels, because their narrowness sharply contrasts with the width of the ankle. Boots can have a magical effect.

SKIRTS. Long and loose, worn with above-the-ankle boots. Avoid flouncy skirts with borders that call attention to the calves and ankles; eschew miniskirts.

S H O P P I N G

How to Read a Price Tag

What's the difference between a $300 and a $3,000 garment—for example, a suit?

FABRIC

The cheaper suit will be made of cheaper fabric. It may be adequate, but it will not have been chosen especially by the designer for its drapability, hand, strength, or softness. And it may not have as good a memory—the ability of a fabric to hold its shape after multiple wearings—as pricier fabric. The expensive suit, by contrast, is designed in the best fabric the designer could find to realize his or her vision, with little regard for cost.

MANUFACTURING

The cheaper suit is a mass-market item. Machine-made, it is probably manufactured in a country where labor is cheap and quality control is not necessarily a priority. The expensive suit is produced in very limited numbers. You may own one of only forty. It is made—very possibly by hand—in a country where labor is expensive and quality control is very important.

DETAILING

Machine detailing is not as strong, luxurious, or subtle. It cannot allow for the irregularities of the human form the way hand detailing can, so the cheaper suit may not fit as well as the expensive one.

DESIGN

Some designers create more conservatively for their "bridge," or cheaper, lines than for their collection lines, which they fill with their more forward-looking designs.

PRIVATE LABELS

Big stores often hire in-house designers to come up with a private-label collection. It's a way of cutting costs for the store—the branded manufacturer is eliminated—and selling pieces more cheaply to the consumer. In other words, a winwin situation, right? Not necessarily. There are really two kinds of private labels: those that make vast profits for the store by selling poorquality merchandise "on sale" at prices well above what the items are worth, and those that are used to create or perpetuate an image for a store that prides itself on high quality and value for its customers. Here are some tips to help you figure out what's what on a private label:

• The poor-quality private label is often on sale at huge markdowns and at unpredictable times of the year, when nothing else in the store is on sale. • The good-quality private label rarely goes on sale except when everything else does—to clear the racks at the end of the season. • The poor-quality private label is often item-driven: one style in twelve different colors instead of a range of styles. • The poor-quality private-label stores will often be heavily advertised. • The good-quality private label should have the look and feel of designer merchandise, but at a price that is about one-third less. • The good-quality private label should be displayed on racks near designer merchandise. • Beware of falsely created store designer names. If a store has more than a dozen of a particular item, it often means they manufactured it. • Check the actual labels in the clothing: they can tell you a lot about whether a store is taking trouble over its private label or not. Are they centered? Are they nicely woven or cheaply printed? Are they sewn in or glued on? • Check the clothing itself. Are there loose threads? Are they made of cheap fabrics in strange colors? What is the country of origin?

How to Shop

If you find yourself bringing home clothes you never wear, here are a few pointers:

• Shop for who you are now, not who you will be five pounds from now. • Buy something because it looks great on you, not because it looks great on a fashion model in a glossy spread. • Let your own legs determine how long or how short your hem should be. • Sizes are relative. Buy what feels comfortable, not what size you thought you were. If you're comfortable in it, you're more likely to wear a garment. • Before you buy, check yourself in the mirror in as many positions as you can—especially sitting down. • Put things on hold if you need more time. If you're going to a series of stores, maybe you'll come across something later that works better. Thinking things over reduces the chances that you'll buy on impulse. • Key times to hit the stores: summer clothes go on sale after Memorial Day; winter items, after Christmas. However, for a variety of economic reasons, the number of sales held during the course of a year has increased. • Avoid pushy salespeople, and beware of those who flatter you too much. When you find a salesperson who speaks your language, stick with him or her. If they're really good, think about helping them out by dropping a line to their manager. • Beware of sales if you're prone to impulse buying. Before you go out, reassess what you have and make a list of what you need; then try to stick to it.

What to Wear When You Shop

Wear clothes that are easy to slip on and off, or a bodysuit that you can fit things over. • Wear slip-on shoes—pumps and stockings if you are buying a dress or suit. • Wear simple clothes—tube skirts, leggings—without a lot of buttons and zippers. • Don't wear a lot of accessories that can slow you down or catch on the clothes you're trying on. • Don't wear a lot of makeup or get your hair done before going shopping.

• Underwear should be smooth and relatively seamless, so that delicate items will drape nicely.

Glamour on the Cheap

Rent-a-gown stores. • Vintage-clothing stores. • Borrow from friends with good taste. • Take a design to a seamstress. • Rummage through the attics of stylish relatives.

Mail Order

It can be more expensive, and a mistake may cost you some postage (not to mention the hassle of going to the post office), but the advantages are many:
• You can try things on in the privacy of your own home and take as long as you want in deciding. • You can try things on with other pieces in your wardrobe and see what works. • You can see things in lighting and mirrors you trust. • You can order as much as you want and then return the rejects. • If you find a mail-order catalogue whose sizes and styles work for you, stay with it. Each company tends to stick to a consistent overall style, year after year.

How to Figure Out Your Size

To arrive at your true dimensions, all you need is a little patience, a tape measure, and maybe someone else to help.

BELTS. Same as pants waist sizes. If your waist is an odd number of inches, buy the belt that is the next larger size.

BUST/CHEST. Make sure to measure around the trunk at its broadest points: keep the tape measure high under the arms and be sure to encompass shoulder blades and breasts.

GLOVES. Measure around the whole hand at its broadest point (do not include the thumb; be sure to measure your right hand if right-handed, your left if left-handed). The size equals the number of inches.

HATS. Measure the crown of the head just above the eyebrows. Convert inches to hat size using the chart below.

HIPS/BUTTOCKS. While standing with feet together, measure around the area where your hips are widest.

INSEAM (FOR ANKLE-LENGTH PANTS). The easiest way to measure is to take a pair of well-fitting pants (down to the ankle) and measure from the crotch seam to the end of the pants leg. Round up the measurement to the nearest half-inch. The number of inches equals the size.

SHIRTS (MEN'S STYLE)

NECK. Measure the collar of a well-fitting shirt you already own. With the collar flat, start at one end (from the middle of the collar button) and measure to the other end of the collar (at the buttonhole). The number of inches is the size.

SLEEVES. With the shirt on, have someone measure from the middle of the yoke (between the shoulders) down the shoulder to the elbow (which should be bent). The size equals the number of inches.

WAIST. While wearing a shirt, measure around your waist, adding a finger's width between you and the tape. The size equals the number of inches.

HAT CHART

GENERAL SIZE	SMALL		MEDIUM		LARGE		X-LARGE	
HEAD SIZE	21$\frac{1}{2}$"	21$\frac{7}{8}$"	22$\frac{1}{4}$"	22$\frac{5}{8}$"	23"	23$\frac{1}{2}$"	23$\frac{7}{8}$"	24$\frac{1}{4}$"
HAT SIZE	6	7	7$\frac{1}{8}$	7$\frac{1}{4}$	7$\frac{3}{8}$	7$\frac{1}{2}$	7$\frac{5}{8}$	7$\frac{1}{4}$

INTERNATIONAL SIZING
dresses, coats, suits, skirts, pants

UNITED STATES	4	6	8	10	12	14	16	18	20
GREAT BRITAIN	8	10	12	14	16	18	20	22	24
EUROPE	32	34	36	38	40	42	44	46	48

shoes

UNITED STATES	4	4$\frac{1}{2}$	5	5$\frac{1}{2}$	6	6$\frac{1}{2}$	7	7$\frac{1}{2}$	8	8$\frac{1}{2}$	9	9$\frac{1}{2}$	10
GREAT BRITAIN	2$\frac{1}{2}$	3	3$\frac{1}{2}$	4	4$\frac{1}{2}$	5	5$\frac{1}{2}$	6	6$\frac{1}{2}$	7	7$\frac{1}{2}$	8	8$\frac{1}{2}$
EUROPE	35	35$\frac{1}{2}$	36	36$\frac{1}{2}$	7	37$\frac{1}{2}$	38	38$\frac{1}{2}$	39	39$\frac{1}{2}$	40	40$\frac{1}{2}$	41

where.

So where do you go from here? The options are practically endless. Check out a few fashion magazines to see what's around. Pick up the phone and order some catalogues. Still searching? Throw on a pair of shoes and head out to the nearest boutique, department store, or mall. Too real for you? Get online and take yourself on a virtual shopping spree. The following information may help.

FREEDOM OF CHOICE

Mail-Order Catalogues

BIRKENSTOCK
800/487-9255
(Shoes)

BOSOM BUDDIES
914/338-2038
(Nursing bras)

CARTIER
800/CARTIER
(Fine jewelry and watches)

CHAMBERS
800/334-9790
(Robes and undergarments in natural fibers)

CINDERELLA OF BOSTON
818/709-1133
(Petite shoes)

THE COMPANY STORE
800/323-8000
(Sportswear)

CRAIG TAYLOR
800/879-4500
(Elegant man-tailored shirts for women)

CURVES
800/417-8370
(Silicone-gel-filled falsies for your bra or swimsuit)

EDDIE BAUER
800/426-8020
(Casual and outdoor wear and gear)

ELITE PETITE
214/241-7307
(Petite shoes)

FREDERICK'S OF HOLLYWOOD
800/323-9525
(Lingerie with sex appeal)

GARDENER'S EDEN
800/822-1214
(Gates Boot Company rubber boots)

GARNET HILL
800/622-6216
(Natural-fiber lingerie and sportswear)

JACK PURCELL/CONVERSE
800/428-2667
(Classic athletic shoes and sportswear)

JC PENNEY
800/222-6161
(Wide variety of clothing, including petite sizes)

J. CREW
800/782-8244
(Sportswear basics)

J. PETERMAN'S COMPANY'S OWNER'S MANUAL
800/231-7341
(Clothing and accessories)

LANDS END
800/356-4444
(Sportswear)

L. L. BEAN
800/543-9071
(Outdoor wear and gear)

ONE 212
800/216-2221
(Fashionable basics, accessories, shoes)

PATAGONIA
800/638-6464
(Activewear)

ROBY'S INTIMATES
800/878-8BRA
(Bras)

S & B REPORT
212/679-5400
($49 annual fee to receive monthly mailer of designer sample sales)

SPEEDO
800/5-SPEEDO
(Swimwear and sportswear)

SPIEGEL
800/345-4500
(Coats, lingerie, accessories, and clothes)

TALBOTS
800/992-9010
800/225-8200
(Clothing and accessories)

TITLE 9 SPORTS
510/549-2592
(High-quality activewear)

TWEEDS
800/999-7997
(Fashionable basics, accessories, shoes)

VICTORIA'S SECRET
800/888-8200
(Intimate apparel)

WATHNE
800/942-1166
(Elegant clothing, accessories, and sporting gear)

National Listings

ANN TAYLOR
800/999-4554 for stores
800/342-5266 for catalogue
(Clothing and accessories)

ARMANI A/X
212/570-1122 for stores
(Giorgio Armani denims and basics)

BANANA REPUBLIC
212/446-3995 for stores
(Sportswear)

BARNEYS NEW YORK
800/777-0087 for store information
(Upscale specialty store)

BASS/WEEJUN
800/777-1790 for stores
(Shoes)

BENETTON
800/535-4491 for stores
(Casual wear)

BLOOMINGDALE'S
212/355-5900 for stores
800/777-4999 for catalogue
(Upscale department store)

BURBERRY'S
800/284-8480 for stores
(Outerwear, clothing, and accessories)

CALVIN KLEIN
800/223-6808 for stores
(Designer clothes)

CASHMERE CASHMERE
800/763-4228 for stores
(Fine cashmere clothing and accessories)

CHANEL BOUTIQUE
800/550-0005 for stores
(Chanel clothes, accessories, and cosmetics)

COUNTRY ROAD AUSTRALIA
201/854-8400 for stores
(Elegant tweeds, accessories, and work wear)

COACH
800/262-2411 for stores
(Handbags and other leather goods)

DAFFY'S
201/902-0800 for stores
(Discount designer clothing)

**DAYTON HUDSON
MARSHALL FIELD**
800/292-2450 for stores
(Upscale department store)

DILLARD'S PARK PLAZA
501/376-5200 for stores
800/DILLARD for catalogue
(Upscale department store)

DOCKERS
800/DOCKERS for stores
(Casual workwear)

EASTERN MOUNTAIN SPORTS
603/924-6154 for stores
(Activewear)

EILEEN FISHER INC.
212/944-0808 for stores
(Relaxed designer clothing)

FERRAGAMO
212/838-9470 for national listings
(Designer clothing and accessories)

FILENE'S
617/357-2601 for stores
(Upscale department store)

THE GAP
415/777-0250 for stores
(Clothing and accessories)

GIORGIO ARMANI
201/570-1122 for stores
(Designer clothes)

GUCCI
212/826-2600 or
800/234-8224 for stores
(Fine leather goods, scarves, and clothing)

HENRI BENDEL
212/247-1100 for stores
(Upscale specialty store)

HERMÈS
800/441-4488 for stores
(Fine leather goods, clothes, and jewelry)

LAZARUS
513/369-7000 for stores
(Major retailer of better women's merchandise)

LEVI'S
800/USA-LEVI for stores
(Denim and sportswear)

THE LIMITED
614/479-2000 for stores
(Sportswear)

LORD & TAYLOR
212/391-3344 for stores
(Upscale department store)

LOUIS, BOSTON
800/225-5135 for stores
(Designer clothes)

**MACY'S
(BULLOCK'S, AÉROPOSTALE)**
800/45-MACYS
212/695-4400 for East Coast stores
415/393-3457 for West Coast stores
(Department store)

MARSHALL FIELD
800/292-2450 for stores
(Upscale department store)

NATORI
212/532-7796 for stores
(Elegant lingerie)

NEIMAN MARCUS
800/825-8000 for catalogue
800/937-9146 for STORES
(Upscale department store)

NINA
800/233-NINA for stores
(Shoes)

NORDSTROM
800/285-5800 for catalogue and stores
(Upscale department store)

PARISIAN
205/940-4000 for stores
(Upscale department store)

OLIVER PEOPLES
310/657-5475 for national and
international listings
(Eyeglasses and accessories)

POLO/RALPH LAUREN
212/606-2100 for national stores
(Designer clothes)

PRODUCT
800/89-PRODUCT for stores
(Designer specialty store)

RICH'S
404/913-4000 for stores
(Major retailer of better women's merchandise)

SAKS FIFTH AVENUE
212/753-4000 for stores
(Upscale department store)

STEPHANE KÉLIAN
212/925-3077 for stores
(Designer shoes)

STUSSY
212/274-8855 for stores
(Unisex sportswear)

TIFFANY & CO.
212/605-4612 for stores
(Fine jewelry and accessories)

TSE CASHMERE
212/472-7790 for stores
(Cashmere clothing)

URBAN OUTFITTERS
215/569-3131 for stores
(Casual wear)

VERA WANG
212/879-1700 for stores
(Designer eveningwear)

STATE LISTINGS

California

AAARDVARK
7579 Melrose Avenue
Los Angeles, CA 90046
213/655-6769
(Wide variety of secondhand clothes)

AMERICAN RAG
150 South La Brea Avenue
Los Angeles, CA 90036
213/935-3154
(Clothing and accessories)

THE AUTHENTIC TRAVELLER
9240 Jordan Avenue, Dept. NR3
Chatsworth, CA 91311
800/826-7221
(Classic traveler's vests)

FRED SEGAL
8100 Melrose Avenue
Los Angeles, CA 90046
213/651-3342
(Specialty store)

**THE GREAT AMERICAN
SHORT STORY**
9166 East La Rosa Drive
Temple City, CA 91780
800-BE SHORT for stores in California
(Clothing for petite women)

GREAT PACIFIC IRON WORKS
235 West Santa Clara Street
Ventura, CA 93001
805/643-6075
(Activewear)

HIDDEN TREASURES
154 Topanga Canyon Boulevard
Topanga Canyon, CA 90290
310/455-2998
(Vintage clothing from the 1930's to the fifties)

L.A. EYE WORKS
7407 Melrose Avenue
Los Angeles, CA 90046
213/653-8255
(Eyeglass frames)

LEATHERS & TREASURES
7511 Melrose Avenue
Los Angeles, CA 90046
213/655-7541
(Specialty leathers)

MARK FOX
7326 Melrose Avenue
Los Angeles, CA 90046
213/936-1619
(Specialty leathers)

MAXFIELD
8825 Melrose Avenue
Los Angeles, CA 90069
310/274-8800
(European and American designer clothes)

MIO
2035 Fillmore Street
San Francisco, CA 94115
415/931-5620
(European and American designer clothes)

THE NORTH FACE
180 Post Street
San Francisco, CA 94108
415/433-3223
(Activewear)

OBIKO
794 Sutter Street
San Francisco, CA 94115
415/775-2882
(Designer clothing)

REAL CHEAP SPORTS
36 West Santa Clara Street
Ventura, CA 93001
310/201-0681
805/648-3803
(Sport clothes at a discount)

RON ROSS
12930 Ventura Boulevard
Studio City, CA 91604
818/788-8700
(Designer clothing)

STRADIVARI SHOES
1133 Montana Avenue
Santa Monica, CA 90403
310/394-3249
(Shoes)

WILKES BASHFORD
375 Sutter Street
San Francisco, CA 94108
415/986-4380
(Designer clothing)

ZOE
2400 Fillmore Street
San Francisco, CA 94115
415/929-0441
(Designer clothing)

Connecticut

JOSEPH ABBOUD
325 Greenwich Avenue
Greenwich, CT 06830
203/869-2212
(Designer clothing)

RAGS
73 Greenwich Avenue
Greenwich, CT 06830
203/869-0915
(Contemporary women's clothing)

R. DERWIN CLOTHIERS
43 West Street
Litchfield, CT 06759
203/567-4095
(Classic clothing and reduced-price Scottish cashmere)

TAHITI STREET
11 East Putnam Avenue
Greenwich, CT 06830
203/622-1878
(Women's swimwear)

THE WILDERNESS SHOP
85 West Street
Litchfield, CT 06759
203/567-5905
(Wilderness wear and casual clothing)

District of Columbia

BRITCHES OF GEORGETOWN
1357 Wisconsin Avenue, NW
Washington, DC 20007
202/337-8934
(Clothing and accessories)

BETSY FISHER
124 Connecticut Avenue, NW
Washington, DC 20036
202/785-1975
(Young American designer clothing)

Florida

CANON CHERRY
9700 Collins Avenue
Bal Harbour, FL 33154
305/861-9966
(Clothing and accessories)

LAST TANGO IN PARADISE
1214 Washington Avenue
Miami, FL 33139
305/532-4228
(Vintage designer clothing and accessories)

MY UNCLE DECO
1570 Washington Avenue
Miami, FL 33155
305/534-4834
(Vintage clothing from the 1950's to the seventies)

THE SPORTS AUTHORITY
3201 North State Road 7
Lauderdale Lakes, FL 33319
305/484-8232
305/735-1701 for national stores
(Sporting goods and apparel)

Georgia

BOB ELLIS
3500 Peachtree Road
Suite A3
Atlanta, GA 30326
404/841-0215
(Designer shoes)

JERONIMO'S
3234 Roswell Road
Atlanta, GA 30305
404/233-3234
(Western wear and boots)

SASHA FRISSON
3094 East Shadowlawn Road
Atlanta, GA 30305
404/231-0393
(Fashionable clothing)

SNOOTY HOOTY
3393 Peachtree Road
Atlanta, GA 30326
404/262-9465
(Sportswear to ballgowns)

TOOTSIES
3500 Peachtree Road
Suite C5
Atlanta, GA 30326
(Fashionable clothing)

Illinois

CHERNIN'S
1001 S. Clinton Street
Chicago, IL 60607
312/922-5900
(Petite shoes)

CHICAGO NIKE TOWN
669 North Michigan Avenue
Chicago, IL 60611
312/642-6363
(Activewear amd shoes)

FLASHY TRASH
3524 North Halsted Street
Chicago, IL 60657
312/327-6900
(Vintage clothing from the 1940's to the seventies)

SILVER MOON
3337 North Halsted Street
Chicago, IL 60617
312/883-0222
(Vintage clothing from the 1930's and forties)

ULTIMO
114 East Oak Street
Chicago, IL 60611
312/787-0906
(Designer clothes)

Louisiana

FLEUR DE PARIS LIMITED
712 Royal Street
New Orleans, LA 70116
504/525-1899
(Specialty store)

MIMI
400 Julia Street
New Orleans, LA 70730
504/527-6464
(Designer wear)

UTOPIA
5408 Magazine Street
New Orleans, LA 70115
504/899-8488
(Clothing and accessories)

YVONNE LE FLEUR
8131 Hampson Street
New Orleans, LA 70118
504-866-9666
(Specialty store)

Maine

ANNE KLEIN OUTLET
Fashion Street Mall
Depot Street
Freeport, ME 04032
207/865-9555
(Discounted Anne Klein apparel)

CALVIN KLEIN OUTLET
11 Bow Street
Freeport, ME 04032
207/865-1051
(Discounted Calvin Klein apparel and accessories)

**DONNA KARAN
COMPANY STORE**
42 Main Street
Suite 3
Freeport, ME 04032
207/865-1751
(Discounted Donna Karan apparel)

THE BLUE HERON
116 Main Street
Northeast Harbor, ME 04609
207/288-9015
(Romantic women's clothing)

FOURTEEN CARROTS
Main Street
Northeast Harbor, ME 04662
207/276-5259
(Handknit sweaters and scarves)

THE HOLMES STORE
Main Street
Northeast Harbor, ME 04662
207/276-3273
(Classic clothing and sailing gear)

J. CREW OUTLET
31 Main Street
Freeport, ME 04032
207/865-3180
(Discounted J. Crew apparel and accessories)

JONES NEW YORK OUTLET
10 Bow Street
Freeport, ME 04032
207/865-3158
(Discounted Jones New York apparel)

L. L. BEAN FACTORY STORE
150 High Street
Ellsworth, ME 04605
207/667-7753
(Outdoor clothes and gear)

THE PATAGONIA OUTLET
9 Bow Street
Freeport, ME 04032
207/865-0506
(Discounted Patagonian activewear)

Massachusetts

CALVIN KLEIN
199 Boylston Street
Boston, MA 02167
617/527-8975
(Designer clothes)

HOUSE OF WALSH
39 Spring Street
Williamstown, MA 01267
413/458-8088
800/572-3735 for other stores
(Classic clothing and sportswear)

JOSEPH ABBOUD
37 Newbury Street
Boston, MA 02116
617/266-4200
(Designer sportwear and suits)

OONA'S
1210 Massachusetts Avenue
Cambridge, MA 02138
617/491-2654
(Vintage clothing from the 1960's and seventies)

**TALBOTS' PETITE COLLECTION
AT CHARLES SQUARE**
20 University Road
Cambridge, MA 02138
617/576-4791
(Talbots store devoted to petite fashions)

Michigan

PENNY PINCHER
12219 Dix Road
Southgate, MI 48192
313/281-8100
(Vintage designer clothing and accessories)

New Hampshire

GARNET HILL
262 Main Street
Franconia, NH 03580
800/622-6216
(Natural-fiber fabrics for home and clothes)

L. L. BEAN FACTORY OUTLET
Route 16
North Conway, NH 03860
603/356-2100
(Outdoor wear and gear)

New York

AGNÈS B.
116 Prince Street
New York, NY 10012
212/925-4649
(Clothing and accessories)

ALMA
820 Madison Avenue
New York, NY 10021
212/628-0400
(Italian designer clothing)

ANN TAYLOR
142 West 57th Street
New York, NY 10019
212/541-3200
(Clothing and accessories)

ARTWEAR
456 West Broadway
New York, NY 10012
212/673-2000
(Contemporary artisanal jewelry)

A.P.C.
131 Mercer Street
New York, NY 10012
212/966-9685
(Clothing and accessories)

AT HAVEN'S HOUSE
Madison Street
Sag Harbor, NY 11963
516/725-4634
(Vintage and new clothing)

BARNEYS NEW YORK
106 Seventh Avenue
New York, NY 10011
212/929-9000
660 Madison Avenue
New York, NY 10021
212/826-8900
(Upscale specialty store)

BEBE
1044 Madison Avenue
New York, NY 10021
212/517-2323
(Career-oriented clothing)

BERGDORF GOODMAN
754 Fifth Avenue
New York, NY 10019
212/753-7300
(Upscale specialty store)

BEST OF SCOTLAND
581 Fifth Avenue
New York, NY 10017
212/644-0403
(Women's cashmere sweaters at discount)

BIG DROP
134 Spring Street
New York, NY 10012
212/966-4299
(Funky clothing)

**BILLY MARTIN'S
WESTERN WEAR**
812 Madison Avenue
New York, NY 10021
212/861-3100
(Western wear and boots)

BLOOMINGDALE'S
1000 Third Avenue
New York, NY 10022
212/705-2000
(Upscale department store)

BOTTEGA VENETA
635 Madison Avenue
New York, NY 10022
212/319-0303
(Shoes and fine leather goods)

BROOKS BROTHERS
346 Madison Avenue
New York, NY 10017
212/682-8800
800/444-1613
(Specialty store)

BUFFALO CHIPS
116 Greene Street
New York, NY 10012
212/274-0651
(Southwestern clothes and boots)

C. P. COMPANY
175 Fifth Avenue
New York, NY 10010
212/260-1990
(Italian sportswear)

CANAL JEANS
504 Broadway
New York, NY 10012
212/226-1130
(Casual and vintage clothing)

CARTIER
2 East 52nd Street
New York, NY 10022
212/446-3459
(Fine jewelry and watches)

CÉLINE
51 West 57th Street
New York, NY 10022
212/308-6262
(French specialty store)

CENTURY 21
22 Cortlandt Street
New York, NY 10007
212/227-9092
(Discounted clothing and accessories)

CHANEL BOUTIQUE
5 East 57th Street
New York, NY 10022
212/355-5050
(Chanel clothes, accessories, and cosmetics)

CHARIVARI
18 West 57th Street
New York, NY 10019
212/333-4040
(Designer collections)

CYNTHIA ROWLEY
112 Wooster Street
New York, NY 10012
212/334-1144
(Designer clothing)

DEBRA MOOREFIELD
128 Wooster Street
New York, NY 10012
212/226-2647
(Elegant, classic women's fashions)

DETOUR
472 West Broadway
New York, NY 10012
212/979-6315
(Clothes and accessories)

DIEGO DELLA VALLE
41 East 57th Street
New York, NY 10022
212/223-2466
(Designer shoes)

DOLLAR BILL
99 East 42nd Street
New York, NY 10017
212/867-0212
(Women's wear at discount)

EMPORIO ARMANI
110 Fifth Avenue
New York, NY 10019
212/727-3240
(Armani suits, casual wear, eyewear, and toiletries)

EQUIPMENT
209 West 38th Street
New York, NY 10018
212/391-8070
(Silk and cotton shirts)

ERIC SHOES
1333 Third Avenue
New York, NY 10021
212/288-8250 call here for other NYC locations
(Designer shoes)

FELISSIMO
10 West 56th Street
New York, NY 10019
212/956-4438
800/708-7690 for catalogue
(Specialty store)

FRAGMENTS
107 Greene Street
New York, NY 10012
212/226-8878
(Designer jewelry)

FREELANCE
124 Prince Street
New York, NY 10012
212/925-6641
(Hip shoes)

GEOFFREY BEENE ON THE PLAZA
783 Fifth Avenue
New York, NY 10022
212/935-0470
(Designer clothing)

GEORGIO SHOES
42 Middleneck Road
Great Neck, NY 11021
516/829-1148
(Shoes)

GIORDANO'S
1118 First Avenue
New York, NY 10021
212/688-7195
(Petite shoes)

GIORGIO ARMANI
815 Madison Avenue
New York, NY 10021
212/988-9191
(Designer clothing and accessories)

GRIFFIN
1094 Madison Avenue
New York, NY 10028
212/772-1130
(Italian designer clothing)

H. KAUFFMAN & SONS SADDLERY
419 Park Avenue South
New York, NY 10016
212/684-6060
(Riding apparel and equipment)

HENRI BENDEL
712 Fifth Avenue
New York, NY 10019
212/247-1100
(Specialty store)

ILENE CHAZANOF
7 East 20th Street
New York, NY 10003
212/254-5564 (by appointment only)
(Vintage accessories from the 1920's to the fifties)

INDUSTRIA
755 Washington Street
New York, NY 10014
212/366-4300
(Designer clothing and accessories)

INA
101 Thompson Street
New York, NY 10012
212/941-4757
(Designer resale shop)

J. M. WESTON
42 East 57th Street
New York, NY 10022
212/308-5655
(Shoes)

JUDITH LEIBER
20 West 33rd Street
4th floor
New York, NY 10001
212/736-4244
(Handbags, belts, and accessories)

KENNETH JAY LANE
725 Fifth Avenue
2nd floor
New York, NY 10022
212/751-6550
(Costume jewelry)

KLEINBERG SHERRIL
35 East 65th Street
New York, NY 10021
212/772-3981
(Finely crafted buckles, belts, and handbags)

LEVI'S STORE
750 Lexington Avenue
New York, NY 10022
212/826-5957
(Jeans and casual wear)

THE LIMITED EXPRESS
7 West 34th Street
New York, NY 10001
212/629-6838
(Clothing and accessories)

LINDA DRESNER
484 Park Avenue
New York, NY 10001
212/308-3177
(Designer clothing)

LIZ CLAIBORNE
133 Beekman Street
New York, NY 10038
(Full Claiborne apparel lines, eyewear, hosiery)

LOVE SAVES THE DAY
119 Second Avenue
New York, NY 10003
212/228-3802
(Vintage clothing)

MAGNIFICO!
426 West Broadway
New York, NY 10012
212/925-3405
(Hand-knit sweaters, children's clothes)

MALO
791 Madison Avenue
New York, NY 10021
212/717-1766
(Men's and women's cashmere clothing)

MAX STUDIO
415 West Broadway
New York, NY 10012
212/714-1730
(Clothing and accessories)

MANOLO BLAHNIK
15 West 55th Street
New York, NY 10019
212/582-1583
(Designer shoes)

MAXMARA
813 Madison Avenue
New York, NY 10021
212/879-6100
(Designer clothing)

MILLER HARNESS CO.
117 East 24th Street
New York, NY 10010
212/673-1400
(Riding apparel and equipment)

NEIMAN MARCUS
1 Paulding
White Plains, NY 10601
914/428-2000
(Designer clothing)

PATRICIA PASTOR
760 Madison Avenue
New York, NY 10021
212/734-4673
(Vintage designer dresses, suits, and accessories)

PENDLETON SHOPS
489 Fifth Avenue
25th floor
New York, NY 10022
212/661-0655
(Sportswear)

PORTICO
139 Spring Street
New York, NY 10012
212/941-7722
(Sleep and bathwear)

PRADA
45 East 57th Street
New York, NY 10022
212/308-2332
(Shoes, and designer clothes)

PRIVATE EYES
385 Fifth Avenue
New York, NY 10016
212/683-6663
(Eyeglasses)

PUCCI
24 East 64th Street
New York, NY 10021
212/752-8957
(Designer clothing)

RALPH LAUREN
867 Madison Avenue
New York, NY 10021
212/606-2100
(Designer clothing)

**RALPH LAUREN'S POLO
SPORT STORE**
888 Madison Avenue
New York, NY 10021
212/606-2100
(Activewear)

REPLAY
109 Prince Street
New York, NY 10012
212/673-6300
(Italian retro clothing)

ROBERT LEE MORRIS
409 West Broadway
New York, NY 10012
212/431-9405
161 Avenue of the Americas
New York, NY 10013
212/645-0444
(Contemporary jewelry)

ROBERT MARC OPTICIANS
782 Madison Avenue
New York, NY 10021
212/737-6000
(Designer eyewear)

SAKS FIFTH AVENUE
611 Fifth Avenue
New York, NY 10022
212/753-4000
(Upscale department store)

SCREAMING MIMI'S
382 Lafayette Street
New York, NY 10003
212/677-6464
(Hip vintage clothes)

SEARLE
609 Madison Avenue
New York, NY 10022
212/753-9021
212/719-4610
(Designer clothing and outerwear)

SELIMA OPTIQUE
59 Wooster Street
New York, NY 10012
212/343-9490
(Eyeglasses)

STELLA DALLAS
218 Thompson Street
New York, NY 10012
212/674-0447
(European designer clothes)

STYLE LAB
64 East 7th Street
New York, NY 10003
212/505-3446
(Clothing and accessories)

SUNGLASS HUT
740 Broadway
New York, NY 10003
212/420-0702
(Accessories)

**SUSAN BENNIS/
WARREN EDWARDS**
22 West 57th Street
New York, NY 10019
212/755-4197
(Designer shoes)

TENT & TRAILS
21 Park Place
New York, NY 10007
212/227-1760
800/237-1760
(Outdoor wear and gear)

TIMBERLAND
709 Madison Avenue
New York, NY 100210
212/421-8890
(Rugged wear and shoes)

TIP TOP SHOES
155 West 72nd Street
New York, NY 10023
212/787-4960
(Shoes)

TOOTSIE PLOHOUND
413 West Broadway
New York, NY 10012
212/925-3931
(Hip shoes)

TRASH AND VAUDEVILLE
4 St. Mark's Place
New York, NY 10003
212/777-1727
(Hip shoes and clothing)

UNTITLED, INC.
26 West 8th Street
New York, NY 10011
212/505-9725
(Designer clothing)

THE WATCH STORE
649 Broadway
New York, NY 10012
212/475-6090
(Watches and accessories)

ZONA
97 Greene Street
New York, NY 10012
212/925-6750
(Jewelry and home furnishings)

North Carolina

THE PHOENIX
Loblolly Pines
Duck, NC 27949
919/261-8900
(Clothing and accessories)

THOR·LO
1072 Crossroads Shopping Center
Statesville, NC 28677
704/873-8243
800/438-0286
(Socks)

Oregon

CASSIE'S
22000 Willamette Drive
West Lynn, OR 97068
503/656-7141
(Clothing and accessories)

DESTINATIONS
8 Nansen Summit
Lake Oswego, OR 97035
503/697-0968
(Travel clothing)

EL MUNDO
3556 SE Hawthorne
Portland, OR 97214
503/239-4605
(Clothing and accessories)

GAZELLE
733 SW Alder Street
Portland, OR 97205
503/228-1693
(Natural-fiber clothing)

PORTLAND NIKE TOWN
930 Southwest 6th Avenue
Portland, OR 97204
503/221-6453
(Activewear and shoes)

Pennsylvania

KNIT WIT
1721 Walnut Street
Philadelphia, PA 19103
215/564-4760
(Clothing and accessories)

MENDELSOHN
229 South 18th Street
Philadelphia, PA 19103
215/546-6333
(Clothing and accessories)

PILEGGI ON THE SQUARE
717 Walnut Street
Philadelphia, PA 19106
215/627-0565
(Clothing and accessories)

TOBY LERNER
117 South 17th Street
Philadelphia, PA 19103
215/568-5760
(Clothing and accessories)

Tennessee

CLOTHES BY MERTIE
133 North Peters Road
Knoxville, TN 37923
615/693-8600
(Women's sportswear and formal wear)

PIECES
211 Louise Avenue
Nashville, TN 37203
615/329-3537
(Vintage clothing from the 1950's to the seventies)

ZELDA VINTAGE CLOTHIERS
5133 Harding Road
Nashville, TN 37205
615/356-2430
(Vintage clothing and accessories)

Texas

AHAB BOWEN
2614 Boll Street
Dallas, TX
214/720-1874
(Vintage clothing from the 1940's and fifties)

THE GAZEBO
8300 Preston Road
Dallas, TX 75225
214/373-6661
(Clothing and accessories)

LILY DATSUN
33 Highland Park Village
Dallas, TX 75205
214/528-0528
(Designer clothing)

STANLEY KORSHAK
500 Crescent Court
Dallas, TX 75201
214/871-3600
(Specialty store)

UNCOMMON OBJECTS
1508 South Congress
Austin, TX 78704
512/444-7868
(Vintage western clothing)

Virginia

LEVYS
2120 Barracks Road
Charlottesville, VA 22903
804/295-4270

4925 West Broad Street
Richmond, VA 23230
804/354-1938
3198 Pacific Avenue
Virginia Beach, VA 23451
804/437-1205
(Designer casual and formal wear)

OUT OF THE BLUE
2138 Barracks Road
Charlottesville, VA 22903
804/979-2583
(Eclectic clothing and accessories)

THE PHOENIX
111 14th Street, NW
Charlottesville, VA 22903
804/296-1115

3039 West Cary
Richmond, VA 23221
804/354-0711
(Clothing and accessories)

SCARPA
2114A Barracks Road
Charlottesville, VA 22903
804/296-0040
(Classic and contemporary shoes)

Washington

EDDIE BAUER
1330 Fifth Avenue
Seattle, WA 98101
206/622-2766
(Casual and outdoor wear)

MADAME & CO.
117 Yesler Way
Seattle, WA 98104
206/621-1728
(Vintage evening dresses)

RUDY'S
1424 First Avenue
Seattle, WA 98101
206/682-6586
(Vintage clothing from the 1930's to the sixties)

International Listings

AUSTRALIA

BELINDA
8 Transvaal Avenue, Doubleday
Sydney
2/328-6288
(Australian designer clothes)

COUNTRY ROAD AUSTRALIA
Pitt Street Mall
142 Pitt Street
Sydney
2/282-6299
(Classic sportswear)

DAIMARU
21 La Trobe Street
Melbourne
3/660-6666
(Upscale department store)

DAVID JONES
Elizabeth Street
Sydney
2/266-5544
(Upscale department store)

GEORGES
162 Collins Street
Melbourne
3/283-5535
(Upscale department store)

**STEPHEN DAVIES
DESIGNER SHOES**
65 Gertrude Street, Fitzroy
Melbourne
3/419-6296
(Custom-made shoes)

FRANCE

AGNÈS B.
3-6 rue du Jour
Paris 75001
40/03-45-00
(Clothes and accessories)

AU PRINTEMPS
64 boulevard Haussmann
Paris 75009
42/82-50-00
(Department store)

CHEVIGNON TRADING POST
49 rue Etienne-Marcel
Paris 75002
40/28-04-69
(American Western furniture and clothes)

GALERIES LAFAYETTE
40 boulevard Haussmann
Paris 75009
42/82-34-56
(Department store)

GR816
5 rue Bleue
Paris 75009
44/79-02-38
(Downtown-style clothing)

HERMÈS
24 rue du Faubourg-Saint-Honoré
Paris 75008
42/17-47-17
(Clothing, accessories, jewelry, and luggage)

INÈS DE LA FRESSANGE
14 avenue Montaigne
Paris 75008
47/23-08-94
47/23-64-87
(Classic clothing and accessories)

L'ÉCLAIREUR
3 rue des Rosiers
Paris 75004
48/87-10-22
(European designer clothes and furniture)

ROBERT CLERGERIE
5 rue du Cherche-Midi
Paris 75006
45/48-75-47
(Designer shoes)

GERMANY

KRAMBERG
Kurfürstendamm 213
Berlin
30/323-6058
(Designer clothes)

JIL SANDER
Milchstrasse 13
2000 Hamburg
40/5530-2173
(Designer clothing)

LUDWIG BECK
Marienplatz 11
Munich
89/23-6910
(Upscale department store)

MEY & EDLICH
Theatinerstrasse 7
Munich
89/290-0590
(Upscale department store)

THERESA
Theatinerstrasse 31
Munich
89/290-0590
(Designer clothes)

GREAT BRITAIN

AGNÈS B.
35-36 Floral Street
London WC2
171/379-1992
(Clothes and accessories)

BROWNS
23-27 South Molton Street
London W1
171/491-7833
(Designer clothing)

BURBERRY'S
18-22 Haymarket
165 Regent Street
London SW1
171/930-3343
(Outerwear, clothing, and accessories)

EMMA HOPE SHOES
33 Amwell Street
London EC1
171/833-2367
(Designer shoes)

FLANNELS
Unit 10, Royal Exchange
Manchester M2
161/834-8669
(Designer clothing)

THE GAP
31 Long Acre
London WC2
171/379-0779 (Call for branches)
(Clothing and accessories)

HARRODS
Knightsbridge
London SW1
171/730-1234
(Upscale department store)

HARVEY NICHOLS
109-125 Knightsbridge
London SW1
171/235-5000
(Upscale department store)

JONES
15 Floral Street
London WC2
171/379-4448
(Clothing and accessories)

JOSEPH
77-79 Fulham Road
London SW3
171/883-9500
(Designer clothing)

KENZO
15 Sloane Street
London SW1
171/235-4021
(Designer clothing and accessories)

LIBERTY
210-222 Regent Street
London W1
171/734-1234
(Clothing and accessories)

MARKS AND SPENCER
99 Kensington High Street
London W8
171/938-3711 (Call for branches)
(Department store)

MICHELE HOLDEN
42 Beauchamp Place
London SW3
171/581-8533
(Parisian dressmaker)

MUJI
26 Great Marlborough Street
London W1
171/494-1197 (Call for branches)
(Natural-fiber clothing)

NEXT PLC
160 Regent Street
London W1
171/434-2515 (Call for branches)
(Clothing and accessories)

OASIS
6 Kensington Barracks
Kensington Church Street
London W8
171/938-4019 (Call for branches)
(Clothing and accessories)

PATRICK COX SHOES
8 Symons Street
London SW3
171/730-6504
(Shoes)

PAUL SMITH WOMEN
40-44 Floral Street
London WC2
171/379-7133
(Smart, hip fashion)

PRADA
44-45 Sloane Street
London SW1
171/235-0008
(Designer clothing and accessories)

ROBERT CLERGERIE
67 Wigmore Street
London W1
171/935-3601
(Elegant footwear)

SPACE NK
41 Earlham Street
London WC2
171/379-7030
(Simple, modern clothes and accessories)

SWAINE, ADENEY, BRIGGS & SONS
185 Piccadilly
London W1
171/409-7277
(Riding clothes and accessories)

WAREHOUSE
19-21 Argyll Street
London W1
171/437-7101
(Runway copies at affordable prices)

WHISTLES
12-14 St. Christopher Place
London W1
171/487-4484
(Classic, influential designs)

ITALY

BALLOON
Piazza di Spagna 35
Rome
6/678-0110
(Bargain-price basics)

GIORGIO ARMANI
Via Sant'Andrea 9
Milan
2/7602-2757
(Designer clothes)

LA RINASCENTE
Piazza Duomo
Milan
2/7200-2210
(Department store)

MAS
Piazza Vittorio Emanuele
Rome
6/446-9010
(Discount shopping, bargain cashmere)

PRADA
Galleria Vittorio Emanuele 63-65
Milan
Via della Spiga 1
Milan
2/760-8636
(Designer clothing and accessories)

PUCCI
Via dei Pucci 6
Florence
55/28-3061
(Fine shoes, bags, and accessories)

ZORAN
Corso Matteoti 1a
Milan
2/760-7958
(Simple, luxurious clothes)

JAPAN

COMME DES GARÇONS
5-11-1 Minami-aoyama
Minato-ku
Tokyo
3/3207-2480
(Designer clothing)

ISETAN
3-14-1 Shinjuku
Shinjuku-ku
Tokyo
3/3352-1111
(Specialty store)

JURGEN LEHL
5-3-10 Minami-aoyama
Minato-ku
Tokyo
3/3498-6723
(Japanese-designed clothes)

TAKASHIMAYA
2-4-1 Nihonbashi, Chuo-ku
Tokyo
3/3211-4111
(Designer clothing)

SWEDEN

PEAK PERFORMANCE
Jacobbergsgatan 6
Stockholm
8/611-3400
(Outdoor clothes)

Cyber World

Some fashionable cyber-addresses:

CONSUMER REPORTS
AMERICA ONLINE keyword CONSUMER
COMPUSERVE go CONSUMER
PRODIGY jump CR
(articles from Consumer Reports *magazine.)*

CONSUMER SELF DEFENSE AND SCAM ALERT
FIDONET tag ANTI_SCAM
(Helps users learn how to protect themselves and recoup their losses.)

COMP-U-STORE ONLINE
AMERICA ONLINE keyword COMPUSTORE
DELPHI go SHOP COMP
GENIE keyword CUS
(Offers discounts on numerous manufacturers' list prices, more discounts for members; over 250,000 products available.)

THE ELECTRONIC MALL
COMPUSERVE go MALL
(Includes stores such as Barnes & Noble, Lands End, and Gimme Jimmy's Cookies.)

FASHION MALL
http://www.Fashionmall.com

JC PENNEY
COMPUSERVE go JCP
GENIE keyword JCPENNY
(Apparel, electronics, merchandise, and gift certificates.)

NEWS GROUP
ALT-FASHION

PRODUCT NET
http://www.ProductNet.com

SEARS
COMPUSERVE go SR
PRODIGY jump SEARS
(Online department store)

RESOURCES

59 **WHITE SEQUINED T-SHIRT**—Jeanette Kastenberg

60 **COTTON SUNDRESS**—Ralph Lauren; **SUNGLASSES**—J. Crew; **SILVER HOOP EARRINGS**—Zima; **BLACK SUEDE BOOTS**—Etienne Aigner; **WOOL TURTLENECK**—Ellen Tracy; **ZEBRA VELVET SKIRT**—Michael Kors; **BLACK COTTON TIGHTS**—Hue

61 **POLKA-DOT SCARF**—The Honey Collection; **STRIPED COTTON T-SHIRT**—Private collection of Hope Greenberg; **WOOL PLAID SKIRT**—Burberry's

62 **PLEATED COAT**—Issey Miyake

63 **MUFFLER**—Natasha Gerrault from Takashimaya

64 **SCARF**—Adrienne Landau; **ALPACA JACKET AND SHIRT**—Zoran

65 **VELOUR T-SHIRT**—Donna Karan; **BLACK PATENT BELT**—Two Blondes; **WHITE JEANS**—Levi Strauss & Co.

66 **BLACK SILK JACKET AND DRESS**—Barneys New York

68 **PEARL NECKLACE**—Carolee; **EARRINGS**—Ciner; **PINK JACKET**—Oscar de la Renta; **BLACK DRESS**—Barneys New York; **BLACK SATIN BAG**—Kleinberg Sherril; **BLACK SATIN SHOES**—Bottega Veneta

69 **STRAW HAT**—Kaminski; **SUNGLASSES**—The Gap; **BLACK DRESS**—Barneys New York; **GOLD CUFF**—Ferragamo; **PATENT BAG**—Ralph Lauren; **SHOES**—Barneys New York; **SILK SCARF**—Pucci; **BLACK JACKET**—Barneys New York; **WHITE SHIRT**—Agnès B.; **SILK PANTS**—Pucci

70 **NAVY WOOL JACKET**—Ralph Lauren; **WHITE COTTON SHIRT**—The Gap; **JEANS**—Levi Strauss & Co.; **BAG**—Bottega Veneta; **SHOES**—Etienne Aigner; **SUNGLASSES**—Brooks Brothers

71 **NAVY GABARDINE SUIT**—Ralph Lauren; **NAVY CASHMERE TURTLENECK**—Ralph Lauren; **NAVY-AND-WHITE-STRIPED SWEATER**—DKNY; **NAVY WOOL SKIRT**—Michael Kors; **SHOES**—Etienne Aigner; **NAVY WOOL JACKET**—Ralph Lauren; **NECKLACE**—Private collection of Lisa Wertheimer; **EARRINGS**—Kenneth Jay Lane; **GOLD SILK PALAZZO PANTS**—Zoran; **MULES**—Susan Bennis/Warren Edwards

72 **SUITCASE**—T. Anthony

78 **SHIRT**—Abe Hamilton; **BRA**—Le Mystère

83 **BLACK BODYSUIT**—Ravage

85 **BODYSLIP**—Bodyslimmers™; **HIGH-WAIST-ED BELLYBUSTER**—Bodyslimmers™; **WAISTCINCHER PANTY**—Bodyslimmers™; **THIGH-SHAPER**—Natori

86 **SILK V-NECK NIGHTGOWN**—Christine and Company; **WHITE TERRY-CLOTH BATHROBE**—Barneys New York

87 **PAJAMAS**—Brooks Brothers; **BOXERS**—J. Crew

88 **BLACK SILK SHOE**—Manolo Blahnik; **SUEDE SANDAL**—Birkenstock

90–91 **BLACK HIGH HEEL**—Diego Della Valle; **BLACK LEATHER LOAFER**—Bass Weejun; **BLACK SATIN LOAFER**—Anne Klein

92 **BLACK STOCKING WITH LACE TOP**—DKNY; **BLACK BACK-SEAM SHINY PANTYHOSE AND BLACK HOSIERY**—Wolford

93 **GREY COTTON SOCK**—American Essentials; **CREAM COTTON SOCK**—Calvin Klein

94 **SILK SHIRT**—Morgane Le Faye; **WHITE TANK**—Michael Kors

95 **SHIRT**—Dolce and Gabbana; **CUFF LINK**—Paul Smith

96 **SHIRT**—Dolce and Gabbana; **RHINESTONE BUTTON**—Dolce and Gabbana

97 **SILK SHANTUNG SHIRT**—Emilio Pucci

99 **SWEATER SET**—Cashmere Cashmere

100 **EVENING SWEATER**—Pamela Dennis

101 **SYNCHILLA PULLOVER**—Patagonia; **TAILORED SWEATSHIRT**—Muji; **CLASSIC SWEATSHIRT**—Champion

102 **TURTLENECK**—J. Crew

103 **CABLEKNIT CASHMERE TURTLENECK**—Ralph Lauren; **HEATHERED CASHMERE TURTLENECK**—Ballantyne for Cashmere Cashmere; **CREAM COTTON TURTLENECK**—The Eagle's Eye; **CREAM COTTON RIBBED TURTLENECK**—Made in America; **BABY-CABLEKNIT CASHMERE TURTLENECK**—Cashmere Cashmere; **WIDE-RIB CASHMERE SWEATER**—Industria

104 **ETCHED SILVER CASE**—Oliver Peoples; **TORTOISE CASE**—Alain Mikli from Oliver Peoples; **BLUE LEATHER CASE**—Alain Mikli; **WOODEN CASE**—Robert Marc; **SILVER CASE**—Martine Sitbon from Private Eyes; **BROWN ALLIGATOR CASE**—Private Eyes; **ANTIQUE CASE**—Selima Optique; **GOLD WIRE-FRAME GLASSES**—Selima Optique

105 **BEIGE CASHMERE SHIRT AND CARDIGAN**—Calvin Klein; **TORTOISE FRAMES**—Calvin Klein; **TORTOISE CHAIN**—Private Eyes

106 **FLEECE VEST**—Patagonia; **STRIPED TURTLENECK**—J. Crew; **OXFORDS**—J. M. Weston; **SUNGLASSES**—Brooks Brothers; **LEGGINGS**—The Gap

107 **WHITE SILK VEST AND PANTS**—Morgane Le Faye; **SILVER BANGLES**—Strictly Sterling; **WHITE SANDALS**—Yves Saint Laurent; **CAP-TOE PUMP**—Bruno Magli; **VELVET VEST AND PANTS**—Eileen Fisher; **EARRINGS**—Takashimaya; **SILK BLOUSE**—Eileen Fisher; **BRACELET**—Barneys New York; **SILK SCARF**—Multiband from Yvette Fry; **VELVET PATENT SLIPPERS**—Stuart Weitzmann

108 **BLACK COTTON LEGGINGS**—DKNY; **GREY ATHLETIC BRA**—Lily of France; **WHITE CREW SOCKS**—THOR•LO

109 **WHITE BLOUSE**—Morgane Le Faye; **ATHLETIC BRA**—Private collection of Hope Greenberg; **PALAZZO PANTS**—Oscar de la Renta; **LOW-HEELED SANDALS**—Susan Bennis/Warren Edwards; **SILK SHIRT**—Emilio Pucci; **LEGGINGS**—The Limited; **HIGH-HEELED SANDALS**—Stéphane Kelian

110 **SILVER-AND-GOLD WATCH**—Rolex; **DIGITAL WATCH**—Timex

111 **WHITE CANVAS SNEAKERS**—Keds

112 **PINK BIKINI**—J. Crew; **GREEN TANK SUIT**—J. Crew

116–17 **WHITE LINEN SHIRT**—J. Crew; **PINK BIKINI**—Calvin Klein; **COTTON TURTLENECK SWEATER**—Linda Dresner; **BIKINI BOTTOM**—Private collection of Hope Greenberg; **STRIPED DRESS**—Private collection of Hope Greenberg; **PEACH BIKINI**—J. Crew; **WHITE TANK**—Agnès B.; **MELON PAREO**—J. Crew; **SUEDE THONGS**—Henri Begleuin from Barneys New York

118 **STRAW HAT**—Smith & Hawken; **STRAW BAG**—Kleinberg Sherril; **SUNGLASSES**—Yves Saint Laurent; **ESPADRILLES**—J. Crew

119 **FISHERMAN'S SANDAL**—Barneys New York; **SNEAKER**—Keds; **SUEDE THONG**—Barneys New York; **BALLET SLIPPER**—Agnès B.; **YELLOW PATENT SANDAL**—Stéphane Kelian

120 **SKIRT**—Hervé Léger, from Barneys New York

121 **SHORTS**—Banana Republic; **SKORT**—Banana Republic

122 **BLACK CASHMERE SWEATER**—Ralph Lauren; **WHITE SILK SHIRT**—Ralph Lauren; **PIN-DOT SKIRT**—Ralph Lauren; **BLACK LEATHER BELT**—Ralph Lauren

123 **BLACK-AND-WHITE-CHECKED WOOL SUIT**—Ralph Lauren; **BLACK JACKET**—Private collection of Lisa Wertheimer; **BELT**—Two Blondes; **SKIRT**—Banana Republic; **LOW-HEELED BLACK PATENT PUMPS**—Bruno Magli; **GLASSES**—Private collection of Lisa Wertheimer

124 **T-SHIRT**—The Gap; **WOOL-AND-CASHMERE JACKET**—Zoran; **BELT**—Joan & David; **KHAKIS**—The Gap

125 **SCARF**—Private collection of Lisa Wertheimer; **SILK-AND-CASHMERE SWEATER**—Zoran; **SILK PALAZZO PANTS**—Zoran; **WOOL-AND-CASHMERE JACKET**—Zoran; **CHECKED CASHMERE TROUSERS**—Zoran

128 **BLUE SILK SHIRT**—Morgane Le Faye; **BLACK LEATHER BELT**—Hermès; **GREY WOOL PANTS**—Ralph Lauren

129 **ALLIGATOR BELT**—Ralph Lauren; **BLACK POLISHED VINYL BELT**—Omega

131 **SATIN BLAZER**—Calvin Klein; **WOOL KNIT BLAZER**—Private collection of Hope Greenberg

135 **JACKET AND PANTS**—Giorgio Armani; **SILK BLOUSE**—Giorgio Armani

136 **RED WOOL SUIT**—Ellen Tracy; **WOOL JACKET**—Private collection of Hope Greenberg; **WOOL SKIRT**—Private collection of Hope Greenberg

137 **WOOL KNIT SUIT**—St. John Knits

138 **SILVER PEN**—Dunhill; **BLACK PEN**—Uni-ball; **AGENDA**—Coach

139 **BLACK PUMPS**—Céline; **TANK WATCH**—Cartier; **PEARL EARRINGS**—Tiffany

140 **WHITE BLOUSE**—Donna Karan; **GREY WOOL SUIT**—Agnès B.; **STERLING SILVER BRACELET**—Agatha; **GREY BAG**—DeVecchi; **BLACK PUMPS**—Bottega Veneta; **STOCKINGS**—DKNY; **EARRINGS**—Private collection of Lisa Wertheimer

141 **GREY CASHMERE SWEATER**—Pamela Dennis; **EARRINGS**—R. J. Graziano; **GREY WOOL SKIRT**—Agnès B.; **BAG**—Takashimaya; **BLACK SILK FAILLE SHOES**—Nina

142 **TAN BAG**—Coach; **BLACK TOTE**—Bottega Veneta

143 **ENVELOPE**—T. Anthony; **CLUTCH**—Mark Cross

144 **SILK SCARF**—Takashimaya; **SWEATER**—Anne Klein II; **BRACELET**—Private collection of Lisa Wertheimer; **SKIRT**—Anne Klein II; **LEATHER BALLET SLIPPERS**—Barneys New York; **SCARF**—Christian Lacroix; **EARRINGS**—Erwin Pearl; **LIGHT BLUE CASHMERE SWEATER SET**—Burberry's; **WATCH**—Baume & Mercier; **KHAKIS**—The Gap; **LOAFERS**—J. M. Weston

145 **SCARF**—Gucci; **DENIM SHIRT**—Joseph; **BELT**—Ralph Lauren; **PANTS**—Ralph Lauren; **WATCH**—Guess; **AGENDA**—Coach; **PEN**—Cross; **BOOTS**—Bruno Magli; **JACKET**—Michael Kors; **STRIPED SHIRT**—DKNY; **PEARL NECKLACE**—Private collection of Lisa Wertheimer; **BELT**—Two Blondes; **LOAFERS**—J. M. Weston; **PANTS**—DKNY

146 **TOP SILVER HOOP**—Zima at Fragments; **FAR RIGHT GOLD HOOP**—Trifari; **MIDDLE RIGHT GOLD HOOP**—Carolee; **LARGE MIDDLE GOLD HOOP**—Erwin Pearl; **MIDDLE LEFT GOLD HOOP**—Private collection of Lisa Wertheimer; **FAR LEFT GOLD HOOP**—Monet; **LOWER MIDDLE SILVER HOOP**—Monet; **BOTTOM SILVER HOOP**—Zima at Fragments

147 **LINK BRACELETS**—Carolee

148 **WOOL JERSEY DRESS**—Industria; **PEARL AND GOLD BROOCH**—Ciner

149 **SHORT SILK TANK DRESS**—Michael Kors; **LONG SILK TANK DRESS**—J. Crew

152 **BLACK DRESS**—Vera Wang; **GOWN**—Vera Wang

154 **EARRING**—Personal collection of Kim Johnson Gross

155 **BLACK SILK SHOES**—Susan Bennis/Warren Edwards; **BLACK BAG**—Bottega Veneta; **BLACK GLOVES**—Fownes; **LIPSTICK**—Chanel

156 **GOLD LAMÉ T-SHIRT**—Michael Kors; **SEQUINED LEOPARD SKIRT**—Pamela Dennis

157 **MULES**—Susan Bennis/Warren Edwards; **BLACK SATIN COCKTAIL DRESS**—Pamela Dennis; **BLACK BAG**—Takashimaya; **EARRINGS**—Kenneth Jay Lane

158 **LIPSTICK**—Orlane; **ATOMIZER**—Muji; **COMPACT**—Private collection of Hope Greenberg

160 **SILK GAZAR TRENCH COAT**—Gemma Kahng

161 **TRENCH COAT**—Burberry's of London

162 **COTTON BARN JACKET**—J. Crew

163 **LEATHER CAR COAT**—New Republic; **PEA COAT**—Ralph Lauren

164 **JEAN JACKET**—Levi Strauss & Co.

166 **LEATHER GLOVES**—Isotoner

167 **REVERSIBLE COAT**—Searle; **TURTLENECK**—The Limited; **LEGGINGS**—The Limited; **BLACK LEATHER BOOTS**—Cole-Haan; **SKI JACKET**—Searle

168 **BOOTS**—Timberland

169 **BLACK LEATHER BOOT**—Chanel; **YELLOW RUBBER BOOT**—Gates Boot Company

170 **CAMEL WOOL COAT**—Paul Stuart; **FISHERMAN'S SWEATER**—Private collection of Lisa Wertheimer; **JEANS**—The Limited; **BOOTS**—Timberland

171 **CAMEL WOOL COAT**—Paul Stuart; **GREY CASHMERE TURTLENECK**—N. Peal; **GREY CASHMERE PANTS**—Donna Karan; **LEATHER GLOVES**—Shalimar; **OXFORDS**—J. M. Weston

172–3 **SILK ORGANZA SCARF**—Adrienne Landow; **CRINKLED SILK SCARF**—Takashimaya; **FRINGED SILK SCARF**—Takashimaya

174 **BLACK CASHMERE-WOOL COAT**—Zoran; **RED CASHMERE SCARF**—Meg Cohen at Metropolitan Design Group; **SILVER SILK SCARF**—Zoran

175 **FUR HAT**—Kaitery

QUOTES

2 B. Altman & Co. ad, *Encyclopedia of Women's Wit, Anecdotes and Stories,* Cathy Handley, ed. (Prentice Hall, Inc., 1982).

6 Australian Aboriginal saying.

14 F. Scott Fitzgerald, "Bernice Bobs Her Hair."

19 "I Feel Pretty," from *West Side Story,* lyrics by Stephen Sondheim.

23 Maria Callas in *Master Class,* a play by Terrence McNally, 1995.

27 Linda Ellerbee, Caroline Warner, ed., *The Last Word: A Treasury of Women's Quotes,* (Prentice Hall, Inc., 1992).

28 Calvin Trillin, "Real Jeans," an essay in *Enough's Enough and Other Rules of Life* (Ticknor & Fields, 1990).

34 Cynthia Heimel, "What Makes Women Tick?" an essay in *But Enough About You* (Fireside Books/Simon & Schuster, 1986).

45 Herman Wouk, *Marjorie Morningstar.*

46–47 Neiman Marcus ad, "Fashions of the Times" supplement to *The New York Times Magazine* (February 26, 1995).

49 Aileen Mehle, "W Eye Suzy," *W* Magazine (March, 1995).

60–61 MTV VJ Duff, as quoted by Marina Rust in "Secrets of Style," in *Vogue* (April, 1994).

67 Inès de la Fressange, as quoted by Jennifer Scruby in "Inès's City Planning," in *Elle* (March, 1995), retrieved from America Online.

76 D. H. Lawrence, *Lady Chatterley's Lover.*

84 Wayne Wolf, our very own quotable art director.

98 Woody Allen, in *The Penguin Dictionary of Modern Humorous Quotations,* Fred Metcalf, ed. (Penguin Books, 1988).

120 Dorothy Parker, "Mr. Durant," a short story in *The Poetry and Short Stories of Dorothy Parker* (Modern Library, 1994).

127 Katharine Hepburn, *An Uncommon Scold,* Abby Adams, ed. (Simon & Schuster, 1989).

134 Giorgio Armani, as told to *Chic Simple.*

140–41 Ralph Waldo Emerson, *The Columbia Dictionary of Quotations,* Robert Andrews, ed. (Columbia University Press, 1993).

147 Robert Lee Morris, in *Women's Wear Daily* (March 1, 1995).

151 Mae West, *21st Century Dictionary of Quotations,* Princeton Language Institute (Dell Publishing, 1993).

154 Cathleen Schine, *Rameau's Niece* (Plume/Penguin Books, 1994).

159 Cindy Crawford, *21st Century Dictionary of Quotations,* Princeton Language Institute (Dell Publishing, 1993).

166 Cybill Shepherd, *In Style* Magazine (March, 1995).

167 Gene Kelly, in the movie *Singing in the Rain;* lyrics by Arthur Freed.

171 William E. Geist, in "Coat Checking at the Philharmonic" in *City Slickers* (Penguin Books, 1989).

176 Michael Kors, as told to *Chic Simple.*

178 Fran Lebowitz, "Tips for Teens," an essay in *Social Studies* in *The Fran Lebowitz Reader* (Vintage Books, 1994).

181 Dorothy Parker, "Glory in the Daytime," a short story in *The Poetry and Short Stories of Dorothy Parker* (Modern Library, 1994).

182 Erich Maria Remarque, *Correct Quotes,* portions by Career Publishing Inc. (WordStar International, 1992).

183 Cynthia Heimel, *Sex Tips for Girls* (Fireside Books, 1983).

184 Elvis Presley, *Ain't Nobody's Business If You Do: The Absurdity of Consensual Crimes in a Free Society,* Peter McWilliams, ed. (Prelude Press, 1993).

185 Jackie Collins, *An Uncommon Scold,* Abby Adams, ed. (Simon & Schuster, 1989).

186 Coco Chanel, *The Columbia Dictionary of Quotations,* Robert Andrews, ed. (Columbia University Press, 1993).

186 Diana Vreeland, *D.V.,* George Plimpton & Christopher Hemphill, eds. (Knopf, 1984).

187 Cole Porter, *The Columbia Dictionary of Quotations,* Robert Andrews, ed. (Columbia University Press, 1993).

194 Thomas Fuller, *Correct Quotes,* portions by Career Publishing Inc. (WordStar International 1992).

195 Elle Macpherson, "The 50 Most Beautiful People in the World 1995," *People Magazine* (March 8, 1995).

195 Claudia Shear, *Blown Sideways Through Life* (Dial Press, 1995).

197 Susan Orlean, "Scene Making," an essay in *Saturday Night* (Fawcett Crest/Ballantine, 1991).

197 Helen Gurley Brown, *The Last Word: A Treasury of Women's Quotes,* Carolyn Warner, ed. (Prentice Hall, Inc., 1992).

198 e. e. cummings, *21st Century Dictionary of Quotations,* Princeton Language Institute (Dell Publishing, 1993).

199 Lynn Schnurberger, *Let There Be Clothes: 40,000 Years of Fashion* (Workman Press, 1991).

199 Woody Allen, *The Penguin Dictionary of Modern Humorous Quotations,* Fred Metcalf, ed. (Penguin Books, 1987).

200 P. J. O'Rourke, *Just Joking,* Ronald L. Smith and Jon Winokur, eds. (WordStar International, 1992).

200 Tennessee Williams, *21st Century Dictionary of Quotations,* Princeton Language Institute (Dell Publishing, 1993).

202 Steve Martin, *1911 Best Things Anyone Ever Said,* Robert Byrne, ed. (Ballantine Books, 1988).

203 Dyan Cannon, *Encyclopedia of Women's Wit: Anecdotes and Stories,* Cathy Handley, ed. (Prentice Hall, Inc., 1982).

203 Françoise Sagan, *The Quotable Quotations Book,* Alec Lewis, ed. (Crowell, 1980).

204 Anna Quindlen, "Hemlines," an essay in *Living Out Loud* (Ivy/Ballantine, 1988).

221 Ralph Waldo Emerson, *The Harper Book of Quotations,* (HarperCollins, 1993).

INDEX

ACKNOWLEDGMENTS

FASHION CONSULTANT Patrick Gates
ACCESSORIES CONSULTANT Lucy Wallace
EDITORIAL RESEARCH ASSISTANT Heather Starr

And special thanks to: Joseph Abboud; Sheila Aimette; Sonja Alaimo; Kathy Ardleigh; Agnès B.; Giorgio Armani; Barneys New York; David Bashaw; Geoffrey Beene; Bill Blass; Beth Berdofe; Claire Bradley; Dawn Brown; Chip Burch; Amy Capen; Cindy Capobianco; Robin Cavan; Tony Chirico; Laurence Coaba; Jill Cohen; Cole-Haan; Franc Cussoneau; Anna De Luca; Lauri Del Commune; Damian Donck; Dr. Scholl's; Marylyn Evins, Ltd.; Christina Felton; Fabrizio Ferre; Eileen Fisher; Tom Ford; Bradley Friedman; Jane Friedman; Stefan Friedman; Elizabeth Gilder; Janice Goldklang, Katherine J. Gómez; Marion Greenberg; David, Glenna, and Carolyn Gross; Patrick Higgins; Nancy Hochman; Christy Hood; Katherine Hourigan; Laura Howard; Andy Hughes; Kathryn Jaharis; Carol Janeway; Evelyn Johnson; Judith Jones; Donna Karan; Vivian Kelly; Calvin Klein; Anne Klein & Co.; Gia Kim; Nicholas Latimer; Ralph Lauren; Carl Lennertz; William Loverd; Michael Kors; Robert Lanterman; Madeline Manogue; Anne McCormick; Dwyer McIntosh; Sonny Mehta; Saundra Messinger; Anne Messitte; Isaac Mizrahi; Russell Nardozza; Joanna Needle; Elyce Neuhauser; Todd Oldham; Carla Phillips; Anne Randall; Robert Marc Opticians; Irene Pires; Torrence Robinson; Tory Robinson; Trace Rosel; Mitchell Rosenbaum (a.k.a. Mitchell Reed); Diana P. Rowan; Cynthia Rowley; Alicia Rusch; Carey Sanda-Bohrer; Jil Sander; Dorothy Sarnoff; Lisa Schiek; Selima Optique; Sarah Slavin; Raquel Scott; Anne-Lise Spitzer; Morgan Stone; Dylan Stone; Lynn Tesoro; Richard Tyler; Adrienne Vitadini; Shelley Wanger; Vera Wang; Wolf Mannequins; Amy Zenn; Zoran.

INVALUABLE RESOURCES

• Elizabeth Devine and Nancy L. Braganti, *The Travelers' Guide* series (St. Martin's Press).
• Leah Feldon, *Dress Like a Million (On Considerably Less)* (Villard Books, 1993).
• Alison Lurie, *The Language of Clothes* (Vintage Books/Random House, 1981).
• Georgia O'Hara, *The Encyclopedia of Fashion* (Harry N. Abrams, 1986).
• Lynn Schnurnberger, *Let There Be Clothes: 40,000 Years of Fashion* (Workman Publishing, 1991).
• The New York Public Library Information Service

CHIC SIMPLE STAFF

PARTNERS Kim & Jeff
ART DIRECTOR Wayne Wolf
ASSOCIATE ART DIRECTOR Alicia Yin Cheng
ASSOCIATE EDITOR Victoria C. Rowan
OFFICE MANAGER Joanne Harrison
DESIGN/PRODUCTION Takuyo Takahashi
COPY EDITOR Borden Elniff
INTERNS: Clare Sun Oh, Ji Byol Lee

COMMUNICATIONS

In our earlier books, we asked for your feedback and you responded from all over—Ecuador to Malaysia, Hong Kong to Edinburgh, Seattle to Miami—and every day we receive more. So thanks, and please keep on writing, faxing, and e-mailing your comments, tips, suggestions of items, topics, stores, and various insights that occur to you. Since a lot of the question we get are about what else is in the Chic Simple book series, we created a catalogue. If you would like to receive one for FREE, please send us a thousand dollars in unmarked bills in a brown paper sack, or just your address to:

CHIC SIMPLE
84 WOOSTER STREET, NEW YORK, NY 10012
Fax: (212) 343-9678
Compuserve number: 72704,2346
e-mail address: info@chicsimple.com
web site address: http://www.chicsimple.com

Stay in touch because...
"The more you know, the less you need."

Please let us know if you're interested in Chic Simple clothing patterns.

A NOTE ON THE TYPE

The text of this book was set in two typefaces: New Baskerville and Futura. The ITC version of **NEW BASKERVILLE** is called Baskerville, which itself is a facsimile reproduction of types cast from molds made by John Baskerville (1706–1775) from his designs. Baskerville's original face was one of the forerunners of the type style known to printers as the "modern face"—a "modern" of the period A.D. 1800. **FUTURA** was produced in 1928 by Paul Renner (1878–1956), former director of the Munich School of Design, for the Bauer Type Foundry. Futura is simple in design and wonderfully restful to read. It has been widely used in advertising because of its even, modern appearance in mass and its harmony with a great variety of other modern types.

SEPARATION AND FILM PREPARATION BY

ULTRAGRAPHICS
Dublin, Ireland

PRINTED AND BOUND BY

BUTLER & TANNER, LTD.
Frome, England

HARDWARE

Apple Macintosh Power PC 8100, Quadra 800 personal computers; APS Technologies Syquest Drives; MicroNet DAT Drive; SuperMac 21" Color Monitor; Radius PrecisionColor Display/20; Radius 24X series Video Board; Hewlett-Packard LaserJet 4, Supra Fax Modem.

SOFTWARE

QuarkXPress 3.3, Adobe Photoshop 2.5.1, Microsoft Word 5.1, FileMaker Pro 2.0, Adobe Illustrator 5.0.1

MUSICWARE

Ali Farka Toure (*The River*), Ray Anderson (*Old Bottles—New Wine*), Boys on the Side (*Motion Picture Soundtrack*), James Brown (*The CD of James Brown*), Greg Brown (*The Poet Game, Dream Café, In the Dark With You, One More Goodnight Kiss*), William Burroughs/Kurt Cobain (*The Priest*), Combustible Edison (*I, Swinger*), Bruce Cockburn (*Dart to the Heart*), Curtis Fuller's Quintet (*Bluesette*), Dead Kennedys (*Give Me Convenience or Give Me Death*), Brian Eno (*Ali Click*), Esquivel (*Space-Age Bachelor Pad Music*), Exotica (*The Best of Martin Denny*), John Hiatt (*Slow Turning*), Billie Holiday (*As Time Goes By*), Brenda Kahn (*Epiphany in Brooklyn*), Ingram Marshall (*Three Penitential Visions*), Rickie Lee Jones (*Traffic from Paradise*), Morphine (*Cure for Pain*), Johnny Nichols (*Thrill on the Hill*), Bonnie Raitt (*Luck of the Draw*), S. E. Rogie (*Dead Men Don't Smoke Marijuana*), John Tavener (*Thunder Entered Her*), Vern Gosdin (*Chiseled in Stone*), John Mayall (*The Turning Point*), Mozart (*Le Nozze di Figaro*), Nancy Sinatra (*The Hit Years*), Bruce Springsteen (*Nebraska*), Sonic Youth (*Dirty*), Various Artists (*Last Temptation of Elvis*), Zap Mamaa (*Adventures in Afropea 1*).

"We ascribe beauty to that which is simple; which has no superfluous parts; which exactly answers its ends."

RALPH WALDO EMERSON

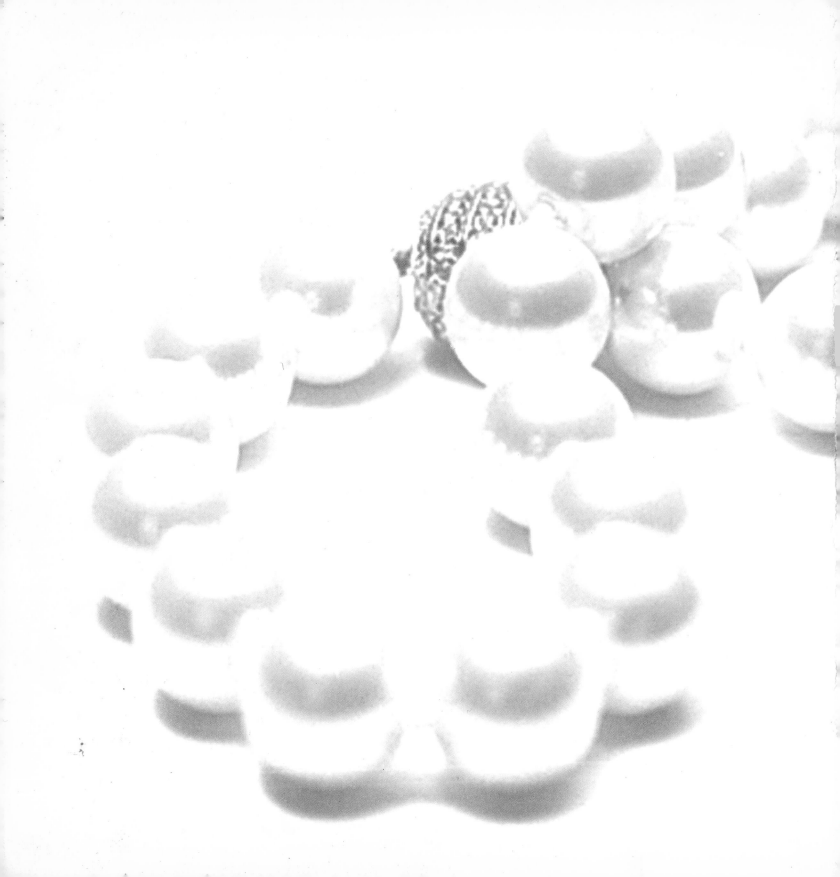